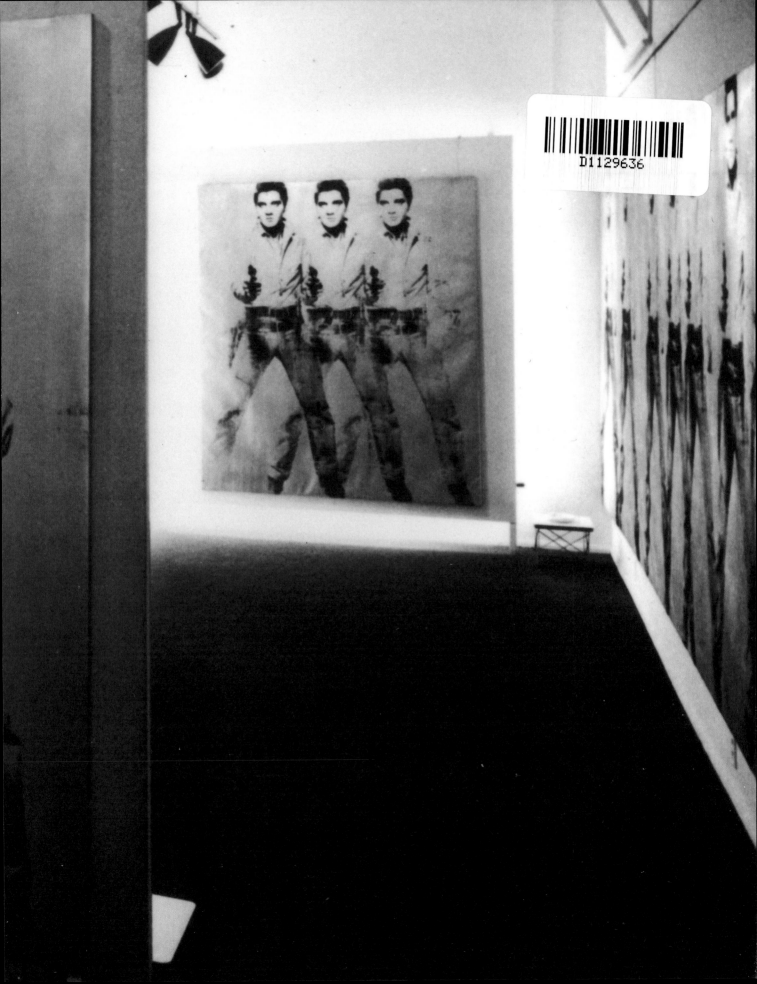

warhol
AND
THE west

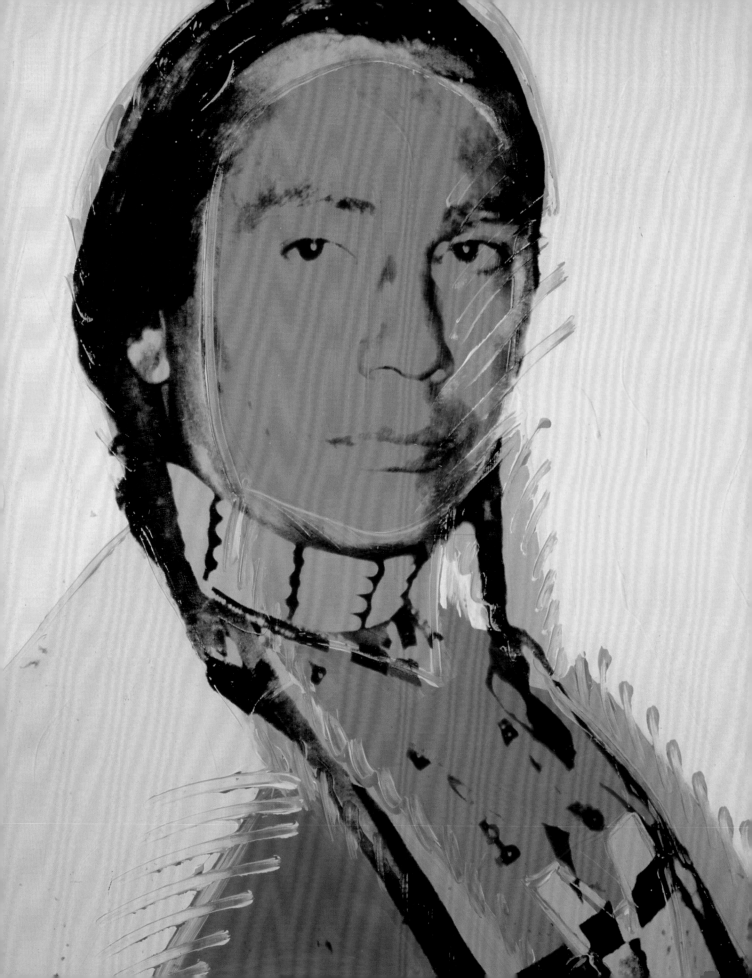

ESSAYS BY

heather ahtone

Faith Brower

Seth Hopkins

warhol
AND
THE
west

CONTRIBUTIONS BY

Tony Abeyta

Sonny Assu

Faith Brower

Gregg Deal

Lara M. Evans

Michael R. Grauer

Seth Hopkins

Frank Buffalo Hyde

Tom Kalin

Gloria Lomahaftewa

Daryn A. Melvin

Andrew Patrick Nelson

Chelsea Weathers

Rebecca West

Booth Western Art Museum CARTERSVILLE, GEORGIA

National Cowboy & Western Heritage Museum OKLAHOMA CITY, OKLAHOMA

Tacoma Art Museum TACOMA, WASHINGTON

in association with

University of California Press

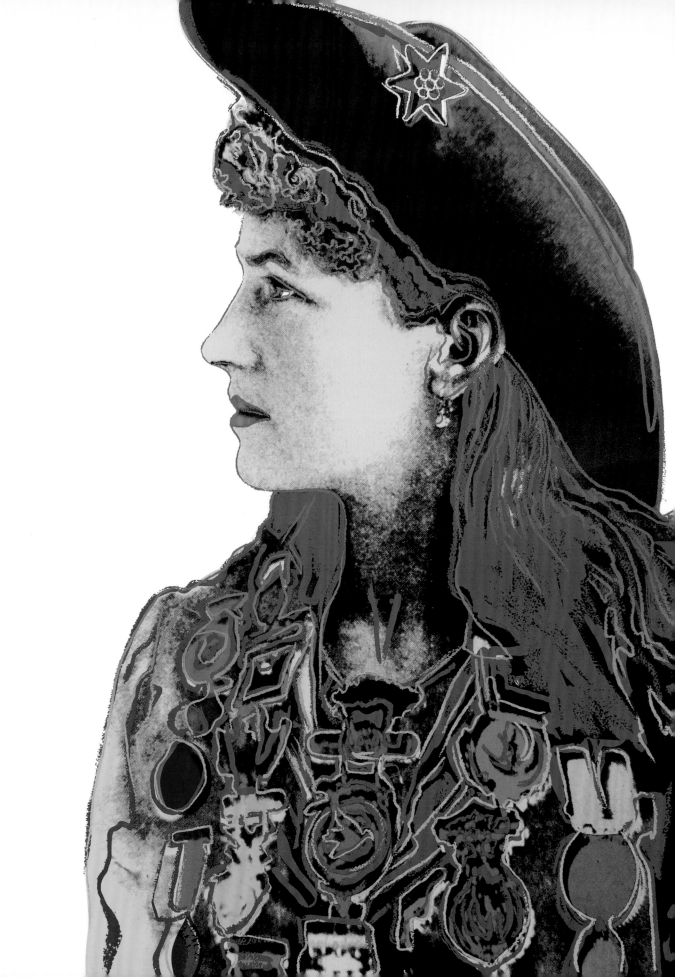

Contents

Plates and Contributions

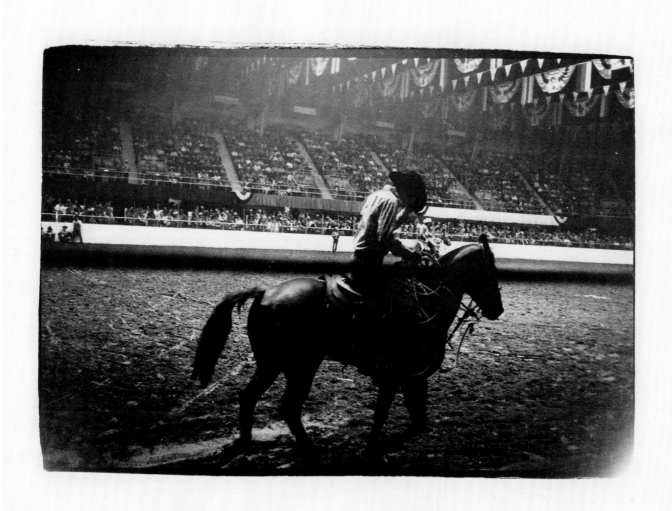

Andy Warhol (American, 1928–1987)
Rodeo, 1981
Gelatin silver print
8 × 10 inches
The Andy Warhol Museum, Pittsburgh;
Contribution The Andy Warhol Foundation
for the Visual Arts, Inc., 2001.2.822

Directors' Foreword

Like many people who grew up watching westerns on television and at the movies, Andy Warhol was influenced by the myths of the American West. *Warhol and the West* provides new scholarship and in-depth analysis of the ways Warhol's western artworks merge the artist's ubiquitous portrayal of celebrities with his interest in cowboys, American Indians, and other western motifs. Even ardent fans of Warhol may be surprised to learn that he explored western themes throughout his career. It is long overdue for Warhol's western oeuvre to be examined, and such a stimulating project is what brought together three museums with shared interests in the art of the American West.

Seth Hopkins, Executive Director of the Booth Western Art Museum, enthusiastically launched this project based on his rigorous research spanning more than a decade. The Tacoma Art Museum and the National Cowboy & Western Heritage Museum then came on board, and the three institutions worked together to realize this landmark exhibition and publication. All three museums are members of the Museums West Consortium, "organized for the purpose of developing and expanding an awareness and appreciation of the North American West . . . [and to] explore opportunities and initiatives to study, exhibit, publish, interpret, and otherwise advance the region's art, history, and cultures for the benefit of diverse audiences."

There is seemingly no better way to advance the study of the West than to look closely at one of the most important artists of the 20th century and how he projected the myths and the values of the region through vibrant images. Our three curators—Seth Hopkins; Faith Brower, Haub Curator of Western American Art at Tacoma Art Museum; and Michael R. Grauer, McCasland Chair of Cowboy Culture/Curator of Cowboy Collections and Western Art at the National Cowboy & Western Heritage Museum— collaborated and brought varied perspectives to shape and inform the project. We are thrilled that through our partnership the exhibition and accompanying catalogue will reach audiences across the country—and potentially around the world—connecting diverse communities to an aspect of Warhol's legacy that illuminates the vitality and relevancy of the West.

This publication is the vision of Faith Brower, who conceived an enormous tribute that reverberates across multiple voices to investigate these fascinating works. The publication came to fruition with the insightful scholarship and essays by Brower; Seth Hopkins; and heather ahtone, Senior Curator at the American Indian Cultural Center and Museum in Oklahoma City; and the additional contributions by artists, art historians, and curators, among others. By offering both Indigenous and non-Native perspectives on the images and nuances in this complex body of work, we hope to continue the important examinations of how people are portrayed in the American West.

The opportunity to share an exhibition and catalogue of relatively unknown imagery by one of America's best-known artists is both unique and important. *Warhol and the West* required significant resources to accomplish, for which we must abundantly thank our patrons, board members, and sponsors. We are privileged to have the support of the University of California Press as our co-publisher for this catalogue. As three individual organizations, we collectively have more than 200 staff members whom we thank for their tireless efforts. We are indebted to the ongoing support of our vast constituencies who we hope gain interest and inspiration from our pursuit to better understand the West through Warhol's work.

Seth Hopkins
Executive Director,
Booth Western Art Museum

Natalie Shirley
President & CEO,
National Cowboy &
Western Heritage Museum

David Setford
Executive Director,
Tacoma Art Museum

8

Curators' Acknowledgments

Warhol and the West provides a new way to consider the artistic legacy of one of the nation's premier artists and his impact on both the art of the American West and contemporary art at large. From Warhol's vast output, we identified 29 subjects he realized in paintings, screenprints, films, and photographs that are directly linked to the American West. Each of Warhol's western works appears in this catalogue along with written remarks from a range of voices. We hope this project initiates ongoing interest in and scholarship of this provocative work and that the diverse perspectives shared will allow readers to broadly negotiate the complexity of Warhol's great oeuvre and how it engages western art.

An exhibition and a catalogue of this nature require tremendous support, beginning with the boards and leaders of our three museums. We thank Cathy Lee Eckert, Deputy Director for Operations, Booth Western Art Museum; Natalie Shirley, President & CEO, National Cowboy & Western Heritage Museum; David Setford, Executive Director, Tacoma Art Museum; and Rock Hushka, Deputy Director and Chief Curator, Tacoma Art Museum, for making this truly exciting adventure in art possible.

This project, which began as the subject of cocurator Seth Hopkins's master's thesis, received the guidance and support of many colleagues and collaborators over the last 15 years. Seth's relationships at the University of Oklahoma, especially with his faculty advisor Byron Price, played an instrumental role, as did those with western art scholars Peter Hassrick and Bruce Eldredge. Over dinner one evening with James Ballinger, then the director of the Phoenix Art Museum, Seth began outlining his thesis options, seeking the input of a leader who had intimate knowledge of western art but also a big-picture view of the art world. The first topic

Seth mentioned was a possible investigation of the western subjects within Warhol's oeuvre, including the *Cowboys and Indians* portfolio, of which the Booth Western Art Museum owned a full suite. Ballinger enthusiastically endorsed the topic, which contains a treasure trove of imagery that is both important within the history of western art and influential for contemporary western artists.

As the project grew into a traveling exhibition and catalogue, it could not have happened without the support of our funders: an anonymous donor, Neva and Don Rountree, Anne B. Eldridge, Luther King Capital Management, and Karen and Joel Piassick at the Booth Western Art Museum; Devon Energy, The E. L. and Thelma Gaylord Foundation, The True Foundation, Arvest Bank, Cox Communications, MassMutual Oklahoma, Oklahoma Gas & Electric, and Oklahoma City Convention and Visitors Bureau at the National Cowboy & Western Heritage Museum; and the Haub Family Endowment, Virginia Bloedel Wright, and, in part, ArtsFund at Tacoma Art Museum. We also truly appreciate the support of the Andy Warhol Foundation for the Visual Arts. We extend our thanks to the Artists Rights Society, especially Janet Hicks, Director of Licensing. The Andy Warhol Museum and its staff were pivotal in supporting the initial research, providing loans of artworks paramount to the exhibition, and contributing images and information for this catalogue. We especially thank Patrick Moore, Director; Keny Marshall, Director of Exhibitions; Amber Morgan, Director of Collections and Registration; Kristin Britanik, Manager of Rights & Digital Collections; and Erin Byrne, Archivist.

The University of California Press helped shape the book, and we appreciate the efforts of Nadine Little, Art History Editor, and her team. Our thanks to Lucia|Marquand and specifically

Tom Eykemans for his lively and intelligent design, and to Michelle Piranio for her careful and impeccable editing. Gina Broze navigated the mountain of rights surrounding this catalogue, for which we are greatly appreciative.

Warhol and the West benefited immensely from the efforts of staff members at our three museums, including our key collaborators Zoe Donnell, Exhibitions and Publications Manager at Tacoma Art Museum, and Melissa Owens, Registrar at the National Cowboy & Western Heritage Museum. Zoe, your expertise, guidance, and support, with doses of reality, were unmatched and made the project a success, and we are truly grateful for your involvement. Melissa, thank you for your support. We appreciate your skillful management of the exhibition tour. Thank you both for moving us forward in every stage of exhibition and catalogue production.

We thank Lisa Wheeler, Sam Gerace, Liz Gentry, Eric King, Nikki Morris, Lindsay LeCroy, and Cathy Hendrix, from among a great staff at the Booth Western Art Museum who went above and beyond in their support of this project. Thanks also go to Columbus State University professor Libby McFalls and her printmaking students Gena Jerwoski and Dalton Tanner. The National Cowboy & Western Heritage Museum wishes to thank Hal Prestwood and August Walker, as well as Seth Spillman. At Tacoma Art Museum we extend our gratitude to Jessica Wilks, for her unwavering support; Ellen Ito, especially for reviewing an essay; Ben Wildenhaus, for his remarkable aptitude and great design work; and Margaret Bullock, for her camaraderie, among a team of remarkable museum professionals.

We are fortunate that the subject of Andy Warhol attracts many fine scholars, and we extend our deep appreciation to the contributors to this catalogue: lead essayist heather ahtone; and Tony Abeyta, Sonny Assu, Gregg Deal, Lara M. Evans, Frank Buffalo Hyde, Tom Kalin, Gloria Lomahaftewa, Daryn A. Melvin, Andrew Patrick Nelson, Chelsea Weathers, and Rebecca West.

Our sincere gratitude goes to the lenders who made the exhibition possible and to those who shared images for the catalogue, including the Andy Warhol Museum; Gilcrease Museum, Tulsa, Oklahoma; National Museum of the American Indian, Smithsonian Institution; and Wells Fargo Bank, N.A.; as well as the private lenders, including W. Roger and Patricia K. Fry; William Foxley; Ralph and Nita Howard; Karen and Joel Piassick; Maureen Zarember, Tambaran Gallery; private collection, Charlotte, North Carolina; and the other lenders who wish to remain anonymous. Our thanks to Liliane and Christian Haub for supporting Tacoma Art Museum's acquisition for the traveling exhibition. We are also indebted to the galleries that supported this initiative, including Heather James Fine Art and LewAllen Galleries. For generously sharing images of their work we thank artists Maura Allen, Duke Beardsley, Gregg Deal, Frank Buffalo Hyde, Robert Mapplethorpe Foundation, Christopher Makos, Alison Marks, Billy Schenck, Mark Sink, Frank J. Thomas, and Will Wilson.

Lastly, we acknowledge the ever-elusive artist whose work we drew inspiration from the whole way through. Warhol challenged us to think about the West and how it shapes our understanding of life in America, past and present. We hope the artist would find pleasure in our interpretation of his great legacy; we trust that he would have provided us with vague and poetic answers to our questions of purpose and intent.

Faith Brower
Haub Curator of
Western American Art,
Tacoma Art Museum

Michael R. Grauer
McCasland Chair of Cowboy
Culture/Curator of Cowboy
Collections and Western Art,
National Cowboy &
Western Heritage Museum

Seth Hopkins
Executive Director,
Booth Western Art Museum

Introduction

Faith Brower, Michael R. Grauer, Seth Hopkins

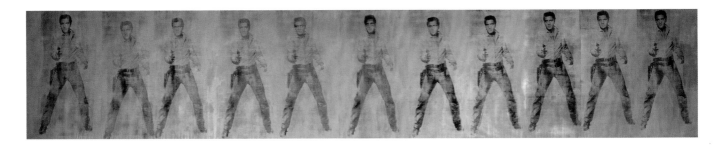

FIGURE 1
Andy Warhol (American, 1928–1987)
Elvis 11 Times [Studio Type], 1963
Silkscreen ink and silver paint on linen
82 × 438 inches
The Andy Warhol Museum, Pittsburgh; Founding Collection, Contribution The Andy Warhol Foundation for the Visual Arts, Inc., 1998.1.58

Andy Warhol was drawn to the lore and lure of the American West throughout his life. In 1963, early in his career as a pop artist, Warhol appropriated a publicity photograph from a western film of a six-gun-wielding Elvis Presley for use in a painting. Appearing nearly life-size, Warhol's images of Elvis boldly confront viewers with the legends of the West. Warhol's foray into blending western subjects with contemporary style did not stop there; he continued to revisit western iconography within the body of his work in the decades that followed.

In addition to repeating the image of Elvis as a cool western cowboy 95 times, resulting in 36 unique paintings (see fig. 1 and page 51), Warhol went on to create portraits of several other western movie stars. He was friendly with and painted several western and Native American artists. He painted a Native American activist emblematic of modern-day civil rights for American Indian people. He made at least two westerns as a filmmaker. He depicted wildlife of the American West and created a large series of sunset images. And he amassed a large collection of Native American and western art, objects, and photographs.

His 1986 *Cowboys and Indians* series— consisting of fourteen screenprints, including ten edition prints that were released in the final portfolio, four additional trial proofs, and related paintings of at least three subjects—represents an important milestone in both the artist's career and the history of western American art. Among the last major projects he completed prior to his death, *Cowboys and Indians* received little critical or public attention at the time of its release and remains one of the most understudied aspects of the artist's career.[1] The images selected for *Cowboys and Indians* include iconic western American figures and subjects that in the hands of Warhol become important comments on the contemporary understanding of the mythology of the West.

Warhol was influenced by the myths of the American West conveyed to him primarily through film and television, similar to a majority of his young American peers, children who grew up waiting to see what Gene Autry or Roy Rogers would do next Saturday on the silver screen. In some ways he never grew out of that fascination, wearing cowboy boots most days. Though inspired by the stories and legends of the West and traveling there possibly a few dozen times, Warhol generally imagined western people and places from his studio in New York. His time in the West was often spent attending art openings and conducting business in Los Angeles and other metropolitan areas, including Dallas, Houston, and Seattle, although he did have formative experiences in the West.

In 1963 Warhol went on a road trip across the country to attend an art opening in Los Angeles.[2] In 1968 he filmed *Lonesome Cowboys* at Rancho Linda Vista in Oracle, Arizona, and at Old Tucson, the set for many important western movies. He had a particular affinity for the Colorado Rockies, and bought 40 acres near Aspen. According to his diary entries, he visited Colorado nearly half a dozen times after buying his property.[3] On these trips, Warhol created snapshots of his travels.[4] Exploits of him skiing and snowmobiling were captured by his friends and associates.

Warhol was not immune to the powerful forces that have drawn creative souls to the artists' mecca of Taos, New Mexico. In addition, he had a romantic view from afar regarding Texans and their home state, at one point suggesting that a museum documenting his career belonged there more than in the familiar urban settings he knew in Pittsburgh and New York.

His affinity for the West extended to his collecting habits. Warhol had significant works of western art in his personal collection, including western landscapes by Albert Bierstadt and Maxfield Parrish, contemporary paintings by Fritz Scholder and R. C. Gorman, and a large oil painting depicting an Indian on horseback.[5]

The genre of western art generally comprises imagery, often in a representational style, that captures the landscape, people, history, myths, and other lifeways of the region west of the 100th meridian. Early Euro-American explorer-artists documented the wondrous and "exotic" environment of western North America in order to show their fellow compatriots how the region and its Native inhabitants appeared. Although authenticity and detail became the principal measures by which western American art was often judged, most artists portrayed the region as both picturesque and romantic. Early artists such as Karl Bodmer, George Catlin, Alfred Jacob Miller, and John Mix Stanley led the way in documenting the Indigenous people who many incorrectly believed would be gone in a generation or two. In fact, two generations later a similarly motivated Edward S. Curtis was creating his own photographic Native American encyclopedia based on the same misconception of a "vanishing race." Tropes such as these have prevailed for

centuries, communicating long-standing cultural misunderstandings and stereotyping, which are present in Warhol's work as well as in these more historical examples of western art.

Following the lead of early Hudson River School artists, Thomas Moran and Albert Bierstadt created majestic landscape paintings that glorified western vistas based in part on their travels in the West. And soon Charles M. Russell, Frederic Remington, and a herd of other artists and photographers were chronicling the end of the cowboy era and lamenting the passing of the "Old West."

Over time, the works of these artists and those of numerous writers and filmmakers combined to create the legendary West full of iconographic and mythical images that drew their power in part from repetition. In *The West of the Imagination*, authors William H. Goetzmann and William N. Goetzmann argue that this process is still at work:

> Western artists have become willing vehicles for the perpetuation of compelling Western images, unafraid to take from the past and to re-work or replicate archetypes. This tendency towards replication is perhaps the most jarring or unusual facet of modern Western art, because it flies in the face of the usual mandate that an artist must offer an original, not a derivative, image. . . . The Western artist has willingly become a human medium for the development and perpetuation of the culturally sustaining history, myth and legend about the West—for him (or for her), aesthetic novelty now has no special lure. Although painters in a traditional mode, this attitude places Western artists in a counter-cultural stance.[6]

For the art historian Patricia Broder, it is only natural that pop artists who sought out quintessentially American subjects to appropriate and repackage would eventually find western icons. "Pop artists James Rosenquist, Andy Warhol, and Roy Lichtenstein," she says, "see the modern West as the cradle of mass culture, and they pay tribute to the Indian and cowboy as fundamental American symbols. The world of Miller, Moran, Bierstadt, Remington, and Russell belongs to history, but progressive contemporary artists have recognized the aesthetic validity of the modern West and found new ways to express it."[7]

Acknowledging the absence of critical analysis of Warhol's western production, the scholar Dorothy Joiner argues for its importance by pointing out that pairs of images from *Cowboys and Indians* can be viewed as "calculated juxtapositions" that force viewers "to reconsider the concept of 'hero' in the context of the American West by portraying the significance of the silent heroes, America's Native Americans."[8] Joiner writes: "These prints are significant in their illumination of America's collective mythicizing of the West. The first print in the series, *Indian Head Nickel*, reproduces in silvery tones the familiar noble profile of an American Indian, which formerly appeared on the U.S. five-cent piece. . . . In contrast to the Indian's fierce nobility is the taciturn self-satisfaction of *General Custer*, his arms folded, his gaze directed toward the distance."[9]

While many of Warhol's western subjects derive their power from nostalgia and familiarity, they may also prompt an unsettling question: How should we as Americans feel about ourselves and our country when confronted by Warhol's *Cowboys and Indians*? The scholar Carla Mulford points out the provocative nature of Warhol's images in the series,

> [which] prompts us to ask whether such representations glorify westerns and the presumed leadership qualities that enabled non-Indian settlers to appropriate, more often than not unfairly, Native people's lands *or* whether they serve as artful commentaries on just such self-satisfied presumption on the part of citizens who know nothing about the Native peoples who have been displaced in order to foster the ideals of "progress" supported as a national American vision.[10]

Andy Warhol's Dream America, a major exhibition of screenprints from the collection of the Jordan Schnitzer Family Foundation, began traversing the West in 2004 and stayed on the road for several years. With stops at museums in Montana, Wyoming, Utah, Oregon, Nevada, Texas, Colorado, Arizona, and California, this show figuratively retraced the steps of some of the real figures depicted in *Cowboys and Indians*.

One would anticipate the portfolio to receive significant interest from viewers in cities like Billings, Montana, and Casper, Wyoming, where western history was actually made. Within this regional context, the catalogue text by the exhibition's curator, Ben Mitchell, likely drew a variety of reactions:

> Warhol's true subject here is the myth of the West, a kit bag of pervasive notions about history, national identity, sentiment, and heroism. A stew cooked up in the kitchens of Hollywood, popular literature, and advertising, flavored with insistent tourism and chamber of commerce boosterism, its main ingredients are the idealization of colonization, a glorification of violence, and a malignant and insidious disregard of racism. Spoons in hand, we are still gathered around that pot today.[11]

Why does Warhol's art resonate so powerfully with Americans? The art critic Arthur Danto has attempted to identify the reasons. "A community is defined by the images its members do not have to find out about," says Danto, "but who know their identity and meaning immediately and intuitively. . . . Everyone in America knew Liz and Jackie, Elvis and Marilyn, Mickey Mouse and Superman, Campbell's Soup and Brillo. When this knowledge vanishes, the culture will have changed profoundly."[12] Such observations apply just as readily to the portraits in *Cowboys and Indians* of John Wayne, Geronimo, Custer, Sitting Bull, Teddy Roosevelt, and Annie Oakley as well as other iconic western images in Warhol's oeuvre.

Pop art was hailed during its heyday as purely American—notwithstanding that the term and the movement originated in England—and Warhol regularly told interviewers that he was as American as they come, and few things are more uniquely American than the West. Determining Warhol's intent or social commentary in any facet of his art is difficult, if not impossible, with the artist always insisting that the surface was all there was. His work *is* a surface, as he suggests: a self-reflecting mirror that looks wryly at American culture—the good, the bad, and the ugly. But despite Warhol's statement, his art goes deeper; it is nuanced and layered in complexities.

One of the critics who knew the artist best, the former Metropolitan Museum of Art curator Henry Geldzahler, provided a fitting summary for any analysis of Warhol's work by posing a series of questions one might prudently ask: "Is he being cynical? Is he kidding? Is he simple? Does he think we're simple? Are we?"[13]

Warhol was notoriously vague in providing details about his work. His casual, detached posturing makes it difficult to interpret the artist's intent. With regard to the West, we are left to wonder: Is Warhol elevating his subjects as American heroes, portraying them as vintage kitsch, or commenting on their has-been status? We may never know, or at least never be sure. What we can be sure of is Warhol's profound ability to find subjects that continue to hold relevance and meaning today, reminding us that the American West and its myths have influenced and inspired people through a turbulent past into a dynamic present and a shared future.

NOTES

1. Exhibitions of *Cowboys and Indians* were presented at Texas Christian University and the Museum of the American Indian (now the Smithsonian's National Museum of the American Indian) in 1986. Since that time the full portfolio has been shown at museums around the country as a stand-alone exhibition or paired with similar work by other artists, such as Roy Lichtenstein or Billy Schenck; however, these showings have been relatively few and far between. *Cowboys and Indians* does not appear in many biographical listings of Warhol's work, including the one in the catalogue for the artist's 1989 retrospective at the Museum of Modern Art, New York. Additionally, images from the suite usually do not find their way into major exhibitions of the artist's work. None, for example, appeared in the MoMA retrospective or in the 2018 Whitney Museum of American Art retrospective, and none regularly hang at the Andy Warhol Museum in Pittsburgh.

2. This journey is the premise of Deborah Davis's book *The Trip: Andy Warhol's Plastic Fantastic Cross-Country Adventure* (New York: Atria Books, 2015).

3. He attended his exhibition openings and visited his property in 1977 and 1981; he celebrated Christmas in Vail in 1979 and each New Year's Eve in Aspen from 1981 to 1984, and traveled to Aspen for a celebrity auction in 1984.

4. Thousands of Warhol's snapshots, including photographs from his time spent in the West, can be found in his photographic archive. In 2014 the Cantor Arts Center at Stanford University received a vast photographic legacy of Warhol's photographs from 1976 to 1987. They worked with Stanford University Libraries to preserve and digitize these holdings, which include more than 3,600 contact sheets.

5. In the 2002 exhibition *Possession Obsession*, at the Andy Warhol Museum, Pittsburgh, this painting is attributed to the 19th-century Spanish artist Genaro Pérez Villaamil, although it is listed as by an unknown artist in the Sotheby's auction catalogue of Warhol's estate. Sotheby's, *The Andy Warhol Collection, Vol. 5: Americana and European and American Paintings, Drawings, and Prints* (New York: Sotheby's, 1988), n.p.

6. William H. Goetzmann and William N. Goetzmann, *The West of the Imagination* (New York: W. W. Norton, 1986), 327–28, 335.

7. Patricia Janis Broder, *The American West: The Modern Vision* (Boston: Little, Brown, 1984), 276.

8. Dorothy Joiner in the gallery guide for *Works by Warhol from the Cochran Collection*, circa 1998, produced by Wesley and Missy Cochran, in the collection of Wesley Cochran.

9. Dorothy Joiner, "Andy Warhol, 1928–1987," *Resource Library Magazine*, 2003, http://www.tfaoi.com/aa/4aa/4aa141.htm.

10. Carla Mulford, gallery guide for the exhibition *Andy Warhol: "Cowboys and Indians,"* Palmer Museum of Art, Penn State University, March 14–June 11, 2000.

11. Ben Mitchell, "Commentary," in *Andy Warhol's Dream America: Screenprints from the Collection of the Jordan Schnitzer Family Foundation* (Eugene: Museum of Art, University of Oregon, 2004), 33.

12. Arthur Danto, "Warhol and the Politics of Prints," in Frayda Feldman and Jörg Schellmann, *Andy Warhol Prints: A Catalogue Raisonné, 1962–1987,* 3rd ed., revised and expanded by Frayda Feldman and Claudia Defendi (New York: Distributed Art Publishers in association with Ronald Feldman Fine Arts, Edition Schellmann, and The Andy Warhol Foundation for the Visual Arts, 1997), 11.

13. Henry Geldzahler, "Introduction," in Frayda Feldman and Jörg Schellmann, *Andy Warhol Prints: A Catalogue Raisonné,* 2nd ed. (New York: Abbeville Press with Ronald Feldman Fine Arts and Edition Schellmann, 1989), 10.

essays

Warhol and the West: Following Faint Trails to the Lost Gold Mine

Seth Hopkins

Andy Warhol often said that his happiest moments growing up in Pittsburgh were his Saturday morning trips to the local movie theater. As a child of the late 1930s and early 1940s, he undoubtedly saw many westerns, as this genre dominated American cinema of the era. In later years he often listed cowboy star Roy Rogers among his favorite actors,[1] and his estate contained hundreds of publicity photos from a variety of movies as well as a Roy Rogers alarm clock (figs. 2, 3).[2] When in the third grade he contracted Sydenham's chorea (also called Saint Vitus's Dance), a complication of scarlet fever, and was home sick, his mother gave him coloring books to fill and paper dolls to cut out. Reportedly, his doctor gave him a toy gun.[3] Having been exposed to western movies, it is very likely he played a form of the game "cowboys and Indians," perhaps reenacting the plots of movies he had attended.

As a child Andy dreamed about other parts of the country, including the West. In his 1985 book *America* he wrote, "Everybody has their own America, and then they have pieces of a fantasy America that they think is out there, but they can't see. When I was little, I never left Pennsylvania, and I used to have fantasies about things that I thought were happening in the Midwest, or down South, or in Texas, that I felt I was missing out on."[4]

After graduating from Pittsburgh's Carnegie Tech (now Carnegie Mellon University), where he studied painting and design, he moved to New York and set out to become a magazine illustrator. He was an almost instant success, garnering an ever-larger volume of work and commanding higher-priced commissions.[5] But Warhol longed to be known as a fine artist, not merely an illustrator, and to enter the star-studded world of New York high society. He dreamed of being an

art superstar. "I want to be Matisse," he once said. "I want to be as famous as the Queen of England."[6]

In 1962 Warhol found the subjects that would make him an international sensation. Acting on a suggestion by the art dealer Muriel Latow, he began painting large canvases featuring multiple images of dollar bills. He then moved on to Campbell's soup cans, creating 32 realistic paintings, one for each available flavor. Unable to get a major New York gallery to show such works, Warhol took his soup can paintings to California, where they were first exhibited at the Ferus Gallery in Los Angeles in 1962. A neighboring gallery ridiculed the show by advertising real soup cans for 20 cents, compared to the $100 Warhol was charging for his paintings. Using this idea to his advantage, however, Warhol had his picture taken at a supermarket signing real cans. Newspapers around the globe ran the photo and helped launch the artist into art world stardom.[7]

Later that year, no doubt influenced by his sojourn to the West Coast, Warhol began creating silkscreened portraits of Hollywood movie stars, including Elvis Presley, Marilyn Monroe, and Elizabeth Taylor. The silkscreening process allowed Warhol to merge elements of commercial art, fine art, and printing in a unique way that suited him perfectly. Fast and relatively inexpensive, silkscreening also enabled him to create multiple versions of the same subject.

Among Warhol's most successful early pop art images is his portrayal of Elvis Presley, dressed in western garb and pointing a gun at the viewer (page 51). The artist completed a series of paintings using this image, sometimes repeated several times on each canvas. The source was a publicity photo for the 1960 movie *Flaming Star* (a title that could have applied to Warhol's career immediately following his successful West Coast debut).[8] In the film Presley plays the tormented

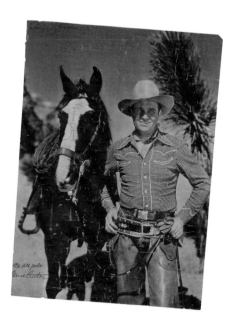

son of a white father and a Native American mother, caught between two warring parties and forced to choose sides. The dramatic nature of his role, the high level of violence, and the inclusion of only two musical numbers make the film unique among Presley's movies. Warhol's art has been compared to a mirror in which we see America, showing us who and what we are. Elvis portrayed as a pop singer would have been Americana, and as a singing matinee idol, double Americana; but Elvis as a singing western matinee idol becomes triple Americana.

The Hollywood actor Dennis Hopper hosted a party for Warhol during his 1963 stay in Los Angeles for the opening of his *Elvis Paintings* exhibition at Ferus Gallery. Years later, in 1971, Warhol would paint a portrait of Hopper wearing a cowboy hat (page 63), paying tribute to the actor's early appearances in such westerns as *The Sons of Katie Elder*, *From Hell to Texas*, *True Grit*, and especially *Giant*. In that 1956 film, Hopper plays a rancher's son who cannot quite measure up to his father's reputation or expectations, facts visually confirmed when at Christmas he receives a hat several sizes too large.

Just as Warhol began to achieve the fame he had dreamed about as a painter, he turned his attention to other forms of expression in the mid-1960s. Screenprinted Brillo and Heinz Tomato Ketchup boxes passed for sculptures. He would promote the rock band the Velvet Underground with whom he traveled in 1966 and 1967 presenting his live companion multimedia light show, the *Exploding Plastic Inevitable*. And he began to experiment with filmmaking.

Some of his earliest film efforts were black-and-white, often silent marathons depicting such mundane subjects as a man sleeping (*Sleep*; 1963) or the Empire State Building (*Empire*; 1964). Another project included the production of short visual portraits Warhol eventually called *Screen Tests* (1964–66). These silent, black-and-white films featured close-ups of visitors to the studio who were posed against a plain backdrop and asked to sit still for roughly three minutes. Hopper was among the approximately 500 people who were "tested."

In 1965 Warhol announced he was giving up painting to concentrate on filmmaking, and though he did reduce his output, he continued to paint sporadically. He hired Ronald Tavel to help develop loose scripts for his more ambitious film projects. Tavel was responsible for the idea behind *Horse*, Warhol's first "western," made in 1965 (pages 52–54). According to Tavel, it was "not so much a take-off on it but a genuine

FIGURE 2
Andy Warhola's childhood movie star scrapbook with photograph of Gene Autry from interior, circa 1938–42 Leather on board, paper, assorted photographs 11½ × 15¼ × 1 inches The Andy Warhol Museum, Pittsburgh; Contribution The Andy Warhol Foundation for the Visual Arts, Inc., T689.1–T689.31b

Western, showing what genuinely went on. And they—the cowboys—had to be celibate, asexuals, and homosexuals. Why else would they spend their whole life on the prairie? They were in love with their horses, obviously."[9] Filming took place at the Factory, a former hat factory Warhol had converted into a studio, and conditions were chaotic.[10] Warhol had rented a small horse for the movie, but a massive black stallion named Mighty Bird was delivered instead. Although the horse was accompanied by a trainer and tranquilizers, it posed a threatening presence in the confines of the Factory. Warhol's art assistant Gerard Malanga wrote the actors' lines in large print on placards and arranged them in order. Tavel wrote out placards with each actor's name. The instructions to the actors were simple: look at Tavel and if he's holding your name up, look at Gerard and read your line. Warhol biographer Victor Bockris recalled: "Malanga and Tavel held up directions for the actors on cue cards. The first one read: 'Approach the horse sexually.' Things disintegrated in a few minutes when the horse kicked one actor in the head, and the whole scene erupted in a brawl."[11] Warhol apparently was content. He only worried that the "western" looked too realistic, and he instructed the sound man to lower the boom so that it appeared in the frame.[12] As the film ends, the main character can be heard attempting to sing an operatic aria, presumably a jab at western movies featuring singing cowboys, derisively known by some as horse operas.

Warhol eventually abandoned formal screenplays and prewritten lines, preferring that the actors improvise the dialogue within a loosely framed plot.[13] This would be the case for *Lonesome Cowboys,* Warhol's other foray into the western genre (pages 55–58). For the 1968 filming Warhol rented Old Tucson, a re-created western town and movie lot just south of Tucson, Arizona. The film's plot revolves around Viva, who plays a beautiful woman ranch owner looking for love. Taylor Mead, a veteran of the underground film scene, plays her homosexual doctor, who sometimes pursues the same men Viva desires. Both lust after five handsome cowboys who ride into town and become romantically involved with each other at various times in the film.[14]

Lonesome Cowboys opened in New York City in May 1969; later, police seized a copy of the film during a showing in Atlanta, declaring it pornographic. Although shocking to many mainstream filmgoers, *Lonesome Cowboys* would have attracted little attention, even in the underground film scene, without Warhol's name attached to it. Despite its poor production values, sloppy editing, garbled and out-of-sync audio, and lack of a discernable plot, *Lonesome Cowboys* won the Best Film Award at the 1969 San Francisco Film Festival.

In the late 1960s Warhol began to devote more time to his lifelong collecting habits. He voraciously collected prints and photographs of Native Americans; American Indian–made weavings, baskets, and jewelry; and tribal art from around the globe. Warhol had a high regard for Native American artists, particularly women. "I think American Indian art is the greatest art," he once said.[15] At another time he expressed his belief that "the women were the best anyway . . . they did those things that I like the best, the Indian rugs— they wove all those beautiful things."[16]

Warhol's interest in Native American art surfaced publicly in 1969 during an exhibition he curated for the art museum at the Rhode Island School of Design called *Raid the Icebox I with Andy Warhol.* Allowed to choose any objects he wished from the museum's storage area, Warhol selected whole collections and displayed them as he had

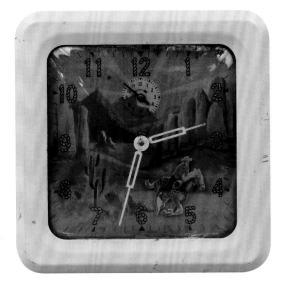

FIGURE 3
Roy Rogers alarm clock,
circa 1951
Metal with glass and
printed ink on paper
5 × 5 × 2¼ inches
The Andy Warhol Museum,
Pittsburgh; Contribution The
Andy Warhol Foundation
for the Visual Arts, Inc.,
TC526.36

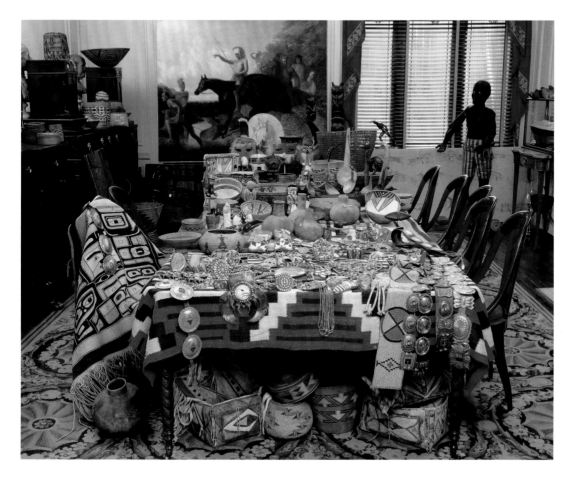

FIGURE 4
Robert Mapplethorpe
(American, 1946–1989)
*Untitled (Home of Andy
Warhol)*, 1987

found them. Among the items he chose were
Native American rugs, baskets, and ceramics.[17]
The museum's director, Daniel Robbins, noted:
"[Warhol] chose American Indian Blankets . . .
wistfully remarking that he wished we had more,
and unfailingly he pointed to all the American
Mound Builders' pots we had."[18]

Warhol's collecting trips became part of his
daily routine. "He shopped for two or three hours
a day for as many years as I can remember," his
former partner Jed Johnson wrote. "He started
buying American Indian artifacts because he lived
around the corner from a store that had great
things that were relatively cheap; he continued
to buy them until he died. . . . I'd ask him why he
bothered to buy twenty small things instead of
one big one for the same price. The answer should
have been obvious to me—one big thing would
have required less shopping, less action."[19] It was
not until after his death in 1987, however, that even

some of Warhol's closest friends realized the depth
of his interest in Native American art.[20] Almost
an entire day of the 10-day liquidation auction
of Warhol's personal collection at Sotheby's was
devoted to the sale of more than 650 pieces of
American Indian art. Sale lots included jewelry,
baskets, textiles, beadwork, and other artifacts
representing tribes from Mexico to Alaska.[21]

When the Sotheby's curatorial team first
entered Warhol's home following his death, they
found that only a few of the rooms appeared to
have been inhabited. The remainder were stuffed
full of furniture, art, and other objects, many of
which had never been unpacked. In anticipation
of the auction, *House & Garden* magazine hired
Robert Mapplethorpe to photograph several
rooms in the house, highlighting various
collecting areas and particular furnishings
(fig. 4). The Sotheby's team had arranged the
furniture and displayed portions of the collection

so the home would appear orderly and tastefully decorated, as if Warhol had "lived" with his collections and providing Mapplethorpe and the Sotheby's photographers plenty to shoot. One of the images shows Edward S. Curtis photographs of Native Americans hanging along a staircase wall; another shows a large table loaded down with Native American art and artifacts, with *Indians on Horseback*, a large painting attributed only to the 19th-century Continental School, in the background.[22]

There is also an indication that Warhol was in the business of selling Native American art during the early 1970s. Bob Ashton, an art dealer and founder of *American Indian Art Magazine*, remembers an exchange he had with Warhol in the early 1970s: "Andy Warhol and Dennis Hopper had opened a little Indian Art store in Taos. One afternoon, Andy and his entourage . . . came to my shop. I proceeded to give them an eight to ten minute lecture on the history of Navajo weaving." Ashton then got his own lecture: "Warhol said, 'Now let me tell you what you really have,' and proceeded to very quickly point out the similarities between Hard Edged painting, Cubism, and Pop Art, and said something to the effect that the Navajo weavers had discovered this sort of thing long before there was a name for it."[23]

Warhol also collected paintings and prints by acknowledged 19th-century masters of American western art. A wilderness scene painted by Albert Bierstadt was perhaps the most prominent of the western art lots, which also included bird prints by John James Audubon and lithographs derived from Charles Bird King's paintings, taken from Thomas McKenney and James Hall's three-volume *History of the Indian Tribes of North America* (1836–44). A full set of the McKenney and Hall books was also in the sale. The nearly 300 Curtis photographs and photogravures represented Warhol's most extensive collection of Native American images.[24]

Images by Curtis may well have been influential on Warhol's approach to creating portraits that made stars of common folk and launched real stars to even greater heights. In 1976 Warhol embarked on a series of paintings he called *The American Indian (Russell Means)* (page 69). Working through Ace Gallery in Los

FIGURE 5
Andy Warhol's cowboy hat (Resistol)
The Andy Warhol Museum, Pittsburgh; Founding Collection, Contribution The Andy Warhol Foundation for the Visual Arts, Inc., 1998.3.6976.1

Angeles, he asked a number of people familiar with contemporary Indian life to recommend one individual who exemplified modern Native Americans. Several people suggested Russell Means, an activist and controversial leader within the American Indian Movement (AIM). In the late 1960s and early 1970s Means had helped orchestrate AIM takeovers at such high-profile sites as Mount Rushmore; Alcatraz; the Bureau of Indian Affairs in Washington, DC; and Wounded Knee, South Dakota, the scene of a 19th-century Indian massacre.[25]

Warhol may not have understood just how controversial a choice he had made in using Means, especially in the midst of the country celebrating its bicentennial. The catalogue for the exhibition of these works at Ace Gallery emphasized Warhol's sympathy toward the plight of American Indians and his interest in supporting their attempts to gain justice and a greater degree of political autonomy.[26] *The American Indian (Russell Means)* series can be read as poignant social commentary, despite Warhol's repeated denials of such motivation. He said, for example, "If you want to know all about Andy Warhol, just look at the surface of my paintings and films and me, and there I am. There's nothing behind it."[27] Warhol biographer Carter Ratcliff describes the image of Means as "an emblem of a challenge," noting that the artist "substitutes flourishes of acrylic for traditional war paint, and this is sufficient to domesticate

these portraits. They still have a threatening aura, however, all the more so since pictures of the American Indian are capable of arousing pangs of colonialist guilt in Warhol's most sophisticated audience."[28] So just as Americans were celebrating 200 years of independence, Warhol was reminding them of the much longer history of unjust dealings with the people who were here long before 1776.

During his career Warhol painted at least two other high-profile Native Americans, R. C. Gorman (page 73) and Fritz Scholder (page 77), both among the first contemporary Native artists to garner a worldwide reputation.[29] Having their portraits painted by Warhol only furthered their fame; both artists advertised that their Warhol portraits would be on view at their next gallery openings. Scholder's portrait by Warhol was featured on the cover of *Artlines* magazine in January 1981. In a letter, Scholder thanked Warhol for hosting him during a weekend in New York and for the great job he did on the portraits.[30] Warhol reportedly visited Gorman in New Mexico several times and may have hosted the artist when he visited New York.[31] Both Gorman and Scholder sat for Polaroid photography sessions with Warhol, a typical part of his portrait process.

Another artist with strong ties to the West who sat for her portrait was Georgia O'Keeffe (page 79). Indications are that Warhol visited her in New Mexico first and thereafter she dropped by his studio on occasion when she came to New York. Warhol's published diary mentions her visiting in 1979, 1980, and then again in 1983, when he interviewed the then 96-year-old artist. Their transcribed conversation appeared in the September issue of *Interview* magazine discussing, among other things, her plan to live to 100. (Alas, she died at 98.)[32]

Warhol's connections to the American West were expressed not only through collecting and relationships but also in fashion, including a cowboy hat (fig. 5) and especially cowboy boots (fig. 6). The collection at the Andy Warhol Museum in Pittsburgh boasts more than 20 pairs of cowboy boots owned by the artist. Several are still pristine, indicating they were seldom worn, perhaps only on special occasions. Others are splattered with paint, suggesting he wore them

while working in the studio. For most of his life, Warhol normally wore cowboy boots, as was frequently noted by interviewers.

In 1981 Warhol devoted himself to an exploration of American myths, in a series of prints and paintings simply called *Myths*, which dealt primarily with imaginary and television- or movie-inspired characters. Among the 10 personalities—which included such laudable figures as *Santa Claus*, *Uncle Sam*, and *Superman*, as well as more villainous ones like *Dracula* and *The Witch* (from *The Wizard of Oz*)—was *Howdy Doody* (page 81), the cowboy marionette who starred in his own TV show for 13 years, appearing in more than 2,300 episodes.[33] Warhol could have just as easily picked Matt Dillon, Paladin, or any other western television character from the 1950s who possessed mythic qualities. In selecting the appealing puppet, Warhol identified an image that would be familiar to and resonate with the largest potential audience. In writing about the *Myths* series, the art critic Arthur Danto described just how resonant the image was, when a large group of socially conscious college students took a break from protesting the Vietnam War and social injustice to sing along with Howdy Doody

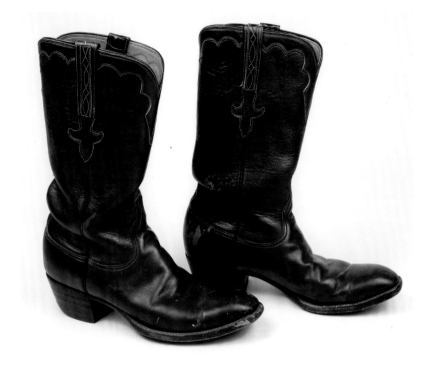

FIGURE 6
Andy Warhol's brown leather cowboy boots (Lucchese)
The Andy Warhol Museum, Pittsburgh; Founding Collection, Contribution The Andy Warhol Foundation for the Visual Arts, Inc., 1998.3.6964.3a-b

during an appearance on the campus of Columbia University in 1968.[34] Danto further noted that the images are like "vessels holding our memories of a particular time and place. . . . In its own way, the portfolio had a memorial function, looking backward. It answered to the same impulses as the technologies of mummification in ancient Egypt."[35] It is telling that Warhol's self-portrait appears among the *Myths*: he cast himself in the role of *The Shadow*. In this work Warhol sees himself as a myth, an incredibly famous figure known around the world, yet quite mysterious, not sharing with the public little-known idiosyncrasies like his obsession with collecting. The public perception of Warhol is quite different from reality, in much the same way that the entire history of the West, at least as portrayed in popular culture, is heavily myth laden.

Warhol loved New York, but also enjoyed visiting Colorado and New Mexico, and admired the spirit of Texans. "Texas really is 'the land of the free,'" he once remarked, "because when a Texan gets money or power, they immediately go out and do whatever they've always wanted to do, and they never think about what other people might think or say about it. And they do it all in a big, big way."[36] Warhol further indicated his love of Texas in sharing his belief that Houston might be a fitting place for a Warhol museum. Asked what such a museum would look like, the artist replied, "Neiman Marcus. Lots of clothes, jewelry, perfume."[37] Many Texans or westerners might identify with a 1985–86 drawing of a gun Warhol created with the words "Have Gun Will Shoot" (page 87). In 1985 a commission would prompt Warhol to bring all of his western influences to bear in an artistic investigation of America's experience of the West, or at least the artist's perception of that experience.

THE CREATION OF *COWBOYS AND INDIANS*

Warhol had produced his first major print series, a portfolio of Marilyn Monroe images based on his earlier paintings of the star, in 1967. As would be the case with many of his early print projects, the Monroe suite consisted of the same image repeated 10 times, each with a different color scheme.[38] With the hiring of Rupert Jasen Smith

as his primary printer in the late 1970s, Warhol began producing thematic print series.

Early efforts included *Ladies and Gentlemen* (1975), images of drag queens; *Gems* (1978), picturing precious stones; and *Grapes* (1979). The following year a commission from Ronald Feldman Fine Arts of New York established a new pattern for Warhol's print portfolios. For *Ten Portraits of Jews of the Twentieth Century*, Feldman suggested a list of more than 100 possible subjects and then worked with Warhol and his staff to narrow the field to the desired 10 images.[39] Experimenting with color as they had in the earlier series, Warhol and Smith created a number of trial proofs for each image, investigating a range of colors per subject.[40] Warhol also created acrylic paintings, usually at least one for each image in the portfolio, often using the same screens, providing yet another saleable product— this one with an even higher price tag. A 1983 project involved producing a portfolio of 10 prints titled *Endangered Species*, among which were at least two western inhabitants: *Bighorn Ram* and *Bald Eagle* (pages 84, 85).

The development of *Cowboys and Indians* (1986) required two years of often frustrating work. Battles with the publisher over content and the deaths of personnel key to the project reportedly made the effort one of the artist's least satisfying ventures, yet still financially rewarding.[41] It began as the idea of the New York artist Edmund Gaultney, who approached an investment banker, Kent Klineman, with the idea in the early 1980s. Gaultney originally proposed a portfolio of American Indian images. Klineman, however, believed a portfolio called *Cowboys and Indians* would be more marketable.[42] Warhol was used to working within the contractual arrangements required by commissions, or "business art," as he called it.[43]

Both Gaultney and Klineman were familiar with and to Warhol. Gaultney and Warhol had a number of mutual friends, while Klineman's wife, Hedy, and Baby Jane Holzer, one of Warhol's early associates, were very close. Warhol's diary entry for August 14, 1984, includes the first mention of the project, referring to an aborted dinner meeting with Gaultney and the Klinemans, and expressing his doubts about the enterprise.[44] Negotiations on

a contract for the western suite were continuing in December, when Warhol's diary entry sounded another cautionary note: "Went to David Daine's, the hair stylist. Kent Klineman, Hedy's husband was there, and all he sees in me is a tax shelter and all I see in him is a check. I don't know if the deal for a *Cowboys and Indians* portfolio he wants to commission is going to fall through because I won't do it as a tax shelter. We'll see."[45]

The contracting parties signed an agreement for the production of the *Cowboys and Indians* portfolio in early 1985. Klineman took great pride in pointing out that his contract with the artist gave him final approval of all images in the suite.[46] This provision was not a standard part of Warhol's art contracts and soon proved to be a source of great frustration to Warhol and his staff. Both Vincent Fremont and Jay Shriver, longtime Warhol assistants, remember that Klineman used his right to final approval excessively throughout the creation of the portfolio, causing publishing delays and considerable headaches for many of those involved.[47]

A letter from Gaultney to Roland Force, the director of the Museum of the American Indian (now the National Museum of the American Indian) in New York, dated May 29, 1985, requested a meeting to discuss various subjects, including items in the museum's collection, but also mentioned the possibility of holding a benefit event there related to the publication of the series in early 1986.[48] A telephone conversation between Force and Gaultney on July 1, 1985, generated a list of possible portfolio subjects, including "Indian Buffalo, Breaking Through the Line, and Sitting Bull."[49] Notes from the conversation indicate that the publishers were planning an edition of 250 portfolios containing 10 images, as well as trial proofs for each image, all measuring 36 by 36 inches. Warhol would also complete 10 to 20 paintings measuring either 60 by 60 inches or 20 by 20 inches. The notes forecast the release in early 1986, with some type of series premiere planned for December of 1985.[50] This timetable would prove to be quite optimistic.

Some images selected for inclusion in this portfolio came from 19th-century photographs depicting recognizable and iconic figures in western and Native American history. Three images were based on Native American artifacts, dating from the same era, housed at the Museum of the American Indian. Once Warhol selected a source photograph, he attempted to make it his own by cropping the image to fit his square picture plane, and with his printer experimented with a range of possible color combinations. Fourteen images were subjected to such experimentation. In the end 10 were chosen for inclusion in the final portfolio (pages 91–123). The writer Nicole Plett saw the irony of a relatively new artistic medium chronicling the end of an era, noting that photography was "a technology that at the time was well suited to capture the last gasps of the American Wild West."[51] Perhaps this was something the artist himself might also have recognized.

After Gaultney's initial contacts, Warhol went to the Museum of the American Indian in October 1985 to shoot photographs of collection objects for possible use in the portfolio. Alvin Josephy, a historian working on an article about the project for *American West* magazine, accompanied the artist to the photo shoot. "Able curators," Josephy wrote, "helped Andy and his master printer, Rupert Jasen Smith, photograph artifacts arranged against a white background: Tlingit and Kwakiutl [Kwakwaka'wakw] masks from Alaska; painted Mimbres pots; a Crow Indian shield; Pomo feather baskets from California; dazzling Navajo blankets; an ancient wooden Kachina figure; and other superb and meaningful Indian objects of the past."[52] While all of these items represented potential images for the portfolio, only three would be among the final serigraphs.

Much of Josephy's article relates his discussion with Warhol about the Hunkpapa Lakota chief Sitting Bull and his tragic death at the hands of Indian police acting on instructions from the local agent for the US Bureau of Indian Affairs. Josephy remarked on the irony of American yuppies buying Warhol's image of Sitting Bull to hang on their walls, possibly learning something about the historic figure in the process.[53] The Sitting Bull image was another that did not make it past the trial proofing process (page 125).

In the same article, Josephy reported seeing a large number of trial proofs for two of the images in the portfolio, *Indian Head Nickel* and *General*

Custer. The historian's observation indicates that some of the images selected for inclusion were already being printed, while other choices were still to be decided upon. A full year would pass, however, before collectors received the portfolios. Warhol told Josephy it would also include "Buffalo Bill, Annie Oakley, an Indian woman, perhaps with child, possibly an 'outlaw wanted' poster and a Western movie star."[54] Only three of these subjects wound up making the cut. At the time, the publishers planned to debut the portfolio in Washington, DC, as well as in New York, early in 1986.[55]

With the project already behind schedule, in April 1986 Force received slides of some of the images being considered for the portfolio, along with an advertising brochure. Bearing the title "Cowboys and Indians, 1986 Limited Edition by Andy Warhol," the brochure contained images of *General Custer*, *Indian Head Nickel*, *Sitting Bull*, *Teddy Roosevelt*, *Northwest Coast Mask* (labeled *Northwest Coast Totem*), and *John Wayne*. The accompanying text reads:

> Cowboys and Indians is Andy Warhol's 1986 edition of original graphics. The edition is 250 signed and numbered portfolios, each consisting of 10 separate images. Each image is 36 × 36, printed on Lenox museum board by Rupert J. Smith. Cowboys and Indians includes classic images derived from Western and Native American history and art. Retail portfolio Price – $15,000.[56]

A letter dated May 9 from Klineman to prepublication purchasers of the portfolio mentions that Gaultney was having health problems, but also reports that seven prints had been completed and reproduced, identified as: *1913 Indian Head Nickel*, *General George Armstrong Custer*, *President Teddy Roosevelt*, *John Wayne*, *Kachina Dolls*, *Northwest Coast Totem* (mask), and *Plains Indian Buffalo Shield*. The titles of several of these images would change at least once before the suite was ultimately published. Klineman further indicated that Warhol and his staff were finishing work on images of *Annie Oakley* and *Mother and Child* but were also considering replacing the image of

Sitting Bull with "a more interesting image of the Indian Chief Geronimo," as was ultimately done. Klineman estimated that the finished portfolios would be in buyers' hands by the end of June.[57] The enclosed brochure also listed Buffalo Bill Cody and a Navajo medicine man among the subjects to be included in the portfolio, although neither of these images was ever even included in the trial proofing process.[58]

Another problem that arose during the creation of *Cowboys and Indians* was the issue of permission to use the image of John Wayne. Klineman says their original choice had been the younger and potentially more popular star Clint Eastwood. Warhol already had some potential source images, having done Eastwood's portrait a couple years earlier (page 89). The actor, however, would not give his consent and negotiations then began with the Wayne estate.[59] Irked with the turn of events, Warhol vented his displeasure in his diary entry for May 17, 1986: "I'm upset because the Kent Klineman contract for the Cowboys and Indians gives Klineman 'final approval' and I can't believe Fred [Hughes] would let this happen. And there's a problem with that John Wayne print, they can't get permission for it because nobody can give it."[60]

To coincide with the new projected release date for the portfolio, the Museum of the American Indian agreed to mount an exhibition of the portfolio with an opening reception scheduled for June 4, 1986. As the opening approached, Warhol and Klineman continued to bicker over the portfolio. The artist recalled the day of the event:

> Kent Klineman came by the office and he didn't like the Annie Oakley, and I said how could he not like it since that's the way he *made* me do it. And so then I asked him if he got the John Wayne thing worked out and he said oh yes, that the son, Patrick Wayne, would give permission if I gave him a painting that he could donate to charity, so that was all worked out, and I said, "Uh, what?" He said Fred had agreed, but I know Fred never would have. I mean this was Klineman's responsibility and I'm not going to take it on for him. If Patrick wants a painting Kent can pay me to do it and then *he* can donate it. And then it was time to go up to the Museum of the

American Indian to my opening, so I had to ride up to Broadway and 155th Street with him after this fight, just forgetting about it and putting it behind us because you have to—these days you have business fights and then just have to go on being friendly. . . . It's a courtyard and small buildings. Really nice, and they did a nice show. It was packed.[61]

Association with the museum lent credibility to the project and helps explain why Warhol did not simply use some of his own collection of Native American artifacts as source images. Shriver believes that it is also likely that Warhol did not want to publicize his collecting habits.[62]

On July 1, having missed another deadline, Klineman wrote to patrons who had prepurchased the suite stating that nine of the ten images were finished, "including an image of Geronimo which is a beauty."[63] Although previous promises had strained his credibility, the publisher reiterated his commitment to finish the project: "I realize that we have promised delivery for May, then June and now July. Believe me, I am doing everything possible to complete it. If I have to do the work myself (I am being facetious), it will be in your hands before July 31st."[64]

Klineman's confident assertion notwithstanding, complications on several fronts pushed final delivery into October, and the image of John Wayne continued to be especially problematic. "Kent Klineman was around," Warhol moaned to his diary on August 12. "He's there saying, 'I don't like the color. What color will the lips be?' And I mean, it's a blue face! What difference does the color of the lips make when it's a blue face? I mean, he's ridiculous."[65]

The art collector Wesley Cochran, who purchased the suite in early 1985, recalled the turmoil of acquiring the portfolio from a collector's perspective. Only a few weeks after receiving their long-awaited purchase, buyers received a letter from Gaultney-Klineman dated November 17, 1986, asking them to return the *John Wayne* print due to an unspecified problem. In return, the publisher offered to have Warhol individualize each of the Wayne prints and to pay shipping costs. "Although Warhol does not intend to change the general appearance of the image,"

Klineman stated, "he will make artistic changes so that each John Wayne image will be unique."[66]

What Cochran did not know at the time was that despite the supposed agreement between Gaultney-Klineman and the Wayne estate, the matter was headed to court. The Wayne estate brought suit against the publishers in both California and New York seeking to settle unspecified claims.[67] In an attempt to thwart the estate's claim against his studio and Gaultney-Klineman, Warhol agreed to recall all of the Wayne images and to have Smith make changes to each one and mark them as originals, not multiples.[68] The publishers believed that making each one unique would provide legal cover for the project, as unique images of celebrities were generally allowed under copyright and usage laws, whereas multiples such as photographs, screenprints, or lithographs issued as limited or open editions would be subject to royalties owed to the celebrity or estate. Cochran dutifully forwarded his *John Wayne* serigraph to New York in January 1987.

A month later, Warhol entered the hospital for relatively routine surgery to remove his gallbladder and died unexpectedly during his recovery, on February 22, 1987.[69] The fate of *Cowboys and Indians* was now in question once again. Eventually, Cochran did receive his print back from the Warhol estate and the color of Wayne's pistol had been changed from brown to blue. The edition number on the returned print was erased and the word "unique" stamped in its place.[70]

Warhol's death left unfinished many of the original paintings of the subjects in the *Cowboys and Indians* suite called for in the contract. Such works were usually part of each print project, providing "original" art to be the focal point of an opening event covered by art world media outlets, and a lucrative source of income for the artist and the publisher. At the time of his passing, Warhol had completed only three paintings: *Kachina Dolls*, *Northwest Coast Mask*, and *Plains Indian Shield*.[71] Critics were much more interested in Warhol's paintings than his prints. Ronald Feldman had shown that an exhibition of paintings related to a print project was the best way to generate publicity. Without such an exhibition, *Cowboys and Indians* never received attention from the art

press and has been doomed to relative obscurity ever since, and with it perhaps any reflected attention on Warhol's other western subjects.

NOTES

1. Glenn O'Brien, "Interview with Andy Warhol," in *Andy Warhol: The Late Works*, ed. Mark Francis (Munich: Prestel Verlag, 2004), 56.

2. Sotheby's, *The Andy Warhol Collection, Vol. 5: Americana and European and American Paintings, Drawings, and Prints* (New York: Sotheby's, 1988), Lot 2896.

3. According to Michael Warhola, the artist's cousin, "Dr. Zeedick gave him a cap pistol, and that's what he did: played with the cap gun and cut out paper dolls." Bob Colacello, *Holy Terror: Andy Warhol Close Up, An Insider's Portrait* (New York: Harper Perennial, 1991), 17.

4. Andy Warhol, *America* (New York: Harper & Row, 1985), 8.

5. David Bourdon, *Warhol* (New York: Harry N. Abrams, 1989), 29.

6. Bourdon, *Warhol*, 25.

7. Bourdon, 120.

8. Colacello, *Holy Terror*, 28.

9. Tavel quoted in *Andy Warhol, 365 Takes: The Andy Warhol Museum Collection* (New York: Harry N. Abrams in association with the Andy Warhol Museum, 2004), 52.

10. Steve Watson, *Factory Made: Warhol and the Sixties* (New York: Pantheon Books, 2003), 198.

11. Victor Bockris, *The Life and Death of Andy Warhol* (New York: Bantam Books, 1989), 163.

12. Watson, *Factory Made*, 199.

13. Watson, 369.

14. Watson, 247.

15. Colacello, *Holy Terror*, 118.

16. Claire Demers, "An Interview with Andy Warhol: Some Say He's the Real Mayor of New York," in *I'll Be Your Mirror: The Selected Andy Warhol Interviews, 1962–1987*, ed. Kenneth Goldsmith (New York: Carroll and Graf Publishers, 2004), 270.

17. Michael Lobel, "Warhol's Closet," in *Possession Obsession*, ed. John W. Smith (Pittsburgh: Andy Warhol Museum, 2002), 68.

18. Daniel Robbins, "Confessions of a Museum Director," in *Raid the Icebox I with Andy Warhol*, ed. Stephen E. Ostrow (Providence: Museum of Art, Rhode Island School of Design, 1969), 14.

19. Sotheby's, *Americana*, n.p.

20. *Possession Obsession*, a 2002 exhibition at the Andy Warhol Museum, focused attention on the artist's collecting activities and allowed visitors a glimpse at this largely private side of his life. In the exhibition catalogue, however, several Warhol associates scoffed at the notion that Warhol was a "collector." Ralph T. Coe, "American Indian Art," in Smith, *Possession Obsession*, 112.

21. Sotheby's, *The Andy Warhol Collection, Vol. 4: American Indian Art* (New York: Sotheby's, 1988), n.p.

22. Sotheby's, *Americana*, n.p.

23. Coe, "American Indian Art," 119.

24. Sotheby's, *Americana*, n.p.

25. Patricia Janis Broder, *The American West: The Modern Vision* (Boston: Little Brown and Company, 1984), 298.

26. As noted in Broder, *American West*, 298.

27. Warhol quoted in Thierry De Duve and Rosalind Krauss, "Andy Warhol, or the Machine Perfected," *October* 48 (Spring 1989): 11.

28. Carter Ratcliff, *Andy Warhol*, Modern Masters Series (New York: Abbeville Press, 1983), 74.

29. Broder, *American West*, 298.

30. Scholder to Warhol, February 28, 1980, Andy Warhol Museum Archives, Pittsburgh.

31. Coe, "American Indian Art," 119.

32. Warhol's diary entries related to O'Keeffe include tidbits such as the interesting coincidence that she once happened to visit on the same day as Pablo Picasso's youngest daughter, Paloma. Another contains information regarding Warhol's role as a go-between in helping Calvin Klein meet O'Keeffe and buy at least one of her paintings.

33. Frayda Feldman and Jörg Schellmann, *Andy Warhol Prints: A Catalogue Raisonné, 1962–1987*, 3rd ed., revised and expanded by Frayda Feldman and Claudia Defendi (New York: Distributed Art Publishers in association with Ron Feldman Fine Arts, Edition Schellmann, and The Andy Warhol Foundation for the Visual Arts, 1997), 118–19.

34. Arthur C. Danto, "Warhol and the Politics of Prints," in Feldman and Schellmann, *Andy Warhol Prints*, 8–9.

35. Danto, "Warhol and the Politics of Prints," 14.

36. Warhol, *America*, 165.

37. Jordan Crandall, "Andy Warhol," in Goldsmith, *I'll Be Your Mirror*, 358–59.

Ironically, today there is an Andy Warhol Museum, although it is in his hometown of Pittsburgh, not Houston. The Museum was created in part by the Andy Warhol Foundation, headed for its first several years by former assistant Fred Hughes, who was from Houston.

38. Feldman and Schellmann, *Andy Warhol Prints*, 276.

39. Colacello, *Holy Terror*, 444.

40. Donna De Salvo, "God Is in the Details: The Prints of Andy Warhol," in Feldman and Schellmann, *Andy Warhol Prints*, 27.

41. Jay Shriver, telephone interview by author, April 19, 2005.

42. Kent Klineman, telephone interview by author, February 11, 2005.

43. Andy Warhol, *The Philosophy of Andy Warhol (From A to B and Back Again)* (London: Pan Books, 1976), 88. Warhol wrote, "I loved working when I worked at commercial art and they told you what to do and how to do it and all you had to do was correct it and they'd say yes or no. The hard thing is when you have to dream up the tasteless things to do on your own. When I think about what sort of person I would most like to have on a retainer, I think it would be a boss. A boss who could tell me what to do, because that makes everything easy when you're working" (92). Upon entering into the contract for the *Cowboys and Indians* suite, Warhol got his wish. Kent Klineman became his boss.

44. Warhol wrote, "I get this feeling about it." Pat Hackett, ed., *The Andy Warhol Diaries* (New York: Warner Books, 1989), 595.

45. Hackett, *Warhol Diaries*, 623.

46. Klineman interview by author.

47. Vincent Fremont, telephone interview by author, May 12, 2005, and Shriver interview by author.

48. Edmund Gaultney, New York, to Dr. Roland Force, New York, May 29, 1985, Cultural Resources Center, National Museum of the American Indian, Suitland, Maryland; hereafter CRC, NMAI. During the time Warhol was working on this project, the Museum of the American Indian was located in New York City and operated by the Heye Foundation. In 1989 the Smithsonian Institution took over responsibility for the collections. The Smithsonian currently operates a cultural resource center in Suitland, Maryland (which houses the majority of the collection), the National Museum of the American Indian on the Mall in Washington, DC, and a location in New York City.

49. Dr. Roland Force, handwritten note, July 1, 1985, CRC, NMAI.

50. Force handwritten note.

51. Nicole Plett, "Andy Warhol's *Cowboys and Indians*," *Southwest Profile*, November–December 1989, 32.

52. Alvin Josephy, "Andy Warhol Meets Sitting Bull," *American West*, January–February 1986, 43.

53. Josephy, "Andy Warhol Meets Sitting Bull," 44.

54. Josephy, 43.

55. Josephy, 43. The suite was shown at the Museum of the American Indian in New York in June 1986, but there is no record of an exhibition in Washington, DC.

56. Peter Wise, New York, to Dr. Roland Force, New York, April 9, 1986, CRC, NMAI. The enclosed draft brochure

has several edits marked on it, indicating Gaultney-Klineman may have asked to review the content, although there is no indication who made the edits.

57. Kent Klineman, New York, to Wesley Cochran, Lagrange, Georgia, May 9, 1986, letter in the collection of Wesley Cochran.

58. Gaultney-Klineman Fine Arts advertising brochure, circa 1986, in the collection of Wesley Cochran.

59. Klineman interview by author.

60. Hackett, *Warhol Diaries*, 733.

61. Hackett, 736.

62. Shriver interview by author.

63. Kent Klineman, New York, to Wesley Cochran, Lagrange, Georgia, July 1, 1986, letter in the collection of Wesley Cochran.

64. Klineman to Cochran letter.

65. Hackett, *Warhol Diaries*, 751. These comments likely refer to one of the trial proofs under consideration. No blue-faced images are included in the published suite.

66. Kent Klineman, New York, to Wesley Cochran, Lagrange, Georgia, November 14, 1986, letter in the collection of Wesley Cochran.

67. David A. Gerber, Los Angeles, to Wesley Cochran, Lagrange, Georgia, December 28, 1987, letter in the collection of Wesley Cochran.

68. Gerber to Cochran letter.

69. Investigations and litigation regarding Warhol's death have never determined exactly why he died or who was to blame. See Bockris, *Life and Death of Andy Warhol*, 346–48.

70. Wesley Cochran, interview by author, May 18, 2005, Lagrange, Georgia.

71. Feldman and Schellmann, *Andy Warhol Prints*, 273.

The American Indian and Warhol's Fantasy of an Indigenous Presence

heather ahtone

PAUL TAYLOR *If you were starting out now, would you do anything differently?*

ANDY WARHOL *I don't know. I just worked hard. It's all fantasy.*

PAUL TAYLOR *Life is fantasy?*

ANDY WARHOL *Yeah, it is.*[1]

PICTURES
SPEAKING A THOUSAND
WORDS AND NONE AT ALL

Andy Warhol's description that life is "all fantasy" is a capitalistic ploy and a conceptual construction that supports his approach to art making. Throughout his career he employed visual references to things that were mundane (Campbell's soup cans and headshots), exploitative (scenes of death through auto accidents and prison death chambers), and mythical (celebrities and movie characters) as he capitalized on the enigmatic question: What is art? His career is extremely well documented, and further discussion of any of his greatest works would be redundant, at best. It is a curious reality, however, that within his oeuvre he periodically included portraits of American Indians, and that this was a subject of one of his final print projects. This coincidence, combined with the scope of his broader common subjects and thematic interests, begs for further consideration. Did Warhol construct *Cowboys and Indians* as an extension of topics that are mundane, exploitative, or mythical? The answer is likely that he saw them as all three.

Warhol was not the first American to have a fantasy of American Indians. In fact, his infatuation with American Indians, which later developed into images in *The American Indian (Russell Means)* and the *Cowboys and Indians* portfolio, was probably seeded at the oft-referenced Saturday matinees where he spent many mornings as a boy absorbing the fantastical world of John Ford western movies. While Warhol's imagined Indian may have been born from this experience, the image of the American Indian did not originate in celluloid. Considering the history of American Indian representation allows for a fuller discussion of Warhol's Indian images and invites consideration of the effect of representation in the hands of non-Natives, and the counterimage in the hands of Natives. Through this broad discussion, the truly American images that Warhol constructed can be seen to participate within a history of manipulation and construction that perpetuates a fantasy of American Indian presence.

One can go into the historical record and discover a variety of images, emerging as early as the 16th century, that depict tribal peoples found in the "exotic" and mysterious lands of the "New World." These were commissioned with the intention of returning documentation to Europe and laying out the mysteries to be explored and conquered in the frontier. Some of the earliest known are watercolors by John White, an English artist who is recognized as the first from his country to travel to the New World on a commission from Queen Elizabeth to make a visual record of the Indigenous peoples of North

America (fig. 7). His travels were facilitated by the 1584–87 expeditions to Roanoke Island in the present-day Outer Banks of North Carolina funded by Sir Walter Raleigh.

White helped establish the practice of the ethnographer-artist as part of the documenting of the new people and cultures being encountered through the expansion of the colonialization project across the Americas.[2] He worked in a style that was termed "limning," an approach to painting that drew upon the contemporary practices being established by the Italian Renaissance and mannerist artists. To a contemporary eye, the rendering of the face and limbs lacks accuracy, which can be credited to the style's preferred emphasis on figural gestures and facial expressions.[3] Although, to us, White's images are recognizably interpretive, at the time of their original publication, they were perceived as naturalistic and "true" representations of real people. The emotional interpretations were foundational for constructing an image of the American Indian, though they would be transformed further by other artists into the images that helped to visualize the New World.

The art historian Stephanie Pratt describes the effect taken from White's watercolors in the hands of the Franco-Flemish engraver Theodor de Bry, who translated White's images into etchings for publication across Europe:

> His manipulation of John White's watercolours, their transformation into graphic imagery, with additions and inventions of de Bry's own making, should be understood as accepted practices of the processes of reproduction. De Bry enhanced images that he might have considered proto-designs . . . without further elaboration. The distinction traditionally held between the two forms of representation is that in John White's watercolours we find authentic American Indian content, whereas in de Bry's images we find subjects that are derivative, manipulated and manipulative, ideologically suspect and Europeanized.[4]

Of course, the watercolors would have had a limited audience, but the broad dissemination through publication of the etchings laid a foundation

for distorted images that carried across several centuries until the introduction of the camera.

The American Indians that populated the North American continent were being visually codified in a land with which their engagement was superficial, at best. The presence of the images that stood in for the living people could never truly represent the people whose lifeways were under threat. The etchings and other image types being circulated in Europe often further animated foreign cultural practices that, out of context, created the earliest fantasies about Indigenous Americans in the 16th century. It is against this established trope that 21st-century contemporary Indigenous peoples remain embattled. This trope of the Indian as a savage and adversary to civilization fostered the emergence of the "red devil" and made possible the appropriation of Indigenous identity by the colonists who "played" Indians as they boarded British ships in 1773, an incident remembered as the Boston Tea Party. This became one of the critical moments in the representation of American Indians within the national historical

FIGURE 7
John White (British, active 1585–1593)
Portrait of an Indian Chief (possibly Wingina); with skin apron and on chest a copper gorget hung from neck, 1585–93
Watercolor and gold over graphite, touched with white (oxidized)
10¼ × 5¾ inches
British Museum, 1906,0509.1.21

record—despite the fact that no Indians were present at the actual events. As the historian Philip J. Deloria discusses extensively, "playing Indian" and the related use of the *fantasy* of Indians are foundational to the "history" of a uniquely American identity.[5] Once the fictionalized version of American Indians was established, it enacted a form of erasure for those individuals whose identities were now represented most commonly by a facsimile stand-in.

ERASURE
REPLACING THE REAL WITH THE FLAT

The image of the American Indian remained in the hands of non-Indian people through the 19th century, though the technology for depicting that image became more accessible. Cameras proliferated across the North American continent with the introduction of the daguerreotype process in 1839, and by midcentury photography was challenging the role of painters and illustrators as a critical form of visual documentation. This was felt not only in images of American Indians but also across the fine arts community in Europe and in the Americas and was critically important to the emergence of French impressionism in the 1860s, spawning modern and, later, conceptual art. Photography signaled a shift in ideas about the most efficient and *authentic* means of representation: it was perceived as an accurate *truth*, allowing the viewer's own experience to validate the image.

This is an important point, which the art historian Janet C. Berlo considers in addressing the 19th-century technology that enabled photographers to manipulate exposures and printing processes, generating a variety of skin tones and other visual cues in reading an image.[6] Distinctly, there was also an imposition on the sitter to remain still for an extended period to ensure that the photograph was clear and unblurred, an unimaginable feat by the standards of today's instantaneous selfie. This need for stillness has been credited for the stoic presentation of sitters as they avoided moving, common in all images made with this early photography, but a characteristic that somehow perpetuated a stereotype about American Indians.

Further, the characteristic images from this period are not racially specific—but they become so as the image of the American Indian circulates in public and social spaces, particularly where Native people are not present except as topical subject.[7]

With the emergence of photography, American Indians were as common a subject as any other, though they were rarely in control of the construction of the image.[8] One might wonder if photorealistic images of Indigenous people disrupted the fantasy that stood in for the imagined spaces of the American West. In fact, they only further cemented the fantasy. After the establishment of the United States as a sovereign state—a settler state—the image of the colonized "savage" was used as justification for the Euro-American/Christian right of Manifest Destiny. For Indigenous people, their presentation in regalia and with the accoutrements of their cultural practices signified the settler state's imposition of Western *civilization*, an imposition in the form of capitalism and nationalism, forcing a confrontation between cultures across the continent. From this perspective, one can argue that the photograph became a weapon. The visual interpretation of American Indians through a Euro-American construction of society and culture would never allow for equitability when the Indians look so *savage* in the modern nation of the United States.

While that may seem a highly racialized comment, a case study analyzing historical photographs prepared by Joanna C. Scherer allows us to see how images of American Indians in their cultural clothes were taken, collected, and distributed.[9] The photograph she examined was of an Omaha delegation photographed at the Council Bluffs agency en route to Washington to advocate on behalf of their tribe's relationships with the United States (fig. 8). The photograph was located at the Rochester (New York) Museum & Science Center, where it was deposited as part of the Lewis Henry Morgan archival materials. Like other materials held in the Morgan archives, the photograph depicts subjects during a period of great cultural transition.[10]

The Omaha people were at a vulnerable point in the history of their sovereignty. As they negotiated to have protections from the

encumbering settlers moving across Iowa and Nebraska, they also recognized that they were not in control of their future. The photograph shows this uncertainty, even as it speaks to their ambitions to remain Omaha. They were well aware of the forced and systematic removal of tribes from the east and southeast of the United States as a result of the 1830 Indian Removal Act. The establishment of Indian Territory and, later, Oklahoma Territory had been cemented even as tribes continued to negotiate treaties setting terms for their forced removals. Tribes were unsettled as a result of the hordes of settlers pouring into the region west of the Mississippi following the Louisiana Purchase in 1803, particularly into present-day Iowa, Nebraska, Kansas, and Missouri. The Omaha delegation, unofficial as it was, nevertheless believed they could effect a positive outcome for their tribal community. This photograph documents the symbolism of their roles as leaders and community representatives for those who can read the coded placement of the feathers, the medals, and their jewelry. The hand gestures read as intentional signals, though I cannot provide an interpretation. Their faces and the resulting image describe an abject resistance to the settler state. In the epoch of historical images, it becomes a remnant of a time lost to a national history that sought to dismiss the continued presence of the Omaha.

This is the crux of the challenge that photography created. As the role of representation moved out of the hands of artists and into the lenses of photographers, the mythical image of the American Indian transferred into a "historical truth"—Indians were part of the American past but no longer expected to be part of the American future, thereby rendering them absent in the present. The photography, in concert with federal policies for removal and assimilation, performed a form of cultural erasure. The Omaha culture, like that of every other tribe on the continent, was suffering an uninvited transition in response to the nationalist expansion, but the Omaha did not disappear as a people even as they were forcibly removed to accommodate the arrival of settlers.

As national expansion was completed across the continent through the 19th century, photographs of American Indians became an effective trope

FIGURE 8
Unidentified photographer
Untitled (daguerreotype of
seven Native Americans),
verso inscription titled
"Indians from Council
Bluffs." [Two of the Native
Americans have been
identified as Yellow Smoke
and Garner Wood], circa
mid-19th century
Daguerreotype
3⅜ × 4⅜ inches
Lewis Henry Morgan
Collection, Rochester
Museum & Science Center,
Rochester, New York,
66.132.19

to *remember* the people whose cultures provided a foundation to the history of the United States.[11] As tribes were relocated and thrust from the American consciousness, the photographs documented their historic (read: past tense) presence. The erasure of the American Indian was further completed through the renaming process of the geography, rivers, and land sites.[12] The United States had created its identity as a nation of self-starters who had arrived in a New World and built a nation wherein each (white) man was born with "certain unalienable Rights, that among these are Life, Liberty and the pursuit of Happiness."[13] The race of American Indian was part of its past. Assimilation policies in place, by the end of the century the American Indian would simply be an American.

IMAGINATION
FILLING THE GAP WITH THE MYTHIC

It is into this erased presence that the field of anthropology gave birth to salvage ethnology, a practice of documenting and collecting the cultures before their anticipated and imminent demise.[14] Photography was considered an important tool to visually document the remaining cultures, including the people and related practices. In 1906 Edward S. Curtis

initiated his epic project *The North American Indian,* a 20-volume ethnographic campaign published between 1907 and 1930 to document the remaining "authentic" Natives (read: they still appeared exotic and unassimilated). Interestingly enough, the project was funded in great part by the anthropologist Lewis Henry Morgan's nephew J. P. Morgan. Curtis set out across the continent to photograph as broad a representation of *real* Natives as possible and to publish the photographs with a comprehensive ethnographic survey of their cultural narratives, history, and language.

It is critical to note, however, that as he set out to do so, Curtis elected to use a dry-plate collodion camera—a distinctly mid-19th-century technology. The effect of this choice is that his photographs, taken in the early 20th century, look older than they actually are, aging the representation. The visual studies scholar Shamoon Zamir provides a comprehensive discussion of the role of Native agency in the construction of the images, though it is difficult to qualify the effect of the chosen technology.[15] The collodion process both darkens skin tones and heightens tonal values—a collective effect that contributed to the creation of a particular phenotype for Indigenous Americans that was not recognizable in the contemporary person. Between the forced historical compositions and the distortion of the visual recognition of actual people, Curtis manipulated the image of Indigenous Americans beyond recognition in a contemporary setting. In contrast, a photograph from the same year by Horace Poolaw (Kiowa) provides an image of Oklahoma tribal people without the constructed manipulation, exposing just how intentional Curtis was with his images.[16]

When the photographer Will Wilson and I set out to photograph the descendants of Curtis's subjects from Oklahoma for our 2017 collaborative project, *PHOTO/SYNTHESIS,*[17] one of the most significant challenges in identifying the original subjects was getting the contemporary tribal citizens to recognize that the images were from the late 1920s, the time of their grandparents' generation, when Curtis worked in Oklahoma.[18] The tribal representatives, well versed in the photographic history of their communities, often attempted to place the faces in a mid-to-late

19th-century visual vernacular and genealogy. The effect of the collodion process was to create a false historicity.

A critical understanding of the role of the technology that Curtis used significantly changes the reading of the images, beyond the well-documented misuse of props and the intentional elimination of modernity (through the choice of clothing, selected angles that avoided power lines, and even the erasure of background automobiles and houses) that Christopher M. Lyman so efficiently elucidated.[19] The Curtis images actively participate in the establishment of the mythic American Indian. Zamir concisely explains:

> *The North American Indian,* it is argued, cannot extricate itself from the binary logic of savagism and civilization that underwrites narratives of Native demise, or vanishing, as well as the historical self-assurance of white culture. Ethnographic salvage, the *raison d'être* of Curtis's project, is seen to perpetuate these beliefs and attitudes because its conceptualization of tradition marginalizes or excludes altogether change and adaptation, thereby divorcing culture from historical process and freezing it in the past in the name of a putative authentic.[20]

Curtis's images establish a distorted and static moment against which the contemporary American Indian must now disentangle an identity distinct from the image; Curtis's image is THE mythic Indian.

APPROPRIATION
RHETORIC OF THE EURO-AMERICAN ARTISTIC DISCOURSE

This lengthy examination of the construction of the seminal images of the American Indian, notably the portrayals by Curtis, is foundational to reading Warhol's images of the American Indian. At least one can certainly see this with his *Cowboys and Indians* portfolio, though Curtis seems to inform all of Warhol's portraits. One can see that the most common portrait format that Curtis uses, presenting the subject's torso and head as a focal block, is evident in many of Warhol's other portraits. For the present discussion, though, it

is critical to examine the relationship between Curtis and Warhol in both compositional structure and intent. Curtis's image of *Standing on the Earth—Oto* (fig. 9) has a direct relationship to Warhol's *The American Indian (Russell Means)* (page 69), notably in the three-quarter-view torso with the head turned to gaze directly at the viewer. I suggest that Warhol may have taken inspiration from the lighting in Curtis's deep shadows in creating the screenprinted color blocking behind the head and along the right side of the face. Curtis's emphasis on the subject's torso relates to Warhol's strong interest in the visual elements on Means's chest—both concentrations emphasizing the subject marked as an Indian.[21]

Despite the strong compositional similarities, perhaps the most intriguing relationship between Curtis and Warhol is the use of photography as a tool for appropriation. Curtis was not the first photographer to document the American Indian. As already discussed, there was a history of images that his images borrowed from and extended, but the significance of his photographs is closely related to the historical significance and scope of his project. Curtis's images are THE images of the West. As Lyman established, Curtis imposed the use of props and clothing with tribes to make them more identifiably Indian;[22] this imposition can be seen as a form of cultural appropriation and, I would argue, a form of visual appropriation. Curtis's desire for his images to be recognizably American Indian was, by action, more important to him than that the images represented the truth of the subject.

To distort the truth, while using a tool for its perceived capacity to record the truth is an intentional manipulation of what is being represented. Yet no comment to draw the reader and viewer's attention to this misrepresentation is made anywhere in the epic project. This practice of deception and intentional misrepresentation is why American Indian communities often disassociate themselves from the images, while recognizing that they are beautiful portraits of their ancestors. What was made evident to me during the *PHOTO/SYNTHESIS* project was another layer for which I had not prepared. During the research process, it was not uncommon to find that the subject's tribal affiliation had been mislabeled and that names, when given, were "Indianized" to read as though the subject was not already known by an Anglicized given name. The levels of misrepresentation in Curtis's work remain yet to be fully explored, certainly from an Indigenous perspective, and the exhibition of his historic images without addressing the fraught nature of the collective and individual images fosters further ignorance as the powerful images perpetuate their misrepresentation. One can argue that the proliferation of Curtis's images across museum collections makes them a prominent visualization of the American Indian presence. For this reason, it would be an understatement to say that the American Indian community remains antagonized by Curtis and his project. From this perspective, Curtis's appropriation of the role of culture broker may be his most egregious act.

Similarly, Warhol appropriated the image of the American Indian in both title and subject in his typological portrait of the activist Russell Means. A full chapter in *The Andy Warhol Catalogue Raisonné, Volume 4* is devoted to *The American Indian (Russell Means).*[23] The writer,

FIGURE 9
Edward S. Curtis (American, 1868–1952)
Standing on the Earth— Oto, 1928
Photogravure
9 × 6½ inches
Original photogravure produced in Cambridge, MA, by Suffolk Engraving Co.
From *The North American Indian, Volume 19: The Indians of Oklahoma. The Wichita. The Southern Cheyenne. The Oto. The Comanche. The Peyote Cult* ([Seattle]: E. S. Curtis; [Cambridge, MA: University Press], 1930), facing page 154, Charles Deering McCormick Library of Special Collections, Northwestern University Libraries

Neil Printz, explains the considerations that were unique to this project and the influential factors that led to Means sitting for the portrait. Printz also points out that Warhol was not interested in Means as a personality, but rather as a type; thus the title of the series—*The American Indian*—was amended to identify the subject specifically not by Warhol, but by a representative of his gallery.

A different kind of representation is at play in the portraits of the American Indian artists R. C. Gorman and Fritz Scholder (pages 73, 77). While the specifics of how Warhol might have encountered either artist remain lost to history, it is likely that their social circles overlapped. Warhol had a gallery in Taos, New Mexico, as did Gorman, and was represented by a gallery in Scottsdale, Arizona, as was Scholder. Both Taos and Scottsdale are fairly intimate communities with highly socialized art circles, and both Native artists are remembered as exuberant personalities. Gorman and Scholder would have fit the profile that Warhol often sought to depict in his portraits; in fact, their American Indian identities may have been of only superficial interest to Warhol. This is likely the reason that their portraits are named for the sitters, keeping with Warhol's longer series of portraits of celebrities, socialites, and patrons. Nevertheless, the Gorman portrait continues to resonate with the flavor of Curtis in the cropping, choice of pose, and stoic presentation (fig. 10).

The same structure is followed throughout the *Cowboys and Indians* portfolio, with a frontal presentation and an emphasis on the face. In the portraits of the "cowboys" (*John Wayne, Annie Oakley, General Custer,* and *Teddy Roosevelt*) and of Geronimo, the torsos are similarly blocked out from source images. In a portrait of Sitting Bull, though, his framing is smaller to incorporate the distinctive feather standing up from the back of his head and the extended line of the pipestem. It is possibly because of this shift in the blocking that the *Sitting Bull* image was removed from the final published portfolio. *Mother and Child* is similarly blocked to include both heads for the benefit of the composition. The singularly distinctive characteristic that Warhol maintains as his own is the strictly square composition, which supports the presentation of the portraits on a grid.

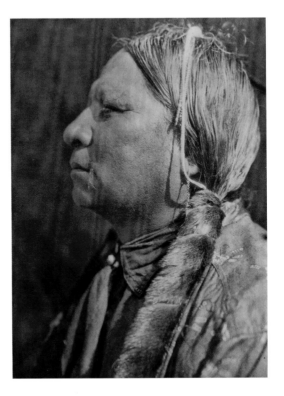

FIGURE 10
Edward S. Curtis (American, 1868–1952)
Walter Ross—Wichita, 1927
Photogravure
9 × 6½ inches
Original photogravure produced in Cambridge, MA, by Suffolk Engraving Co. From *The North American Indian, Volume 19: The Indians of Oklahoma. The Wichita. The Southern Cheyenne. The Oto. The Comanche. The Peyote Cult* ([Seattle]: E. S. Curtis; [Cambridge, MA: University Press], 1930), facing page 36, Charles Deering McCormick Library of Special Collections, Northwestern University Libraries

Perhaps what is most unique about the *Cowboys and Indians* series is its incorporation of objects photographed from the National Museum of the American Indian's permanent collection: a Kwakwaka'wakw mask of Sisi'utł, a Hopi carved katsina of Angwusnasomtaka (Crow Mother), and a Crow shield. These objects were a rare breaking away from living subjects within Warhol's work after the Campbell's soup cans of the 1960s.[24] In fact, it is the relationship between the objects as commodity that guided my discussion of the portraits as an act of commercialization. As much as Warhol was an artist, he was also a collector of American Indian art, and he admired the artistic hand in such works. Considering his initial success as an illustrator, he would have appreciated the elements of design and refined aesthetic presentation as much in a Navajo rug (fig. 11) as in a soup can label.

The commercialization and commodification of the portrait, certainly of the American Indian, were achieved completely by the 19th century and further exploited in the hands of Curtis and Warhol in the 20th century. As the subject is appropriated into an iconic remnant of a constructed American

past, it becomes a visually mundane image—typological rather than specific. Simultaneously in this period, art gained in cultural currency as America became established as the center of the fine art world in the postwar years. Art that appealed to the common person who was tired of European elitism gained in popularity. Warhol recognized the power of what is distinctly American, as well as popular, and seized upon the convergence of the two through his art. This capitalistic appropriation of the American Indian is about more than simply the artist and the subject, though. The art critic Rosalind E. Krauss explains:

> There is, however, a structure that has always struck me as particularly revealing in relation to Warhol, and since this structure resonates both in the domain of the social and historical field . . . and in that of "figment," it seems important to bring into the present context. The structure, which René Girard calls mimetic rivalry, or metaphysical desire, rests on the notion that all desire is triangulated, which is to say, never the simple, linear relationship between two things (a desiring subject and the object that subject desires) but always three things (a subject, a mediator, and an object)—since the subject only ever desires in imitative rivalry with the mediator, desiring thus what the mediator desires.[25]

Warhol's idea of the West was mediated through the *Cowboys and Indians* portfolio as a subject of his personal interest and commodified for those who desired Warhol's imagined spaces. The portraits function within the triangle of desire that Warhol's genius intuits from a society that wants a credible history that it can own, even at the expense of those whose bodies are now fodder for visual commodification.

Warhol's images of American Indians play on the subject as a myth. Additionally, not only did Warhol appropriate Curtis's photographic compositions and poses as a form of mundanity, but his intentional and blatant conversion of the racialized bodies is a matter of exploitation. Warhol effectively positions the American Indian within the triangle of his oeuvre. There remains a critical interest in Warhol's conception to maintain enough truth to support the mythical

nature of the images. This is supported by the elimination of the *War Bonnet Indian* image from the published portfolio. The other Indians are all genuinely American Indian, whereas the subject of *War Bonnet Indian* is derived from the 1955 Hollywood film *White Feather* (page 128). This image may have been of personal interest as a subject, but it was not entirely authentic enough to fit within the portfolio.

PRESENCE

ARTISTS WORKING NOW AND WARHOL'S INFLUENCE (OR NOT) ON THEM

As mentioned before, the complex relationship between the American Indian community and Curtis's constructed images remains contentious. Warhol's images participate in this same complex appropriation of Native representation, but to a lesser degree because of the limited number of images produced and the evident derivative nature of them—a product of Warhol's intentionality with the blatant appropriation process. Both artists participated in the commercialization of the American Indian subject, and in response to this there is a strong body of Native photographers

FIGURE 11
Unidentified artist
(Navajo)
Navajo blanket, late 1800s/
early 1900s
Woven wool
58 × 45 inches
The Andy Warhol Museum,
Pittsburgh; Founding
Collection, Contribution The
Andy Warhol Foundation
for the Visual Arts, Inc.,
1998.3.8181

on a mission to supplant the surviving myth and resist the exploitation.

Several Native photographers began countering Curtis as soon as they got access to cameras. Hulleah Tsinhnahjinnie (Seminole/Muscogee/Navajo) has used both original and historical photography of friends and family to speak to her own experience as part of a legacy family of artists, cultivating her knowledge of tribal identity across generations as it informs her contemporary experience. Larry McNeil (Tlingit), a master of juxtaposition, explores "the intersection of cultures, American mythology, irony, satire," and his art "embodies a distinctive sense of American identity."[26] Constructing images that borrow from cosmological figures, pop culture, and landscape, McNeil appropriates iconic Tlingit symbols to dispel the stereotypes that abound.

A number of artists respond directly to Curtis, in the scope of American Indian representation and the scale of their projects, aiming to provide an accurate and tribally appropriate representation of Indigenous peoples. Will Wilson (Navajo) developed a project that is grounded in Indigenous principles of reciprocity and agency. With his Critical Indigenous Photographic Exchange (CIPX), initiated in 2012, Wilson has powerfully appropriated the wet-plate collodion camera to create portraits of Indigenous people who participate as primary agents in the process (fig. 12). With his *Talking Tintypes* series, he adds a layer of augmented reality that enables viewers using the free smartphone Layar app to scan an image, activating video through a QR code; in this way, the photographic subject is able to speak directly to the viewer about his or her contemporary concerns. In contrast to Warhol's portraits, the hand of the mediator becomes secondary to the agency of the subject, an act of pure generosity on the part of the artist.

Matika Wilbur (Swinomish and Tulalip) is currently engaged in Project 562, a multiyear commitment to photograph members from all of the federally recognized tribes in the United States. She has been working on the project since 2012, guided through communities by tribal members who nominate cultural leaders to represent them as subjects for the portraits. Kali Spitzer (Kaska Dena) has taken up the

FIGURE 12
Will Wilson (Navajo, born 1969)
Chairman John Shotton, Citizen of Otoe-Missouria Nation, Missouria Tribe and Affiliated Iowa, 2016
Archival pigment print from wet collodion scan
55 × 45 inches

call for Native portraiture and often focuses on the head and torso, but she also takes evocative photographs showing the experience of Indigeneity through details such as hands resting on a drum. Photographs by Zoe Urness (Tlingit) of water protectors from the Standing Rock Reservation protesting the Dakota Access Pipeline garnered a Pulitzer Prize nomination while serving as a lightning rod for attention to the growing number of Indigenous photographers such as those covered by the *New York Times* and *National Geographic*.[27]

What is most important to take away from this survey of Curtis and Warhol is that the image of the American Indian has for too long been managed, controlled, and constructed by non-Native people who saw the subject as a mythical, even mundane, figure and subject to exploitation as a commodity. While these images will persist in the canon of American art, what is most exciting is

that the canon is expanding in the capable hands of Indigenous artists whose connections to their culture allow them to transcend the historicizing limitations they have inherited. One can hope that their images will generate new manipulations that serve as a conduit for American Indians to be recognized as a living, thriving, and critical part of the American experience.

NOTES

1. Paul Taylor, "The Last Interview," in *I'll Be Your Mirror: The Selected Andy Warhol Interviews, 1962–1987*, ed. Kenneth Goldsmith (New York: Carroll and Graf Publishers, 2004), 393.

2. Stephanie Pratt, "Truth and Artifice in the Visualization of Native Peoples: From the Time of John White to the Beginning of the 18th Century," *British Museum Research Publication*, no. 172, European Visions: American Voices, ed. Kim Sloan (2009): 33–41.

3. Pratt, "Truth and Artifice," 34.

4. Pratt, 35.

5. Philip J. Deloria, *Playing Indian* (New Haven, CT: Yale University Press, 1998).

6. Janet Catherine Berlo, "Will Wilson's Cultural Alchemy: CIPX in Oklahoma Territory," in *PHOTO/SYNTHESIS*, ed. heather ahtone (Norman, OK: Fred Jones Jr. Museum of Art, 2017), 16–61.

7. Jolene Rickard, "The Occupation of Indigenous Space as 'Photograph,'" in *Native Nations: Journeys in American Photography*, ed. Jane Alison (London: Barbican Art Gallery, 1998), 57–71.

8. For a full discussion of the few Native American photographers who emerged in the 19th century, see Hulleah J. Tsinhnahjinnie and Veronica Passalacqua, eds., *Our People, Our Land,*

Our Images: International Indigenous Photographers (Davis, CA: C. N. Gorman Museum, University of California, Davis; Berkeley: Heyday Books, 2006).

9. Joanna Cohan Scherer, "A Preponderance of Evidence: The 1852 Omaha Indian Delegation Daguerrotypes Recovered," *Nebraska History* 78, no. 3 (2012): 116–21.

10. Scherer, "Preponderance of Evidence."

11. Yael Ben-zvi, "Where Did Red Go?: Lewis Henry Morgan's Evolutionary Inheritance and U.S. Racial Imagination," *CR: The New Centennial Review* 7, no. 2 (Fall 2007): 201–29.

12. John R. Short, *Cartographic Encounters: Indigenous Peoples and the Exploration of the New World* (London: Reaktion Books, 2009), and G. Malcolm Lewis, *Cartographic Encounters: Perspectives on Native American Mapmaking and Map Use* (Chicago: University of Chicago Press, 1998).

13. United States Declaration of Independence, July 4, 1776, https://www.archives.gov/founding-docs/declaration-transcript.

14. Steven Conn, *History's Shadow: Native Americans and Historical Consciousness in the Nineteenth Century* (Chicago: University of Chicago Press, 2004).

15. Shamoon Zamir, "Native Agency and the Making of *The North American Indian*: Alexander B. Upshaw and

Edward S. Curtis," *American Indian Quarterly* 31, no. 4 (Fall 2007).

16. Nancy Marie Mithlo, ed., *For a Love of His People: The Photography of Horace Poolaw* (Washington, DC: National Museum of the American Indian, Smithsonian Institution, 2014).

17. *PHOTO/SYNTHESIS* was an exhibition at the Fred Jones Jr. Museum of Art, University of Oklahoma, created as a collaborative project that built a portfolio of images in response to Edward S. Curtis's body of work made in Oklahoma. Wilson and I collaborated with the seven tribes that Curtis had photographed in 1928, inviting the tribes to assert their own priorities by deciding who would represent their communities; the subjects of the portraits were then invited to prepare their own statements for the exhibition labels, allowing the tribes and the subjects to be the primary voices of the exhibition.

18. ahtone, *PHOTO/SYNTHESIS*.

19. Christopher M. Lyman, *The Vanishing Race and Other Illusions: Photographs of Indians by Edward S. Curtis* (Washington, DC: Smithsonian Institution Press, 1982), 92–93.

20. Zamir, "Native Agency," 615.

21. Additional portraits from the Curtis oeuvre can be selected to continue making this argument about Warhol appropriating Curtis for his portraits of American Indians, but truly, once the comparisons are being made, it becomes more evident that Curtis may have been an influence on Warhol's greater interest in portraits. As it is not my intention to establish such a statement, I invite the reader to look at the Curtis and Warhol portraits

in relationship and draw an individual conclusion.

22. Interested readers are encouraged to read the entirety of Lyman's argument in *The Vanishing Race and Other Illusions*.

23. *The Andy Warhol Catalogue Raisonné, Volume 4: Paintings and Sculpture, Late 1974–1976*, ed. Neil Printz and Sally King-Nero (London: Phaidon Press, 2014), 491–533.

24. A full discussion of the photography and the objects can be found in Seth Hopkins, "Andy Warhol's *Cowboys and Indians* Suite" (MA thesis, University of Oklahoma, 2005).

25. Rosalind E. Krauss, "Carnal Knowledge," in *Andy Warhol*, October Files 2, ed. Annette Michelson (Cambridge, MA: MIT Press, 2001), 116.

26. Larry McNeil, "Larry McNeil Bio," 2017, https://www.larrymcneil.com/about.

27. James Estrin, "Lens: Native American Photographers Unite to Challenge Inaccurate Narratives," *New York Times*, May 1, 2018, https://www.nytimes.com/2018/05/01/lens/native-american-photographers-unite-to-challenge-inaccurate-narratives.html, and Maurice Berger, "Reclaiming an Old Medium to Tell New Stories of Native Americans," *National Geographic*, October 8, 2018, https://www.nationalgeographic.com/culture-exploration/2018/10/photography-tintype-native-american-artists/.

Make It Pop: Contemporary Western and Native American Pop Art

Faith Brower

Andy Warhol's ongoing impact on the art world is widely known. Less documented, though, are the ways in which his pioneering approach has fueled a new aesthetic in contemporary western art and Native American art. Warhol's influence over these two disparate genres, which are commonly misperceived as static, is profound and provides artists in both fields the opportunity to challenge stereotypes and provide social critique.

Warhol and pop art—an artist and an art movement immersed in commercialization and consumerism—may seem at odds with western art, a genre that often celebrates America's preindustrialized past with nostalgic views of cowboys and Indians through settlers' eyes and imaginations. Historically, artists of the American West tend to be romantic storytellers who reference and, often, long for the time before American capitalism and Hollywood rose to prominence. When some of the more traditional western painters create portraits of George Armstrong Custer, Buffalo Bill, and other notable western figures, there is heroism, sentimentalizing, and romanticization often attributed to these depictions. When Warhol portrays these and other mythic icons of the West, he instills them with renewed relevance. The *Cowboys and Indians* series, for example, made historical photographs modern through their appropriation and transformation into isolated forms against a white backdrop with a striking palette and features accentuated with bold lines. Warhol took the familiar western characters and made them pop. His influence can be felt in the works of several contemporary artists who offer new perspectives on old themes through the use of color, seriality, and appropriation of pop culture materials.

Native American artists have also found value in applying pop art principles to their work, including its graphic style, the incorporation of mainstream visual culture, and cultural critique. In a field that is often misconstrued as confined to art forms such as masks, baskets, rugs, and beadwork, many Native artists have been pushing the boundaries of modern and contemporary art to "break the buckskin ceiling"[1] and to make imperative statements about art, life, and cultural appropriation. Pop art is an aesthetic choice and conceptual framework for Native American artists to draw attention to social inequities and the commodification of cultural objects, and to reclaim agency.

Warhol's impact on modern and contemporary artists is both overt and oblique. In the 1960s and 1970s his work was radical in that it departed from both the accepted genre paintings of the 19th century and the avant-garde abstractions of the 20th century, and it elevated appropriations from pop culture into art. He suggested that art should imitate life and yet he still managed to change how we look at the world around us. He opened a door that made it relevant for art to engage with popular culture in new ways. Inside this door we find western and Native artists creating spaces in which to reflect on, interpret, and even challenge contemporary experiences and values. The artists discussed here are just a selection of the many fine artists who infuse Warhol-inspired imagery and pop sensibilities into works of great resonance, thereby demonstrating pop art's ongoing relevance while adapting it to meet the needs of a new generation.

WARHOL AND CONTEMPORARY WESTERN ARTISTS

A number of artists of the American West draw inspiration from pop art to challenge the realistic, nostalgic confines of western art and

bring dynamic voices into the conversation. Duke Beardsley is one of those new voices. Born into a multigenerational cattle ranching family in Colorado, Beardsley reflects on the cowboy tradition and lifestyle in his art. Although he is known for his realistic, monochromatic portraits of working cowboys and cowgirls, a recent body of work exemplifies Warhol's influence on western art today, as Beardsley combines the storytelling nature of western art with a fresh take on a classic tale.

Purely western in subject matter, *Jackpot Roping* (2017) depicts a mounted cowboy demonstrating his skills with a lariat. Roping is part of daily life on the ranch and a fairly popular subject for classic western artists, including Edward Borein, Frederic Remington, and Charles M. Russell. Roping is also a competitive sport at rodeos that shows off the cowboy's abilities. Beardsley used to compete recreationally in jackpot roping events and is intimately familiar with the fine skills needed to rope a steer.[2] *Jackpot Roping* deviates from the nostalgia common in the western art genre and is infused with pop art tendencies in its vibrant colors, composition, and seriality.

Much like a Warhol arrangement, Beardsley's painting is made up of nine separate square canvas panels arranged in a three-by-three grid. Each panel has a bright single-color background with a portrait of a cowboy with his horse and lariat. While traditional western artists may have relied on rugged mountains, billowing dust, and other forms of situational context for excitement, Beardsley incorporates a range of colors that bring liveliness and interest to the roping competition. Each of the nine panels shows the cowboy in a different gesture performing tricks of the trade. The repetition in imagery and the sequencing of portraits demonstrate how static paintings can convey movement and the passing of time—a concept that Warhol also explored in certain paintings (see, for example, the *Elvis* paintings, pages 10, 51). *Jackpot Roping* is also reminiscent of Eadweard J. Muybridge's notable photographic studies of human and animal locomotion, as the sequencing of images becomes film-like in its presentation.

While Beardsley acknowledges Warhol's influence on his use of color, the compositional repetition comes from farther afield.[3] Beardsley's work was exhibited in *Out West: The Great American Landscape*, an internationally traveling exhibition that toured China in 2007. The artist embraced the opportunity to travel abroad for the exhibition.[4] On this trip, Beardsley was moved by contemporary paintings he saw that emphasized repetition to reflect on how it feels to be one in a billion in China today. This sentiment resonated with the artist, who lives near Denver in the intermountain West—a region facing major population growth that is impacting water, land, infrastructure, and even the ranching way of life. Beardsley began to think differently about how he uses the cowboy figure and started employing it as a symbol to make a statement about the evolving West—not through nostalgia, but through repetition.

Beardsley's 2017 *Close Range* (fig. 13) is an impressive painting with a bold palette featuring

FIGURE 13
Duke Beardsley (American, born 1969)
Close Range, 2017
Mixed media
81¼ × 48½ inches

256 cowboys, each one painted on its own five-by-three-inch Masonite tile, assembled together to create a large colorful grid. The lone figure riding its horse is an iconic western image appearing in both art and film. Beardsley's recurring image reinforces ideals of what a cowboy represents, for some: independence, freedom, and work ethic. The cowboys in *Close Range*, though, are more abstract than those in *Jackpot Roping* or Beardsley's earlier monochromatic portraits. Here, the rider on his horse is created from small but broad brushstrokes and contrasts with the many realistic and typically very detailed portraits of cowboys common in western art. This abstract cowboy emerges as a new motif in Beardsley's recent work.

Western art, pop art, and abstraction were born out of many conflicting beliefs, yet Beardsley merges these styles. He further emboldens his work with pop art decorum by appropriating media sources. In *Fake News* (2017), Beardsley's distinctive abstract expressionist cowboy wears a large hat while riding a horse. The image is repeated 11 times side by side in a lineup, further suggesting movement of the herd. The cowboy and horse are painted on top of collaged pages from western magazines. This poignant triptych, made with the 2016 presidential campaign in mind, draws comparisons between the political impact of so-called fake news reports and the falsehoods inherent in our myths about the American West.

The title of the mixed-media painting is a phrase commonly used by the current US president when he does not like a story that has surfaced in the media in a cynical ploy to defuse criticism. Beardsley's painting signals a state of affairs in which social media enables the rapid circulation of stories and sensations and our national leadership openly spreads misinformation. In relation to the American West, fake news also brings to mind the famous quote in John Ford's 1962 film *The Man Who Shot Liberty Valance*: "When the legend becomes fact, print the legend." The myths of the West have profoundly affected how the region is perceived, and misperceived, around the world, demonstrating the far-reaching impact of representations and misrepresentations. Both art and the media

played a large role in circulating these messages and creating the myths that many still believe to be true today.

Within a mythology where cowboys are the iconic symbol of the American West, Maura Allen's work offers a fresh take on the ranching life. Growing up one of eight children in the San Francisco Bay Area, she appreciates the value that ranchers place on everyone in the family working together for a common good.[5]

Raise Your Girls Right (2018) does what few western artworks do: it positions a woman as the subject from a woman's perspective. Allen's painting is layered with a number of visual elements, including pink damask repeated like wallpaper as a background image, alluding to the gendered stereotypes that associate a woman with domesticity. A drawing of a dress reinforces the stereotypes and feminine flair of the pink pattern. In contrast to the delicate damask print is the dark silhouette of a cowgirl in the foreground. She rides her horse with a rope raised as if ready to restrain the stereotypes pictured on her horizon.

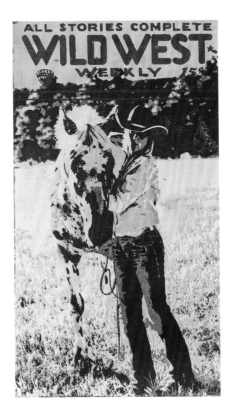

FIGURE 14
Maura Allen (American, born 1963)
Western Tales Vol. II, X, 2019
Acrylic on panel
14 × 8 × 1½ inches

Painted on top of the cowgirl's horse is the phrase "raise boys and girls the same way," an idea that reflects what Allen has come to see and believe from her experiences traveling across the West. In her view, on western ranches the girl's chores are not valued less than the boy's chores; instead, the emphasis is on teamwork and everyone working together to accomplish the shared goals.[6] Allen's cowgirl is an important symbol of strength and unity in the West that is rarely seen.

Warhol portrayed only three western women in his oeuvre, and their images are different from many of his other depictions of women. His portraits of the Hollywood sex symbols Marilyn Monroe and Elizabeth Taylor, for example, emphasize the sultry lips of the former and the coiffed hair of the latter. By contrast, he portrayed Annie Oakley highly decorated with medals and donning a cowboy hat (page 123), a Native American woman carrying a child on her back (page 113), and an elderly Georgia O'Keeffe with a scarf covering her hair (page 79). Warhol demonstrates the range of values that women have in the West and breaks from the tradition of linking them to their sexualized bodies.

Allen confronts gendered stereotypes in a series of works in which she appropriates early 20th-century pulp magazines and makes them her own by painting scenes of contemporary ranch life below their mastheads. In *Western Tales Vol. II, X*, from 2019, Allen painted a cowgirl in her hat, collared shirt, and blue jeans standing next to her horse underneath the *Wild West Weekly* masthead (fig. 14). The depiction opposes the many ways in which old western publications illustrate women as being weaker than men or as sex symbols. In the original *Wild West Weekly* magazine, the men on the covers appear in heroic, strong, and daring acts of capturing outlaws, climbing cliffs, and engaging in shootouts and brawls. Women are hardly ever featured on the covers. They make more appearances on the covers of *Dime Western*, a popular magazine in circulation in the United States from 1932 to 1954 and one of the countless publications that spread fictionalized stories of the West through its articles. But there women are portrayed to appeal to heterosexual male desires: damsels in distress falling out of their dresses or captured and tied up, needing men to save them.

The limited appearances of women on these covers and the highly sexualized images suggest that there is no place for women in the West or if there is, it is in a subservient role, which couldn't be further from the truth. Allen repositions western women as hardworking and independent, providing greater representation of their influential yet often overlooked roles in the West. As the field of western art continues to evolve, it would be an important strategy for artists to take cues from Warhol and Allen and project more authentic and diverse portrayals of women in the West in order for the work to be relevant and meaningful to contemporary audiences.

For half a century, Billy Schenck has had an undeniable presence in the western art world. Schenck's colors, shadows, and photorealist style that yields almost no discernable brushstrokes combine to evoke an exciting vision of the West with brilliant images of wide-open spaces and dramatic desert cliffs (fig. 15).

Schenck is perhaps the only western artist who worked alongside the first generation of pop artists in New York, and Warhol's influence on him is irrefutable. In 1966 Schenck had a brief but fortuitous time hanging out with the Velvet Underground and others in Warhol's circle.[7] When he later moved to New York City in 1970, he worked as a painter and connected with notable artists and musicians, including many regulars at the Factory.[8] By 1975, however,

FIGURE 15
Billy Schenck (American, born 1947)
Land of the Dineh, 1991
Oil on canvas
30 × 50 inches

Schenck left the buzzing art capital and moved west, where he could live within the scenes of his painted imagination.

Growing up in Ohio, Schenck spent many summers in Wyoming, where he was exposed firsthand to the western landscape and cowboy way of life. Like many children of the era, he tuned in to Hollywood westerns on TV and read pulp fiction. While in New York, he found great inspiration in the popular western films of the 1960s and 1970s. Much of his work from the 1970s takes on a cinematic quality that both appropriates film stills and reinvigorates them through his bold use of color and hard-line composition. Schenck's paintings and photography routinely reference stereotypical narratives of the West about heroic cowboys, damsels in distress, and Native Americans.

Like Warhol, Schenck was also drawn to the art of southwestern Native American cultures. Both artists painted katsinas, the important ceremonial figures in Hopi culture (see page 103). In a group of paintings from 2011, Schenck depicts katsina figures in the foreground with a colorful weaving composed of strong geometric lines in the background. In his more recent works on the subject, which include at least six paintings made from 2014 to 2016, each painting is named after an important katsina in the Hopi culture. The katsina figure appears in front of a single-color backdrop of dusty rose, blue, tan, or gray—a formula akin to Warhol's famous style.

Schenck spent decades living in the Southwest, and the omnipresent cultures of American Indians bear some influence on his choice of subject matter in the katsina paintings. Representing these figures is controversial, however. Since anthropological and ethnographic work began in the Hopi communities in the early 20th century, katsinas have been misused and misrepresented.[9] Schenck's work with katsina figures speaks to the commodification of southwestern Native American cultures. Because of the increase in cultural tourism in the Southwest over the last several decades, it has become very common for katsina figures to be made by people who are not of Hopi descent. These unauthenticated figures are bought and sold as commercial items, which is disrespectful to their original ceremonial and cultural purpose. The reproduction of these sacred figures in artworks raises important concerns about the line between pop culture appropriation as an aesthetic strategy and cultural appropriation that risks misrepresenting people and their heritage. These issues are addressed by a number of the Native American artists that follow in this essay.

WARHOL AND CONTEMPORARY NATIVE AMERICAN ARTISTS

Pop art is a recurring strategy among many modern and contemporary Native artists who are working to increase visibility of the social injustices caused by colonization. Several Native artists who started their careers in the 1960s and 1970s, including Jaune Quick-to-See Smith and Fritz Scholder, bring pop attributes to their work without directly citing Warhol. Other artists who rose to prominence in the 1980s and 1990s, including David Bradley and Stanley Natchez, demonstrate Warhol's influence on contemporary Native art. In this millennium there are many Native artists who draw from various caches of popular culture to bring new directions to pop art.

Frank Buffalo Hyde (Onondaga Nation, Beaver Clan; Nez Perce) creates vibrant paintings imbued with social commentary, several of which respond directly to Warhol's legacy. *Meta Painting—Black Feather* (2017), for example, is a pastiche of pop references, including Warhol's ubiquitous "fright wig" *Self-Portrait* (1986) combined with the logo for Bob's Big Boy restaurant chain, a tipi, a hamburger, and a bison head. The bison is a repeated symbol in the artist's work, as he explores the ways in which the mighty creature is referenced and often trivialized in mainstream culture. It is well known how the bison was brought to near extinction by western colonization. Here, Hyde's visual references point specifically toward the commodification and commercialization of the bison as he presents dichotomies in his work between mass-produced consumerism, seen in fast-food restaurants, and handmade work by Native people. Further emphasizing this tension, Hyde incorporates a feather with a copyright symbol to comment on the commercialization of Native art.[10]

These themes were also prevalent in Warhol's work, as he often blurred the boundaries and expectations of paintings and prints, for example, or explored topics of consumerism and mass production. Hyde indigenizes these themes as he demonstrates their ongoing relevance to Native people today.

Hyde further links his work to Warhol's legacy in a series of celebrity portraits. Hyde's *SKNDNS | Native Americans on Film* series includes 13 paintings that explore both the stereotypes of Native Americans that the film industry promotes and the Native American actors who broaden the representation of Native people in film. In *Archival Library Ghost* (2012), he appropriates an image very similar to the one Warhol used in his portrait of Sitting Bull for the *Cowboys and Indians* series (page 125). In Hyde's painting the man is rendered in black brushstrokes on a deep gray background. The portrait is familiar yet generic, evoking the similarities among countless early 20th-century staged photographs of Native men that live on in our photographic archives and communicating stereotypes and tropes of Native people while also sharing meaningful and rare images of ancestors. A thin red line runs vertically near the center of the painting and references blood quantum—a controversial series of laws enacted by the US government to control and limit Native populations.[11] The work is both personal and political, and uses pop art strategies as a means for communicating these meaningful and difficult issues.

The *SKNDNS* series includes portraits of two important female actors: Irene Bedard and Sheila Tousey. Hyde's portraits are reminiscent of Warhol's renowned depictions of Marilyn or Liz, with the simplification of facial features and pink, fleshy skin tones accentuated with bright colors for eye shadow and lipstick and set upon a contrasting background color. In this way, Hyde places these women within the pop culture canon and questions why they were not there in the first place. Indigenous actors, like many actors of color, have not received the same opportunities provided to white actors in America. Warhol's work can easily be criticized for not regularly reflecting people of color.[12] Because Warhol's work derives from and mirrors pop culture, the

criticism also must be applied to the industries and circumstances from which he appropriated his images and for which he did commission work. Hyde, however, is able to see through systematic acts of oppression and resist problems of representation. He intervenes and provides a platform for Native women in film to receive their due recognition.

Also in the *SKNDNS* series is a portrait of Sacheen Littlefeather as she appeared at the Oscars on March 27, 1973 (fig. 16), attending in the place of Marlon Brando, who won Best Actor for his role in *The Godfather*. Brando rejected the award as an act of protest against how the film and television industry portrayed Native Americans. He invited Littlefeather to give a speech on his behalf. The activist actress took to the national stage and referenced the problems of oppression, the lack of Indian representation, and the then recent incident at Wounded Knee, South Dakota.

Hyde's portrait of Littlefeather speaks to that era as a radical time for Native activism.

FIGURE 16
Frank Buffalo Hyde
(Onondaga Nation, Beaver
Clan; Nez Perce, born 1974)
Incident at the Oscars, 2012
Acrylic on canvas
24 × 18 inches
National Museum of
the American Indian,
Smithsonian Institution,
Washington, DC

FIGURE 17
Alison Marks (Tlingit, born 1989)
Cultural Tourism, 2017
Nylon silk, felt, electric motor
Height: 96 inches
Installation view, *One Gray Hair*, Frye Art Museum, Seattle, February 2018

Specifically, the 1973 occupation of Wounded Knee by some 200 American Indian Movement protesters was a defining event. The seizure of this town on the Pine Ridge Reservation raised awareness of the ongoing breach of treaties with Native Americans by the US government. Profoundly, the occupation took place on the site of a historic massacre of Native American men, women, and children in 1890.

Brando's rejection of the Oscar and Littlefeather's Indigenous presence at the Academy Awards drew national attention to the ongoing civil rights concerns for American Indians. It was a historic moment that initiated a conversation that continues today about the pervasive disparities in how the film and television industry treats people of color and women. Hyde's portrait of Littlefeather celebrates a milestone of Native American activism and recognizes the role that popular culture can have in advancing racial and cultural equity.

The work of Alison Marks (Tlingit) oscillates between artistic genres with postmodern and conceptual underpinnings and a few pop art inclinations that arise as she integrates aspects of Native and American popular culture. She inserts a Native lexicon into her work, creating a place for it and acknowledging its general absence from contemporary culture, aside from its problematic appearances in the pervasive stereotypes of Native people and cultures.

Marks is one of several Native American artists who visually integrate QR codes in their work.[13] Her painting *The Messenger* (2014), for example, merges Native American iconography with the ubiquitous tech symbol, though here the black-and-white painted QR code takes the shape of an owl—a messenger symbol—and wittily references both the artist's Tlingit background and the function of the code to transmit messages.[14] As Marks explains, "Formline is an ancient system of Tlingit design. *The Messenger* is formline in the digital age."[15]

Another of her works that merges symbols from mainstream culture with Native iconography is *Cultural Tourism* (2017; fig. 17), which combines a totem pole with the "tube man" or "air dancer" advertising signage commonly used at car dealerships. Best viewed in real time or video in order to capture its artificial waving-in-the-wind movement, the sculpture criticizes

the widely disbursed images of totem poles as consumer goods. *Cultural Tourism* is reminiscent of the First Nations artist Brian Jungen's influential work repurposing Nike shoes into Northwest Native masklike objects. Marks and Jungen lament the way these important cultural objects are taken out of their original contexts and exploited in an act of commodification. These important artistic acts of appropriation are similar to how Warhol and the first generation of pop artists appropriated everyday symbols to comment on postwar capitalist society.

Marks's "air dancer," in its appropriation of a commercial advertising tool, is reminiscent of Warhol's sculptural work, including his Brillo boxes. Warhol's source material, though, was a consumer product with superficial cultural depth on its own. When transformed into a sculpture, it established a dialogue about capitalist culture and its context as a common household product that points toward the postwar consumer society and rise of the middle class. But Brillo boxes are not sacred or culturally important materials. By contrast, Marks's work evokes deep ancestral connections and centuries-old art forms, and she uses pop culture references to make her critique paradoxical and more satirical, to bring awareness to the problems of cultural appropriation, commercialization, and commodification.

The artist also raises an important question about appropriation in Native pop art in relation to pop art in general, in that the symbols that are common in Native cultures are less known in the dominant culture. For example, the *tináa*, a copper shield, is a culturally significant object to Tlingits and other Northwest Coast communities.[16] In the copper pendant *In God We Trust* (2014), Marks adapts the formal shape of a copper shield and adds ornamentation to make it look like a folded dollar bill. Part of her *Potlatch Dollars* jewelry series, it wryly distinguishes between the value Native communities place on certain objects and that of American currency. The appearance of money and currency in art often emboldens a critical interpretation of capitalism and commodity culture. Warhol incorporated American currency in his *Dollar Bills* series in the early 1960s and later in the

Dollar Signs series from the 1980s. In Marks's copper shields, details of presidential portraits, the White House, and the hand-engraved lettering and numbers from American currency are juxtaposed with disparate symbols in a blending of cultures that points to the ways in which Marks synthesizes the distinct cultures of her respective nations.

Gregg Deal (Pyramid Lake Paiute) creates work that tackles important social issues through both painting and performance. He confronts the realities, and many of the absurdities, of how Native people are represented and misrepresented in mainstream culture. Through the appropriation of recognizable imagery, his work is a platform for social justice to inspire awareness and change.

The stereotypes and tropes of Native Americans are all around us in grocery stores and department stores, in movies theaters and on television, in books and magazines, and in art.[17] In the 2015 mural-sized painting *Defiant to Your Gods* (fig. 18), Deal includes 14 offensive representations of Native Americans taken from pop culture. While these are just the tip of the iceberg, they signal the widespread and pervasive misconceptions about Native people spread through everything from Disney animated films and national sports team logos to the packaging of lollipops. The hurtful images are amalgamated with several abhorrent words used to defame Native people. In the painting, these words and images swirl around a young Native person. She stands alongside an image of an American flag and the phrase "You don't look Indian enough." She is in a toxic environment surrounded by ignorance and assumptions, but she is confident, finding her strength and resiliency despite the pain inflicted by such harsh visual and verbal assaults.

In his pursuit to address centuries of wrongdoings, Deal draws from pop art's legacy of appropriation in order to discuss the problems of representation. In several of his works, including *Childlike Identity* (2017) and *Faces of Indian Country 2* (2018), he incorporates the mascot of the Major League Baseball (MLB) team Cleveland Indians along with portraits of Native people to

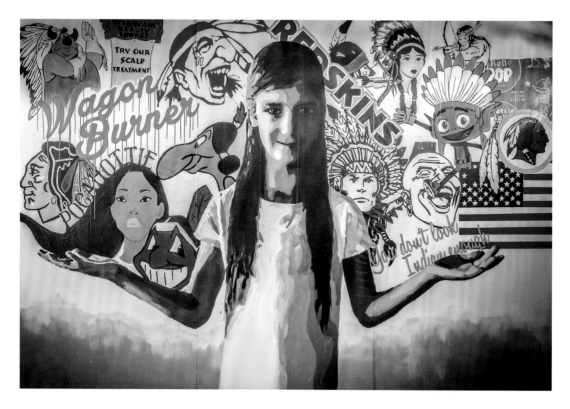

FIGURE 18
Gregg Deal (Pyramid Lake
Paiute, born 1975)
Defiant to Your Gods, 2015
Acrylic on wood panel
96 × 144 inches

emphasize the absurdity and pain entwined in the derogatory logo, known as Chief Wahoo. After decades of defamatory use of the logo, MLB and the team announced that they will stop using it on uniforms beginning in 2019, although it will still appear on select merchandise.

MLB is not the only offender, however, and Deal also appropriates the logo and name of the National Football League (NFL) team in Washington, DC, to draw attention to both the fictionalized rendering of a Native American man and the racial slur that somehow passes as the team's name. *Defiant to Your Gods*, for example, associates that team name with the other disparaging references to Native people in pop culture. In *Blood Painting* (2016) Deal literally incorporated his own blood, along with gold leaf, to respond to issues of corporate greed at the expense of Native people. Here, the Washington, DC, football team logo is prominently painted over a background of screenprinted comments about Native people culled from online forums. These ill-founded comments form the backdrop

of injustices disseminated and consumed daily through pop culture.

Deal is not alone in raising concerns over the racial injustices found in sports team logos. Several other Native artists bring visibility to this issue, including Frank Buffalo Hyde in his 2018 painting *Scalp Tickets Not Cultures* and Bunky Echo-Hawk (Pawnee, Yakima) in his painting *Not Your Mascot* (circa 2012), among other artists.

Because American popular culture stereotypes, trivializes, and offends Native peoples and cultures through sports team logos, consumer goods, and costumes, pop art provides a provocative platform through which Indigenous artists respond to these injustices and reclaim their imagery. A number of western artists also embrace pop art's distinctive approach to move beyond the romanticized representations of the region often found in the art of the American West. Warhol's impact is found not only in stylistic and color influence and the appropriation of popular material but also in his manipulation

of ordinary objects to turn them into something extraordinary. The pioneer of pop art ventured into western territory and changed the course of how we see things, making us think differently about the conventional, the mundane, and all that we may not typically notice. Warhol teaches us to look at the surface of everyday things and how they are represented. He provokes us to look more deeply at the afterimage or the feelings evoked by certain objects.[18] It becomes our responsibility to own what we see and understand the messages conveyed.

NOTES

1. Jaune Quick-to-See Smith statement at the Crossroads: Art + Native Feminisms conference, Museum of Arts and Design, New York, February 18, 2017.

2. Duke Beardsley, phone conversation with author, September 27, 2018.

3. Beardsley phone conversation.

4. *Out West: The Great American Landscape* was organized by Meridian International Center in collaboration with the National Art Museum of China and the Chinese Ministry of Culture. The exhibition featured 68 contemporary western artworks by 50 artists and traveled to Washington, DC; Beijing; Ürümqi; Xi'an; and Shanghai.

5. Maura Allen, phone conversation with author, September 27, 2018.

6. Allen phone conversation.

7. Julie Sasse, *Bill Schenck: Serigraphs, 1971–1996* (Santa Fe: Schenck Southwest Publishing, 2010), 4.

8. Sasse, *Serigraphs, 1971–1996*, 5.

9. Gloria Lomahaftewa and Daryn A. Melvin discuss the appropriation of Hopi culture more fully in their essay on Warhol's *Kachina Dolls*; see page 101.

10. Frank Buffalo Hyde, email to author, October 15, 2018.

11. Hyde email to author.

12. His series of *Mao* portraits (1972–73), the *Ladies and Gentlemen* series (1975), and *The American Indian (Russell Means)* series (1976; page 69) are the obvious exceptions, along with the other portraits of Native Americans discussed in this volume and the important *Race Riot* paintings of 1964.

13. Will Wilson (Navajo) beaded two functional QR codes into his *eyeDazzler* from 2011. *QR Code* (2013) by Joe Feddersen (Okanogan/ Arrow Lakes) is a glass vessel mirroring the shape of a woven Plateau-style basket, which has QR style, geometric pixel patterns on its surface. Velma Kee Craig (Navajo), in her 2013 woven *Bar Code/QR Code*, appropriates the design of the American flag and reformats the square of stars into a black-and-white QR code surrounded by the black, white, and red stripes of a barcode.

14. Alison Marks, "The Messenger," https:// alisonmarks.com /portfolio/the-messenger/.

15. Marks, "The Messenger."

16. Marks, "In God We Trust," https://alisonmarks .com/portfolio/in-god-we -trust/.

17. This topic is addressed in current scholarship, including the important exhibition *Americans*, curated by Paul Chaat Smith and Cécile R. Ganteaume, on view from 2018 to 2022 at the National Museum of the American Indian, Washington, DC.

18. Donna De Salvo discusses the afterimage impact of Warhol's work in her essay "Afterimage," in *Andy Warhol: Retrospective*, ed. Heiner Bastian, rev. ed. (London: Tate Publishing, 2002).

plates and contributions

Triple Elvis

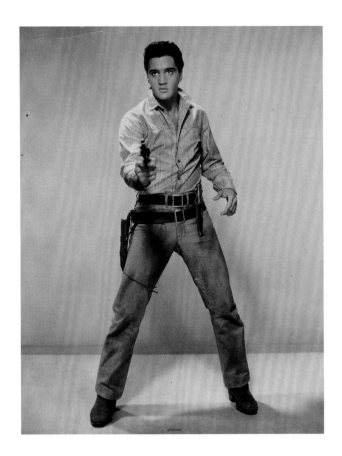

In 1963 President John F. Kennedy was assassinated, the Vietnam War was amping up, the Beatles were about to explode on the mainstream, and Andy Warhol was making work in his first studio outside his home.

In 1963 Elvis Presley was a bona fide star filming *Fun in Acapulco* and *Viva Las Vegas*, his 13th and 15th films; it would be the beginning of a downturn in his career.

Triple Elvis was a continuation of Warhol's celebrity obsession. What is different about this piece is that it combines the star power of Elvis with the western film serial gunslinger motif. Also, it is one of the few times Elvis has been portrayed as an actor in a film rather than as an iconic rock star.

In terms of subject matter, the Elvis with a holster and gun, while suggestive of the cowboy genre, does not evoke the same connotations as, say, a John Wayne piece. The silver background is suggestive of the silver screen. Warhol makes subtle, deliberate choices. The multiplying of the image suggests displacement of the idea of portraiture by creating a sense of timelessness.

Natives have long laid claim to Elvis as one of our own. It's rumored that he had Cherokee blood in him. Which is par for the course as far as people claiming Indigenous background—their "great-great-grandmother" was Cherokee. He was also a twin, so when I saw *Double Elvis* (1963) for the first time, I immediately thought of his twin that died at childbirth, Jesse Garon Presley.

Let me add here that my mother is a huge Elvis fan. I've listened to hours and hours of his music and seen every TV special. We had Elvis velvet paintings and Christmas ornaments. I visited Graceland with my mother when I was seven, and the day he died it was as if we lost a part of the family.

I lived in Pittsburgh for two years. My daughter was born there and during the winter we'd go to the Andy Warhol Museum. So I've spent hours and hours poring over his works from many different eras, including his collaborations with Jean-Michel Basquiat and his infamous piss paintings. I was also fortunate enough to be married at the Andy Warhol Museum.

If I had to put *Triple Elvis* into one category or the other of Cowboys or Indians, I would say that this piece falls into both. I am ultimately a bit ambivalent about that series. The palette is subdued, not the artist's usual visual cornucopia of complementary colors.

——

Frank Buffalo Hyde

Postcard ("Greetings from Paris") from Charles Henri Ford to Andy Warhol, dated July 1963
9⁵⁄₁₆ × 7³⁄₈ inches
The Andy Warhol Museum, Pittsburgh; Founding Collection, Contribution The Andy Warhol Foundation for the Visual Arts, Inc., 1998.3.4589

——

ANDY WARHOL
Triple Elvis [Ferus Type],
1963
Silkscreen ink and silver paint on linen
82 × 69 inches
Private collection

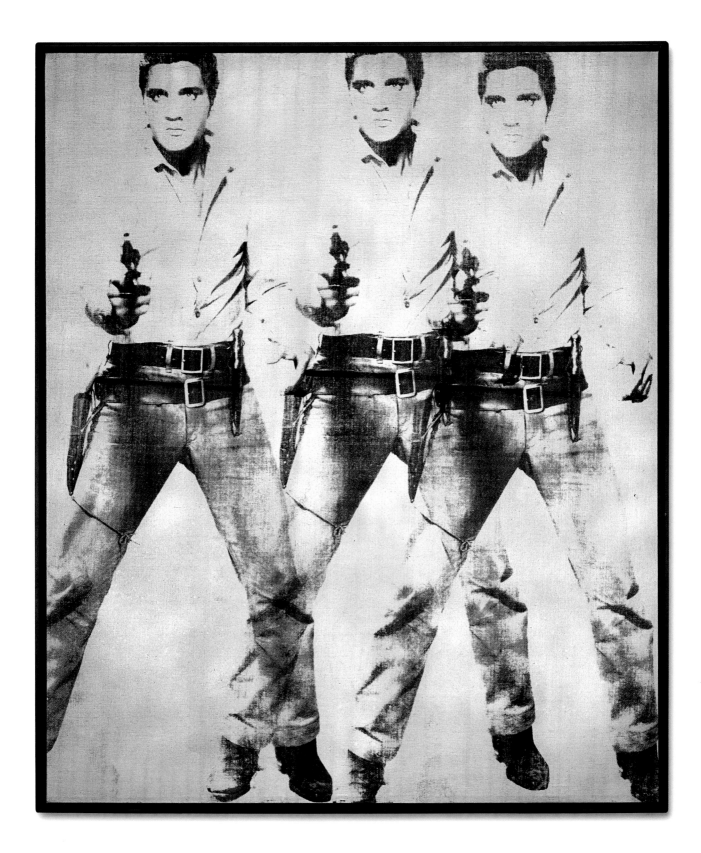

Horse

In late 1964 Warhol purchased an Auricon camera that allowed him to record sound for the first time. He began shooting a series of 16mm feature films, consisting of two or three 1200-foot reels; each reel runs slightly longer than 33 minutes. Warhol often turned the camera's unblinking eye on his superstars, filming whatever happened—chaos or boredom—in a single unbroken take until the film ran out. The Auricon recorded sound directly onto the optical track, eliminating the need for an additional sound recorder; its portability made it indispensable in early television field reporting. Warhol learned about the camera from the critic and filmmaker Jonas Mekas, who used it for his visceral 1964 film *The Brig*, a cinematic interpretation of Kenneth H. Brown's play of the same name, produced by the Living Theatre.

In 1965 alone, Warhol made nearly 30 feature films, approaching, but not quite matching, Warner Brothers' productivity in the 1930s; they churned out a movie, or more, a week. In the unusually busy two-week period during which he made *Horse*, Warhol filmed three other features, working in a variety of genres simultaneously. The writer Ronald Tavel supplied the scenarios for a number of Warhol's films, including *Horse*, which Tavel considered one of his best. He interviewed the performers to get a sense of character and to identify any useful talents; he then generated a nine-page script. *Horse* unfolds in three reels, although the second reel filmed is screened third, and the middle reel halts the action, featuring a static shot of the horse as various characters interact with it. This stutter in time functions like the hiccups and repetitions Warhol so deftly orchestrated in his silkscreen paintings.

As seen in the frame enlargement, the poet Dan Cassidy (Tex), a last-minute replacement, sprawls on the floor in dirty white jeans and tall boots; behind him, the horse trainer Leonard Brook is obscured by the animal's head. A teenaged Larry Latreille (Kid) cockily perches atop Mighty Bird, rented for the day from the Dawn Animal Agency (still active in New York); the art critic Gregory Battcock (Sheriff) stands center screen, a Stetson tilted over his eyes. On the floor to his left, the artist Macario "Tosh" Carrillo (Mex) wears dark jeans and jacket. Behind them stands the silvered Factory wall, with its twin elevator and stairwell doors, a messy desk, and a scrap of broken mirror next to the well-used payphone, hidden by the horse's head.

They began with a script featuring a slim narrative, and Warhol did everything he could to subvert audience expectations of a western film. Although *Horse* is similar to *Lonesome Cowboys* (1968; pages 55–58) in its sly, teasing homoeroticism and scenes of wrestling, the two films are worlds apart in terms of cinematic illusion. *Lonesome Cowboys* relishes in an idealized West, featuring weathered dude ranches and rocky deserts, actors handsomely backlit by fiery sunsets. In *Horse*, despite the animal standing dead center and the hats and pistols of the cast, the film unfolds inside the hectic, urban frame of the Factory. The phone rings repeatedly and members of the crew, including Warhol, enter to take the calls; visitors disembark from the elevator right into the action, blinking and startled by the hot lights.

The cast was not provided the script prior to shooting and read their lines as best they could from large handwritten cue cards, held, mostly offscreen, by Tavel and Warhol's studio assistant at the time, Gerard Malanga. An air of perpetual tension prevails as the performers struggle to engage with each other and keep the dialogue and action moving, with one set of cues held by Tavel, the other by Malanga. Warhol provokes a high-wire act between person and persona, idealizing iconic western figures while pointing to the illusion with which they are constructed, like the braces that prop up

ANDY WARHOL
Horse, 1965
16mm, black-and-white film, sound, 100 minutes
Film still courtesy of The Andy Warhol Museum, Pittsburgh, 1997.4.58

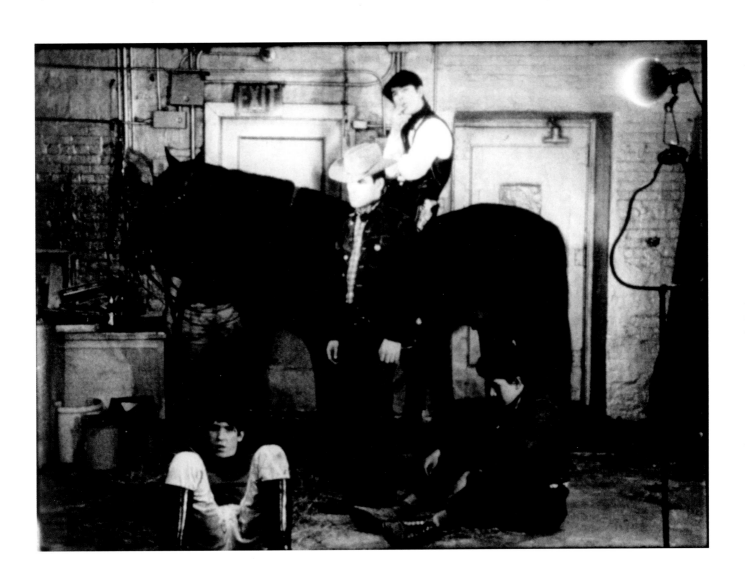

the well-dressed but flimsy walls of a film set. After Carrillo demonstrates his unique talent by opening Battcock's fly with his toes, he provokes an attack from the others for being suspiciously nonwhite. The cast later pretends to "make love to the horse," as called for in the script, spooking Mighty Bird, though its skillful trainer soothes the beast.

Tavel boldly excavates the perversity, colonialism, and racism that lurk beneath the wholesome cowboy myth. His script calls for the performers to discuss onanism, distribute land deeds (actually paper towels), lewdly drink and spit up milk, and finally play strip poker, yielding a nearly naked Latreille and Carrillo. The final reel screened unexpectedly features the socialite and amateur soprano Florence Foster Jenkins singing a piece from Gounod's *Faust*, to which Carrillo dramatically dances, joined in the end by Tavel, clearly smitten by his handsome dance partner. Jenkins's failed opera (she was an ambitious but untalented woman who performed disastrously at Carnegie Hall and was portrayed by Meryl Streep in a 2016 biopic) makes explicit the film's connections to the genre of horse operas and to the singing cowboys of Warhol's 1930s youth.

————

Tom Kalin

Lonesome Cowboys

The western movie—its portrayal of good versus evil, hard-boiled dialogue, anachronistic costumes, stereotypical characterizations of Native Americans and Latinos, and conventional gender roles—is a genre that permeated the United States in the 20th century. Film and television brimmed with stories of cowboys and Indians, damsels in distress, brothels and madams, standoffs at high noon, white hats and black hats. By the late 1960s the production of westerns in the United States had fallen off considerably since their heyday in the 1940s and 1950s.[1] But the cast and crew who alighted in Arizona in January 1968 to film *Lonesome Cowboys*—not to mention the director, Warhol himself—had come of age during the golden age of westerns.

Like many of Warhol's films, *Lonesome Cowboys* had no proper script, but some sort of written scenario, penned by Paul Morrissey, may have circulated among the cast and crew in Arizona, or even earlier in New York.[2] The story originated as an adaptation of *Romeo and Juliet*, but aside from some of the character names—Ramona (Viva) and Julian (Tom Hompertz)—and the final scene in which Ramona commits suicide with the aid of her nurse (Taylor Mead), the film's action cuts a circuitous path, straying from and returning to a loose plot involving a band of cowboys who invade a small town; rape the local madam, Ramona; and then experience dissent within their ranks before Ramona dies and two of the cowboys abandon the group. Throughout the film, the actors clearly improvise much of their dialogue, peppering it with plays on the clichéd language of westerns. The result is a combination of recognizable tropes and heartfelt, yet sometimes absurd or even disturbing, dialogue. Eric Emerson and Joe Dallesandro discuss western attire while Emerson does ballet barre exercises at a hitching post. Viva and Emerson lie in a clearing against a backdrop of prickly pear cactus, giggling, examining each other's teeth, and critiquing each other's kissing style. After Ramona's rape, two of the cowboys (Julian Burroughs and Dallesandro), clad in bandanas and cowboy hats, lament what they have become, "sleeping out in the goddamn rocks," behaving "like animals," not being able to get their "hair done," and resolving to quit the gang to raise children and await World War I.

This slippage between conforming to the western genre and subverting it to underscore the film's status as self-conscious pretense is something that Warhol and Morrissey also took advantage of when they began filming at Old Tucson, a film set that had been a popular shooting location for movies and television, but by 1968 had become more of a tourist attraction. Old Tucson was replete with a saloon, storefronts, dirt roads, and a mission church, but also a souvenir shop called Cactus Creations, which appears within a shot of the cowboys riding into town. Such campy cracks in the verisimilitude of the western, this marriage of sincerity and irony, are probably what led more sympathetic early critics of *Lonesome Cowboys* to categorize it as a spoof or parody and other, more dismissive ones to declare it a total failure.[3] But the casual approach to the western genre is typical of Warhol's films; he had long been capitalizing on the predictability of Hollywood movies as a pretext for his own brand of queer, ramshackle action.

Such action did not go unnoticed by the bystanders who were on location the day *Lonesome Cowboys* began filming. In his 1980 memoir *POPism*, Warhol recounts the experience as if it were the plot of an actual western:

> It was misty the day we started shooting *Lonesome Cowboys*. The dialogue the boys were coming out with was going along the lines of "You dirty cocksucking motherfucker, what the hell is wrong with you?" and in the

middle of this type of thing, we saw that they were bringing a bunch of tourists in, announcing, "You're about to see a movie in production. . . ." Then the group of sightseers marched in to "You fags! You queers! I'll show you who's the real cowboy around here, goddamn it!" They started going nuts, rushing their kids away and everything.

Eventually, the grips, the electricians, and the people who build the sets formed a vigilante committee to run us out of town, just like in a real cowboy movie. We were all standing on the drugstore porch, except for Eric, who was doing his ballet exercises at the hitching post, when a group of them came over and said, "You perverted easterners, go back the hell where you came from."[4]

Warhol goes on to describe how local sheriff's officers arrived by helicopter and stood on top of a water tower monitoring the cast's behavior, ready to arrest anybody who took off their clothes. Because conditions became too disruptive at Old Tucson, they cut short their second day of filming and shot the rest of the film at Rancho Linda Vista, an artists' community outside Tucson in Oracle, Arizona.

Warhol's account of his group's run-in with the law underscores just how effectively a generation of Americans who grew up watching westerns had internalized the archetypal characteristics of the genre. Far from simply spoofing western films, much of the acting in *Lonesome Cowboys* is earnest if not downright serious, and suggests an intimacy and familiarity among its players that reaches beyond the circumstances of filming. Western heroes such as Gene Autry and John Wayne functioned as role models for American soldiers fighting in the Vietnam War, the unpopularity of which peaked in 1968 with widespread public protests.[5] Burroughs, as it happens, was rumored to be a military deserter during the war, joining up with Warhol's coterie of Factory regulars after taking on a pseudonym. Perhaps playacting a disillusioned cowboy who dreams of escape and a quiet life may have been an opportunity to articulate desires—to settle down in a small town, to have a family—heretofore forbidden to him in a public venue.[6] The production of *Lonesome Cowboys*

allowed Warhol and his cast to play out a fantastical idea of life on the western frontier unfettered by social constraints—to be heroes in a world in which they were decidedly outcasts.

Many of the actors in *Lonesome Cowboys*, Emerson and Viva especially, were years-long veterans of Warhol's cinema—a practice that used the camera not so much to frame specific action within its lens, but as an apparatus for inciting actions that spread beyond its watchful eye. *Lonesome Cowboys* ends with Dallesandro and Hompertz riding off into the sunset, intent on going to California to take up surfing. Far from absurd, this was what actually happened, as Warhol's next film was *San Diego Surf* (1968), filmed in La Jolla and featuring much of the same cast as *Lonesome Cowboys*. Perhaps Viva sums up Warhol's cinematic practice best when she says in that later film, "I can't tell the difference anymore between shooting and not shooting and, you know, between reality and fantasy."[7]

———

Chelsea Weathers

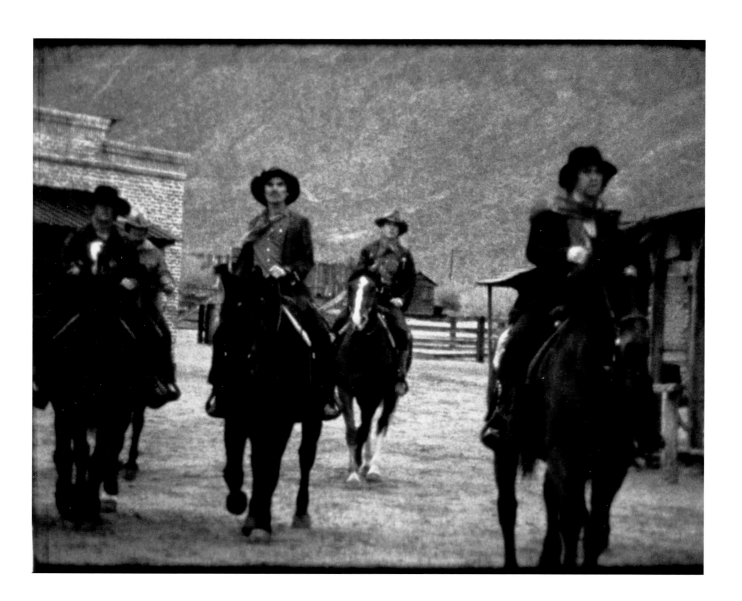

NOTES

1. For the western as a genre and its production in the mid-20th century, see Philip French, *Westerns: Aspects of a Film Genre and Westerns Revisited*, rev. and expanded ed. (Manchester, UK: Carcanet Press, 2005); John G. Nachbar, ed., *Focus on the Western* (Englewood Cliffs, NJ: Prentice-Hall, 1974); and Jim Kitses and Gregg Rickman, eds., *The Western Reader* (New York: Limelight Editions, 1998).

2. According to one Tucson journalist, Julian Burroughs claimed to have written a script for the film, but Tom Hompertz responded to that claim by saying he had never seen a script. Taylor Mead also reported that although a script had existed, by the time they arrived in Tucson it had been cut down to about three pages of ideas. Dan Pavillard, "Romeo and Juliet: Warhol, '68, Wherefore Art Thou, Script?," unlabeled, undated clipping from the Warhol clippings files at the Film Studies Center, Museum of Modern Art, New York. Shirley Pasternack cites Pavillard's headline as being from the *Tucson Daily Citizen*; Pasternack, "Warhol," *City Magazine* (Tucson), May 1989, 40.

3. Reviews that refer to *Lonesome Cowboys* as a spoof include Kevin Thomas, "'Cowboy' on Cinema Screen," *Los Angeles Times*, December 19, 1968; "Lonesome Cowboys," *Variety*, November 3, 1968; and A. Reynard, "At the Cinema: Warhol's Lonesome Cowboy," *Spokane Natural*, December 5–18, 1968, 8. Clippings from Time Capsule 7, Andy Warhol Museum archive. Stephen Koch later said of *Lonesome Cowboys*, "Warhol's Western is a bad film, even an abominably bad film. It is sloppily made. It does not do what it wants to do. It is very boring." Koch, *Stargazer: Andy Warhol's World and His Films* (New York: M. Boyars, 1985), 105.

4. Andy Warhol and Pat Hackett, *POPism: The Warhol Sixties* (New York: Harcourt Brace Jovanovich, 1980), 261–62.

5. According to the film critic J. Hoberman, "The average recruit had entered his teens at a time when eight of the top prime TV shows were Westerns. Small wonder that John Wayne, the greatest of movie cowboys, became a talisman for a substantial number of American soldiers in Vietnam . . . where dangerous areas were known as 'Indian country' [and] Vietnamese scouts were termed 'Kit Carsons.'" J. Hoberman, "How the Western Was Lost," in Kitses and Rickman, *Western Reader*, 88.

6. In his book *Factory Made*, Stephen Watson includes a short biographical sketch of Julian Burroughs, claiming that his real name was Andrew Dungan, and that he went AWOL in June 1967 by failing to return to duty after his military training, which he had begun nine months earlier, when he was drafted. He chose his alias because he admired William Burroughs and even claimed to be the writer's son. See Stephen Watson, *Factory Made: Warhol and the Sixties* (New York: Pantheon Books, 2003), 346–48.

7. *San Diego Surf*, shot in 1968, VHS transfer screened at the Andy Warhol Museum, 2009. This film was apparently not edited until the mid-1990s by Paul Morrissey. Conversation with Greg Pierce, film curator, Andy Warhol Museum, fall 2008.

Little Red Book #135

Before phones and cameras merged into compact devices that are carried by people around the world, Warhol privileged and prioritized a bulky Polaroid camera. He was a voracious photographer who seemingly foreshadowed the current obsession with casual documentation. Although Warhol had no social-media platform, he took care in organizing thousands of his photographs into more than 200 albums that reveal many of the people, places, and objects that he encountered in his daily life. He called these albums *Little Red Books*.[1]

The name of the photo albums evokes one of the most widely printed books in the world, *Quotations from Chairman Mao Tse-Tung*, also known as the "Little Red Book." It contains passages from the leader's speeches and writings, and was disseminated throughout China in one of the government's more subtle acts of political and social control. Warhol was undoubtedly familiar with the Chinese publication; he appropriated Zhang Zhenshi's portrait of Mao that appears in the Little Red Book for a large series of paintings and prints of the Chinese leader that he made in 1972 and 1973.

Warhol's *Little Red Books* contain snapshots, largely of people, but also of places he visited and objects he found interesting enough to document. The actual albums are consumer goods—store-bought albums with red covers. It is possible that Warhol found humor or irony in appropriating the colloquial title of Mao's book, although in doing so he instills the albums with political associations.

It is important to note that much of Warhol's work from the 1960s and 1970s contains strong political connotations, both direct and obvious messages and those that are more oblique or concealed. His *Little Red Books* and portraits of Mao were created during the Cultural Revolution in China, and in the context of the postwar Red Scare in the United States, the *Mao* portraits are bold. Warhol chose the communist leader as a subject in response to a request that he create work about "the most important figure of the 20th century."[2] The sheer quantity of Warhol's paintings, prints, and even wallpaper on the subject acts as a critique of political propaganda in its own right. The *Mao* series is a fascinating study of the many layers and political implications in Warhol's work.

At first glance *Little Red Book #135*, like the other albums, may appear to be a haphazard presentation of objects rather than a carefully arranged photo album. *Little Red Book #135* in particular is devoted largely to Warhol's long-standing interest in Native American art. Among the 20 photographs in the album are 16 images of Indigenous carvings, basketry, and textiles that were photographed from 1969 to 1970. It is unknown if these items were from Warhol's personal collection, which was significant, or were photographed at an antique store or a museum.[3] In one Polaroid, Warhol tightly cropped a carved face in a way that anticipates his photograph, made 16 years later, of a Kwakwaka'wakw mask that was the source image (page 98) for his *Northwest Coast Mask* print in the *Cowboys and Indians* series (page 99). His focus on the details of these carved faces rather than on the complete work is an artistic abstraction that sacrifices the full context of the original. When working in photography, Warhol developed a style that is identifiable in part by the way in which he positions and crops his subjects. Several of the snapshots in the album demonstrate his interest in shape and form as they highlight parts of a basket or weaving. Many of the photographs are out of focus, are tightly cropped, or have inadequate lighting. One photograph shows the object so close to the edge of the frame that it is barely even pictured, making it difficult to ascertain the subject. Rather than discarding these photographs, Warhol preserved them in an album, suggesting they had some value.

For Warhol nearly everything that passed through his hands had some kind of inherent value. He was a compulsive and, at times, fairly indiscriminate collector. In this sense, the *Little Red Books* are similar to his *Time Capsule* series (1974–87), for which he would injudiciously package all the items on his desk into a box that was then sealed and stored, presumably to be opened at a later date. Both the *Time Capsules* and *Little Red Books* create nearly endless opportunities for Warhol scholars and enthusiasts to try to glean meaning from what were very often randomly assembled materials linked by time and place. They provide a visual component to the "diaries" that he narrated to Pat Hackett nearly every day from 1976 to 1987.[4] (Fittingly, Warhol also visually documented aspects of his life in what are now known as the *Factory Diaries*—some 300 videotapes mostly created in the 1970s.) His privileging of unexceptional photographic material challenged a long-term effort on the part of photographers to have their work valued as fine art. In doing so, Warhol's avant-garde style democratized the photograph, thereby turning his *Little Red Books* into the political antithesis of their communist namesake.

Faith Brower

NOTES

1. To celebrate its 25th anniversary in 2013, the Andy Warhol Foundation for the Visual Arts donated many of Warhol's *Little Red Books* to museums around the country.

2. Mark Loiacono and Christie Mitchell, "Plates," in *Andy Warhol: From A to B and Back Again*, ed. Donna De Salvo (New York: Whitney Museum of American Art, 2018), 294.

3. The 16 Native American works in *Little Red Book #135* do not match any of the photographs in the Sotheby's catalogue from the estate sale; *The Andy Warhol Collection, Vol. 4: American Indian Art* (New York: Sotheby's, 1988).

4. Pat Hackett, ed., *The Andy Warhol Diaries* (New York: Warner Books, 1989).

ANDY WARHOL
Little Red Book #135,
1969–70
Red binder with 20 Polacolor Type 108 photographs
Album: 4 × 6 × ½ inches
Tacoma Art Museum, Gift of The Andy Warhol Foundation for the Visual Arts, 2013.23 A–T

Dennis Hopper

Dennis Hopper was always an artist, long before he became an actor. He began painting in childhood, took up photography and art in the mid-1950s, and then creatively explored an unconventional approach to filmmaking that paralleled his acting career. He was deeply involved with the Los Angeles art scene in the early 1960s and was a passionate collector of contemporary art by artists such as Edward Kienholz, Roy Lichtenstein, Jasper Johns, and Ed Ruscha. He purchased one of Warhol's seminal Campbell's soup can paintings from their first showing, at the Ferus Gallery in Los Angeles, in 1962, though soon regretfully sold it back to the gallery's owner, who wanted to keep the series of paintings together as a group.

Warhol, too, was a collector—not only of art but also of cult personalities such as Bob Dylan, Lou Reed, Nico and the Velvet Underground, and the many frequent visitors to the Factory in New York, including Hopper.

Hopper fit the description of an American icon with his charismatic passion for contemporary art and film. He reigned in the American West as an actor playing such memorable roles as a young rancher in a Texas town, alongside James Dean, in his breakthrough film *Giant* (1956), directed by George Stevens. The next decade saw him hit the road on a drug-induced cross-country motorcycle trip with Peter Fonda in *Easy Rider* (1969), which was also Hopper's debut as a film director. That film would connect Hopper to the small New Mexico town of Taos, where he bought a house and lived for much of the 1970s; he would also buy an old movie theater in Ranchos de Taos, where Georgia O'Keeffe had once screened selections of movies for the community in the 1950s and where Hopper screened avant-garde and foreign films, as well as cartoons for children on Saturdays.

Warhol thrived on the adventurous antics of iconic personalities, often living vicariously through

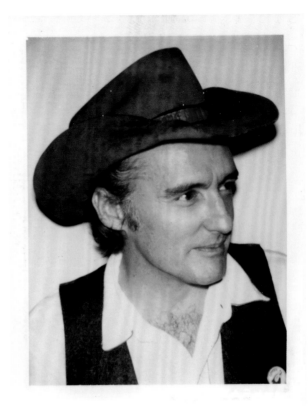

them. In 1964 he made several black-and-white screen tests of Hopper. As the actor described, "I was in another film that Andy did called *The 13 Most Beautiful Boys in the World*. . . . Andy just told me the title and turned on the camera and walked away . . . [B]eing the egomaniac that I am, I sat there and did a Strasbergian emotional memory."[1] Hopper also sat for a series of Polaroids in 1977.

Warhol's 1971 painting *Dennis Hopper* was based on a photograph taken by Henry Grossman during the filming of *The Last Movie* (1971), starring and directed by Hopper. After the success of *Easy Rider*, he was given a large budget by Universal Pictures to create his next film, with free rein to direct without intervention. *The Last Movie* was shot in a small village in Peru with nearly 50 hours of footage. The film reflects a time in Hopper's career when he was finding his own creative direction and independent identity as a director, photographer, and painter, aside from his acting career.

This reflective portrait captures the transitional moment of Hopper's filmmaking style and American

Andy Warhol
Dennis Hopper, 1977
Polaroid Polacolor Type 108
4¼ × 3⅜ inches
The Andy Warhol Museum, Pittsburgh; Founding Collection, Contribution The Andy Warhol Foundation for the Visual Arts, Inc., 1998.1.2967

———

ANDY WARHOL

Dennis Hopper, 1971

Acrylic and silkscreen ink on linen
40 × 40 inches
The Andy Warhol Museum, Pittsburgh; Founding Collection, Contribution The Andy Warhol Foundation for the Visual Arts, Inc., 1998.1.573

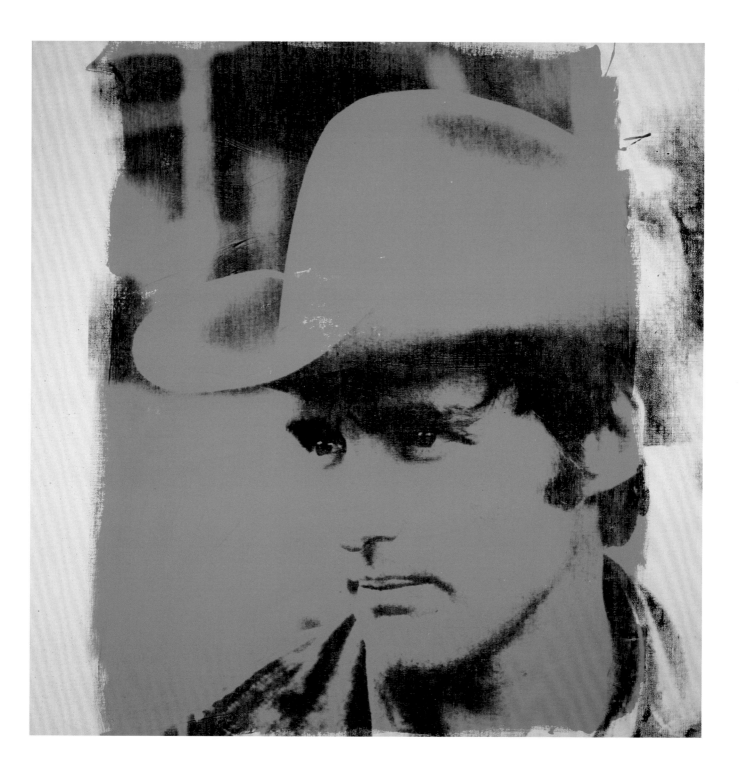

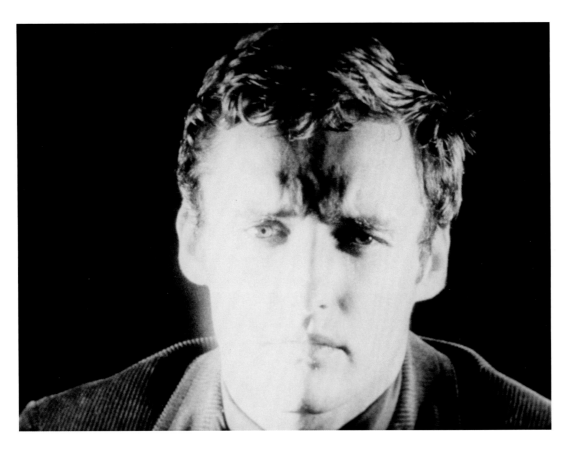

Andy Warhol
Screen Test: Dennis Hopper
[ST153], 1964
16mm, black-and-white film,
silent
4 minutes 30 seconds
The Andy Warhol Museum,
Pittsburgh; Founding
Collection, Contribution The
Andy Warhol Foundation
for the Visual Arts, Inc.,
1997.4.113.153

avant-garde cinema, as well as the art and the visionary cultural changes and rebellion that were happening at the time, birthed from Beat Generation ideals. Hopper's piercing stare gazes into a new world that was to leave conservative conventions behind.

Warhol was always ahead of them all, surrounding himself with the key protagonists in contemporary American expressions and documenting with certainty many who were to become influential, progressive icons of our time.

———

Tony Abeyta

NOTES

1. Quoted in Callie Angell,
Andy Warhol Screen Tests:
The Films of Andy Warhol
Catalogue Raisonné (New York:
Harry N. Abrams, 2006), 101.

Sunset

Natural themes are few and far between in Warhol's work, but the setting sun was the star in his film *Sunset* (1967) and the subject of a series of unique prints of the same name (1972). In each of these works Warhol takes hold of a universal subject to problematize everyday standards of film and printmaking, respectively.

Riding into the sunset is a tried-and-true trope of western cinema. It evokes the end of a hard day on the range and the promise of a new beginning on the horizon. The sun is usually a backdrop—a part of the scene that can go almost unnoticed because it is so familiar. Warhol sets his sights on this ubiquitous element of daily life for the duration of the 16mm film. Over the course of 33 minutes, the sun sets beyond the horizon accompanied by a voiceover of Nico from the Velvet Underground reciting spoken-word poetry about light, life, and death. Similar to Warhol's other cinematic achievements that use the moving-image format of film to document fairly inanimate objects, here the camera remains focused on the radiant disc slowly, and predictably, escaping our visual orbit. The film challenges mainstream pictures with its experimental approach. While the film blatantly observes the sunset, it also is meant to reflect on religion.

In the mid-1960s the philanthropists and art collectors John and Dominique de Menil commissioned Warhol to create the film for the 1968 World's Fair in San Antonio.[1] There is also speculation that the film was intended for the then imminent Rothko Chapel in Houston, which the de Menils also commissioned.[2] Perhaps Warhol was a little unclear as to where the film would appear. The artist remarked: "Fred [Hughes] . . . arranged a commission for me from the de Menils to film a sunset for something to do with a bombed church in Texas that they were restoring. I filmed so many sunsets for that project, but I never got one that satisfied me."[3] In a letter to Warhol, the de Menils specified that the film should be "appropriate for a church," but neither their exhibition at the San Antonio World's Fair nor Warhol's film saw the light of day.[4] Had Warhol's *Sunset* been screened in a church, the imagery of a setting sun would have served as an interesting correlation to the nimbi or halos that typically adorn the heads of saints illuminating the windows and walls of Catholic churches. For an artist known for portraiture to elicit correlations to a halo without a saint is alluring.

In fact, religion and spirituality may seem unlikely concerns for an artist who made his name by painting celebrities and commodities, but Warhol and his work are much deeper than the surfaces may imply; there are layers of complexities even in works that may appear to be superficial. As a symbol of spirituality, a sunset is a fairly nondenominational choice for a Byzantine Catholic who attended church throughout his life, although he was rather cagey about his devotion. Nearly 20 years later, in one of his last major works, Warhol would more specifically reference Christian iconography, consumerism, and the AIDS epidemic, among other themes, in the *Last Supper* series (1986), presciently created just before the artist's death in February 1987. And just a few years earlier, Warhol had painted *Cross* (1981–82), a bold blood-red symbol of the Christian faith on an ominous black background. In the *Sunset* film, however, spirituality is not linked to an organized religion, but rather to the meditative experience of watching time pass by as the sphere drops into the ocean and rhythmic analogies of life and death are emphasized through the poetic soundtrack.

As Warhol indicated, he filmed the setting sun many times, in both California and New York. Ultimately, the incomplete film includes a sunset recorded over the Pacific Ocean. Yielding a soul-stirring experience, *Sunset*, like some of Warhol's other films, quintessentially challenges the notion

and presentation of moving images. The film is also believed to provide the source image for the *Sunset* print series,[5] which was commissioned by Philip Johnson for the Marquette, a luxury boutique hotel in Minneapolis designed by Johnson/Burgee. The series includes 472 unique prints created for the hotel along with an additional 160 unique prints for an astounding total of 632 prints. Each is a unique color variation on the subject.

Using separate screens, the background colors and texture, the circular sun, and a dotted overlay combine in captivating prints with gorgeous coloring and gradations. The glowing orb of the sun appears in light blue, teal, lilac, golden yellow, orange, and fire red, depending on the print. The atmospheric sky and ocean appear in horizontal bands of color that vary from print to print, ranging from soft pastels to vibrant secondary colors. The color combinations sometimes yield a monochromatic image and at times contrast brilliantly with the surrounding hues, in both cases evoking color-field abstractions. Although color-field paintings and abstractions are not typically associated with the pop artist, he does experiment with these styles in various ways throughout each decade. Each *Sunset* print, with its individual coloration, blurs the boundaries between painting (considered unique) and prints (produced in multiples)—distinctions that Warhol's ambitious approach to this series provokes.

The coloration and simplicity of the subject combined with its focus on nature are evocative within Warhol's oeuvre. It has been proposed that the *Sunset* series has political underpinnings that would align it with Warhol's *Race Riots* (1963), the various *Death and Disaster* works of the 1960s, including many paintings and prints of electric chairs, or even his later *Camouflage* series (1986–87). The art historian Richard Axsom, citing an unpublished essay on the subject by the art collector Stephen F. Dull, convincingly posits that the *Sunset* print may be a representation of the detonation of a hydrogen bomb and relays Warhol's familiarity with such depictions appearing in popular news sources of the 1950s and 1960s, including a cover of *Time* magazine in 1954 that is strikingly similar to the print.[6] Axsom further notes that a 1962 hydrogen bomb test was named Sunset, and surmises that this is no coincidence.[7] In this view, Warhol's *Sunset* takes on a double meaning and represents not only

a natural phenomenon that concludes each day but also the political and modern realities of postwar America where the threat of nuclear warfare ignites fear of destruction on an apocalyptic scale.

Axsom offers that this interpretation of *Sunset* could be justified alongside a more blatant reading of Warhol's works on nuclear warfare, including *Red Airmail Stamps* (1962) and *Atomic Bomb* (1965).[8] The latter painting may be based on a photograph of the first atomic bomb explosion on July 16, 1945, in White Sands, New Mexico.[9] If in fact Warhol repurposed an image from the White Sands explosion and created a print of a sunset in California to mirror a hydrogen bomb test, then the artist is demonstrating recondite ways in which the American West becomes a stage for political acts of death and disaster. It further disrupts any romantic or idealized visions promoted through the typical myths and legends of the West that Warhol revisits in much of his work about the region and offers a new way of looking at Warhol's western works as commentary about the closing of the frontier and the end of an era that had captivated his childhood fantasies.

———

Faith Brower

NOTES

1. For more information about the de Menil commission, see Michelle White, *Sunset: A Film by Andy Warhol*, brochure (Houston: Menil Collection, 2016).

2. Frayda Feldman and Jörg Schellmann, *Andy Warhol Prints: A Catalogue Raisonné, 1962–1987*, 3rd ed., revised and expanded by Frayda Feldman and Claudia Defendi (New York: Distributed Art Publishers in association with Ron Feldman Fine Arts, Edition Schellmann, and The Andy Warhol Foundation for the Visual Arts, 1997), 267.

3. Andy Warhol and Pat Hackett, *POPism: The Warhol Sixties* (New York: Harcourt Brace Jovanovich, 1980), 273.

4. John de Menil to Andy Warhol, June 26, 1967, University of St. Thomas papers, Menil Archives, The Menil Collection, Houston.

5. Feldman and Schellmann, *Andy Warhol Prints*, 267.

6. Richard Axsom, "Lament for a Dead President: Andy Warhol's *Flash—November 22, 1963*," in Sara Krajewski, *Andy Warhol Prints: From the Collections of Jordan D. Schnitzer and His Family Foundation* (Portland, OR: Portland Art Museum, 2016), 63.

7. Sunset was the name given to a hydrogen bomb test over Christmas Island in the South Pacific on July 10, 1962. "Operation Dominic: 1962—Christmas Island, Johnston Island, Central Pacific," https://nuclearweaponarchive.org/Usa/Tests/Dominic.html, updated January 3, 2005.

8. Axsom, "Lament for a Dead President," 78n6.

9. Richard Axsom, email message to author, October 28, 2018.

———

ANDY WARHOL

Sunset, 1972

Screenprint on paper
Edition 30/40
34 × 34 inches
The Andy Warhol Museum, Pittsburgh; Founding Collection, Contribution The Andy Warhol Foundation for the Visual Arts, Inc., 1998.1.2400.1

The American Indian (Russell Means)

Russell Means (1939–2012) is arguably one of the most important figures in contemporary American Indian history. As a founding member of the American Indian Movement (AIM), he became the face of modern Indigenous resistance and an icon of the Red Power movement. Though a controversial figure both within and outside of Indian Country, no one can deny the impact of his words and actions, or the way he fought for his people, the Oglala Lakota, and for all Indian nations.

When in 1976 Warhol approached the Los Angeles art dealer Douglas Chrismas, founder of Ace Gallery, about producing a series of portraits featuring American Indians, Means was an obvious choice. That summer Ace Gallery contributed $5,000 to AIM for the use of Means's likeness in Warhol's series.[1] Created between August 1976 and early 1977, *The American Indian (Russell Means)* series consists of 26 paintings measuring 50 by 42 inches, 12 paintings at 84 by 70 inches, and 23 drawings. These works stand as a testament to modern Indigeneity, disrupting stereotypes with the bold image of Means as a 20th-century warrior and intersecting with Warhol's artistic nod to Indigenous struggles and resistance.

Warhol's image of Means is iconic and important. At the time of its creation during our struggle for equal rights, there were neither prominent nor honest ways of portraying the lives of modern Indigenous people. America was seeing our faces for the first time, and the idea of Natives as a modern living people facing myriad problems associated with our existence was entirely new. The cast of characters standing at the helm of that fight stood as beacons of hope coming after years of hopelessness.

Or did it? There is criticism of Means's clothing in the portrait, and of course the very commodification of the Indigenous image by an artist renowned for commodifying popular culture. When considering

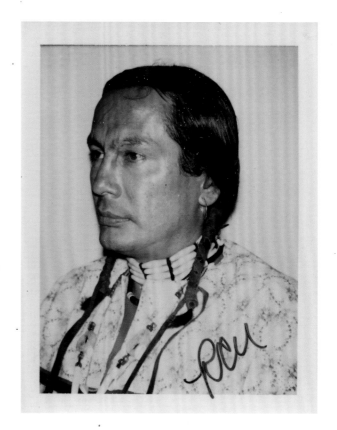

the history and use of the Indigenous image, we can square up a deeper understanding of this specific piece to the Indigenous image at large.

The American understanding of Indigenous people is rooted in relic and stereotype—buckskin and headdresses—an interpretation that is reiterated by the modern ethnographic zoos of film, literature, advertising, and art. There are still those today who are surprised to learn of our acts of resistance, dating back more than 100 years, to the policies thrust upon Indigenous people. Consigned to a past-tense existence, Native people lived only in the mystical and contrived tableaux of the Old West where Central Casting cowboys and Indians informed everything from Boy Scouts to an entire film genre, popular imagery and art, and even the ethnocultural toponymy of the American landscape. These served as the most potent—and sometimes only—references Americans had to Indigenous people.

It is easy to look at these times and places through the eyes and vernacular of today. For

Andy Warhol
Russell Means, 1976
Polaroid Polacolor Type 108
4¼ × 3⅜ inches
The Andy Warhol Museum,
Pittsburgh; Contribution The
Andy Warhol Foundation
for the Visual Arts, Inc.,
2001.2.1597

ANDY WARHOL

*The American Indian
(Russell Means)*, 1976

Acrylic and silkscreen ink on linen
50 × 42 inches
The Andy Warhol Museum,
Pittsburgh; Founding Collection,
Contribution The Andy Warhol
Foundation for the Visual Arts, Inc.,
1998.1.211

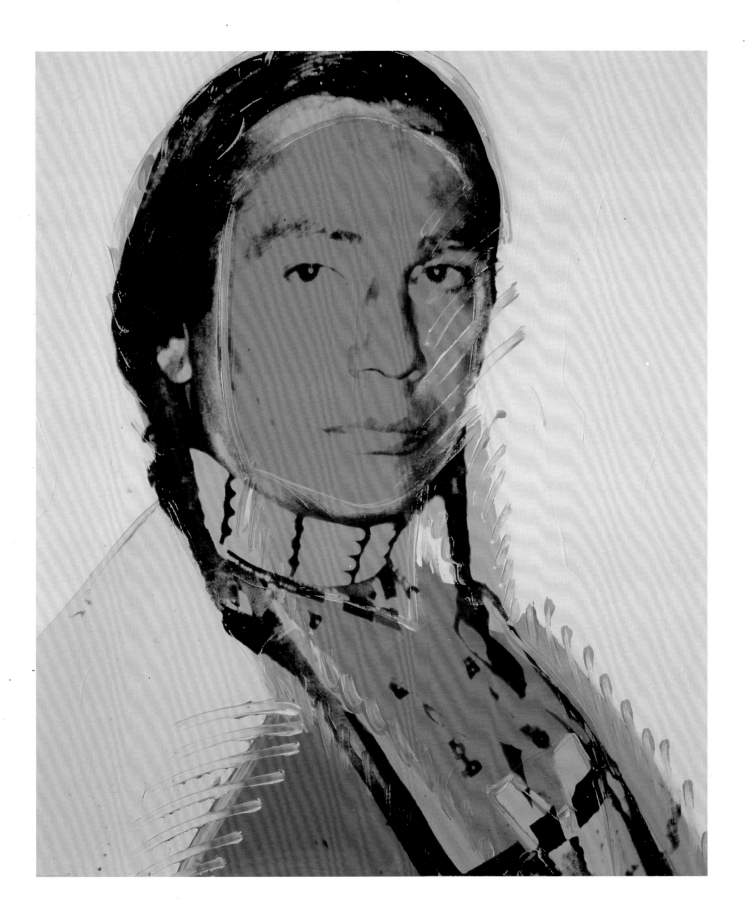

example, Means has been criticized for this image in that it reiterates the trope of the Plains Indian as the only "real Indian." Some context is useful here.

When Means and other members of AIM were the visible force of Indigenous resistance, there were no clear definitions of what a modern Indigenous person looked like, even to Indigenous people. All of these activists were coming out of two life-changing events: boarding schools and the Vietnam War. To gravitate toward something familiar in defining oneself as a Native person is an obvious choice, so eagle feathers, bone chokers, beaded hatbands, and ribbon shirts became de rigueur. But aside from how Natives portrayed themselves at the time, those outside Indigenous culture—particularly those of the hippie era—adopted a similar style based in part on their romanticized perception of Indigenous people and values. It must be considered how incredible this was.

Native peoples were defiantly asserting their identity in the public eye for the first time. Indigenous identity and imagery had always been ascribed *to* us but rarely *by* us. Expressing Indigenous identity through fashion simply hadn't been done before. Although wearing feathers may seem akin to stereotype today, at the time and place of Alcatraz and Wounded Knee, it was an act of defiance. Until passage of the American Indian Religious Freedom Act in 1978, Indigenous people were not allowed to have eagle feathers. Ceremonial wares and dress were technically illegal. For American Indians in the civil rights struggle to openly wear such things, to smudge, and to pray constituted a very real and direct statement of resistance. Examining the historical implications of such things gives a different view on what Means wears in Warhol's image.

Relative to Warhol's work and purpose, certain obvious themes come to mind: consumerism, commodification, the repetition of image, marketing, and advertising. We must consider what someone with Warhol's stature as an artist and pop culture provocateur does to the Indigenous image when he makes it, mass produces several images, and presents them under his mantle. He is, in fact, consuming an image that has been regurgitated in innumerable ways throughout the history of America only to be hijacked by America's culture, which is about consumption. Warhol's portrait of

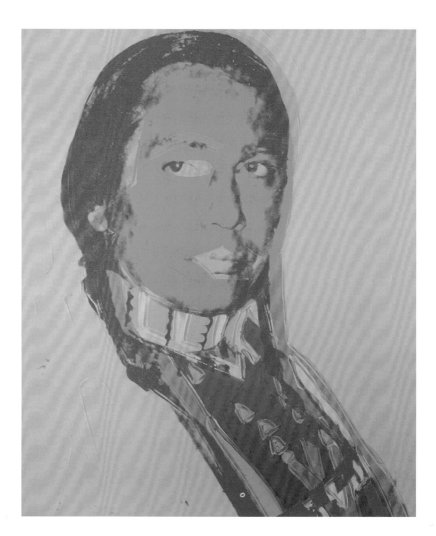

Means, and those of the Native artists R. C. Gorman and Fritz Scholder (pages 73, 77), came at a time of sociocultural relevance, and in this relevance, the image is consumed and produced in a new way, through Warhol's art. What does this say about the Indigenous image?

Ironically, the assertion of Indigenous identity by Indigenous people is a controversial topic. Our image has been wielded by others for over a century, playing an integral part in creating, maintaining, and sustaining the experiment called "America." Through these depictions, Indigenous people are presented in a way that not only suggests subjugation but also positions us as subhuman. To admit American aggression and paternalism toward Indigenous people is to relinquish the greatness of the country and all the propaganda that goes with

Andy Warhol
The American Indian (Russell Means), 1976
Acrylic and silkscreen ink on linen
50 × 42 inches
The Andy Warhol Museum, Pittsburgh; Founding Collection, Contribution The Andy Warhol Foundation for the Visual Arts, Inc., 1998.1.212

it, particularly the historical narratives. Instead, the ubiquity of the Indian image and the identity associated with it are not of our making, thus wresting from us any control we may have had in informing it with authenticity and integrity. Yet this is so commonplace, so much a part of the landscape of our existence, that statements like these seem unfathomable to the average American, making it nearly impossible to process what life has been like for the original people of this continent.

The existence of this image—*The American Indian*—has a troubled history both in what it represents and in the monetary gain that comes from wielding it. While it may be true that Warhol was interested in capturing the image of a leader and modern-day warrior in the Indigenous resistance, the repetition of an already exploited image neuters those intentions and leads to two, often conflicting, results.

At one end of the spectrum, Means's portrait is symbolic of America's need to see, recognize, and hopefully reconcile a modern Indigenous person's place in America. Sovereignty and equality are the calls of Indigenous people, and the American Indian Movement, like the larger civil rights movement in which it was born, is its clarion.

On the other end lies the consumption of the Indigenous image. While its commodification for monetary gain is unconscionable, uglier still is its use in validating the underlying white supremacist ideals associated with the building of the American nation. There is no place for the American Indian to have equality in an America predicated upon the exploitation and fetishization of an entire continent of people. Social relevance aside, Warhol did indeed gain monetarily from Means's image.

While there are no rules about using a subject to create artistic work, ethical considerations become more convoluted where they concern this continent's First People. There has been very little gain for Indigenous people whose image or likeness is constantly replicated by those in the dominant social class. From First Contact to the present, the history of exploitation of land, creation and violation of treaties, and the like all point to a place where the idea of our image is worth more than the people themselves. The very bodies Indigenous people inhabit stand in direct contrast to the romantic nationalism, patriotism, and

imperialism this country is not just built upon but still serves as the nourishing milk. Russell Means spent a lifetime pushing back against that notion. And while his image and legacy are immortalized in art, film, literature, and history, we must also note that even for someone who stood as honestly and unapologetically as he did in the 1960s and 1970s, there was an effort to force his likeness into a narrative that made sense, and not the narrative he and thousands of Indigenous people know, understand, and proclaim even now.

————

Gregg Deal

NOTES

1. Catalogue note, *Contemporary Art Day Auction*, Sotheby's, New York, November 18, 2016, Lot 139: *The American Indian (Russell Means)*.

R. C. Gorman

Warhol created many celebrity portraits—of musicians, film and television stars, politicians, athletes, and royalty—as well as those commissioned by wealthy and influential clients. By the time he made his images of R. C. Gorman, such a portrait was symbolic of a certain kind of status. In addition to a group portrait of 10 artists who were represented by the gallerist Leo Castelli, which included Warhol's own self-portrait, he depicted only a few visual artists: Jean-Michel Basquiat, Joseph Beuys, Keith Haring, Julian Schnabel, Robert Mapplethorpe, Georgia O'Keeffe (page 79), and two of the significant Native American artists who had a presence in the New York City art scene: Gorman and Fritz Scholder (page 77).

By the late 1970s the Navajo artist Rudolph Carl Gorman had achieved impressive popularity. He was one of a handful of Native American artists to receive critical attention in the contemporary art world in addition to the specialized world of "American Indian" art, as it was called then. Gorman's spare, figurative work often depicted women of the Southwest with emotive lines but an economy of design and composition. He never worked within the stylistic restrictions the public was accustomed to expecting from "Indian" artists from the Southwest, which had emphasized ethnographic details of ceremonial life presented at a timeless remove from modern life, with very few pictorial conventions associated with realism and certainly no sensual nudity or expressionistic merging of figure and landscape. Gorman's female figures, drawn from live models, are self-possessed and usually face away from the viewer. Their voluminous robes and blankets obscure the center of mass while hinting at movement and stillness simultaneously. Hands, feet, hairstyles, and the lines describing cheek and eyelid are detailed and beautifully shaded, while fabrics draping the figure are either sparingly outlined in a way that merges

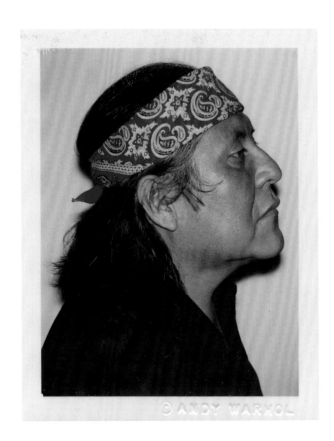

Andy Warhol
R. C. Gorman, 1979
Polaroid Polacolor Type 108
4¼ × 3⅜ inches
The Andy Warhol Museum, Pittsburgh; Contribution The Andy Warhol Foundation for the Visual Arts, Inc., 2000.2.802

figure and ground or dramatically shaded with energy and movement. Both techniques sometimes transform the draping fabric into a monumental landscape. Gorman was not romantically tied to women, but maintained long friendships and was especially inspired by the women in his family. He wrote, "I don't use too many men models. Men are dull until you take their clothes off. They all dress and look alike. Men are beautiful only when naked. But a woman is a mystery, with or without clothes."[1] And indeed, Gorman's oeuvre includes nudes of men, without the draping of blankets or shawls. Like his female figures, the male nudes turn away from the viewer and the strong feet and hands provide the visual weight of the compositions.

Gorman served in the US Navy from 1951 to 1955 and then sought art training in Mexico City, where he was influenced by the works of José Clemente Orozco, Diego Rivera, David Alfaro Siqueiros, Raúl Anguiano, and Francisco Zúñiga.[2] He then ventured to San Francisco, where he worked at the post office and took art classes at San Francisco State

ANDY WARHOL
R. C. Gorman, 1979
Acrylic and silkscreen on linen
40 × 40 inches
Courtesy of Phillips Auctioneers

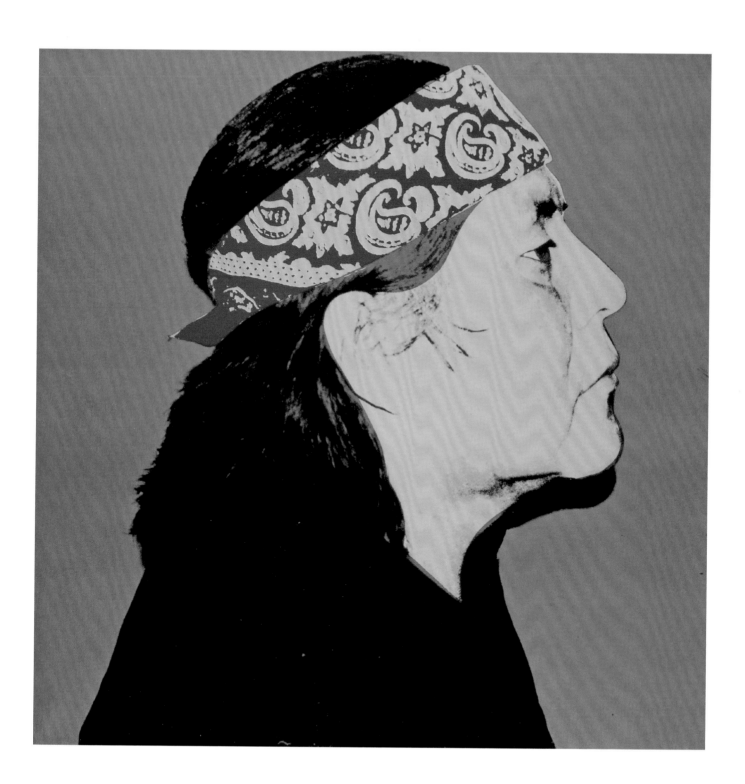

College (now San Francisco State University). He began showing his work in 1963 in San Francisco, then in Taos in 1964. He returned to Mexico City several times in the late 1960s to learn lithography under José Sánchez at his Taller de Gráfica Popular (People's Graphic Workshop). Like Warhol, Gorman was using a collaborative printmaking process, though the methods differed drastically. Warhol's silkscreen technique was primarily a commercial printing process; Gorman's art lithography process using stone matrices for printmaking had dwindled. In fact, there was only one artist's lithography workshop in the United States for much of the 1950s. The establishment of Tamarind Press in Los Angeles helped begin a revival of artist lithography in the country. When Tamarind moved to Albuquerque in 1970, its proximity to Taos, where Gorman had purchased property and opened Navajo Gallery in 1968, led to lithography becoming a more significant part of his work.[3]

Both Warhol and Gorman faced occasional criticism for churning out large bodies of similar work using printmaking processes. Warhol emulated machine-based processes and mass production as a reaction against the mystique of the hand of the artist, even though the accidents produced by human error were very much a part of his work. The screens were printed off-register, with irregular blobs of ink marking the surfaces. Warhol treated commerce itself as art, whereas Gorman treated commerce as a tool to open doors for Native Americans. A basic philosophical tenet of Gorman's was the belief that at least some of his work should be affordable for everyday people,[4] reflecting values associated with his early artistic training in Mexico City, where lithography had been so vital to Mexican sociopolitical artistic practices in the first half of the 20th century.

Gorman was very sociable, known for his hospitality and conviviality. It's uncertain how he and Warhol met, but their social circles overlapped at times; both artists socialized with Dennis Hopper, Arnold Schwarzenegger, Elizabeth Taylor, Tab Hunter, and many of the same collectors and art dealers. Warhol was a consumer of television, movies, newspapers, and magazines, and Gorman had received a fair amount of media coverage, including two PBS documentaries, by the time Warhol created his portraits of Gorman in 1979.

That year the two artists were photographed together at an art opening in New York and exhibited together around that same time. Gorman said about Warhol, "He was a leader. He started trends. He was certainly an original type of person. In person, he looked like a rag doll. He was a very nice person, very quiet, very strange, very weird. He would take me out to dinner and he himself wouldn't eat anything. He'd sit there and watch me gorge myself. . . . He was always trying to drag me to some disreputable bar but I didn't want to stay up that late so I never went."[5] Gorman was an equally original person; his characteristic wardrobe combined brightly patterned Hawaiian shirts and graphically patterned bandanas. He stood out in the New York art scene and was part of the regular circulation of art and entertainment figures between New York and the artistic enclaves of northern New Mexico.

One of the Warhol paintings of Gorman is visible in a photograph of Gorman and Taylor taken at Gorman's home in Taos in 1980. In the photograph he leans in to bestow a kiss on Taylor's cheek. His photographic profile precisely echoes his profile in the Warhol portrait on the wall behind them, down to the wisps of hair escaping from the bandana and spreading across his cheek. Warhol's portraits of Gorman marked Gorman's status as a significant artist. They also represented Gorman as a collector of art, which was something he was known for during his lifetime and is a part of his legacy today.

———

Lara M. Evans

NOTES

1. R. C. Gorman, *The Radiance of My People* (Santa Fe: Santa Fe Fine Arts, 1992), 64.

2. Doris Monthan, *R. C. Gorman: A Retrospective* (Flagstaff, AZ: Northland Publishing Co., 1990), 19–20.

3. Monthan, *Gorman: A Retrospective*, 23–27.

4. Monthan, 137–38. See also Gorman, *Radiance of My People*, 155.

5. Gorman, *Radiance of My People*, 105–6.

Fritz Scholder

Warhol's commissioned portraits provided the artist financial stability and made it possible for him to create less lucrative work, such as his film projects. Although it is tempting to assume the portraits represented vanity items for the sitters and a cash infusion for the artist, they actually document the participation of the sitters within the center of American art and American popular culture. Several portraits of important Native American men made between 1976 and 1980 demonstrate the increasing significance of Native peoples in American public life. Warhol painted a portrait of the American Indian Movement activist Russell Means (Oglala Lakota) in 1976 (page 69), then the Navajo artist R. C. Gorman in 1979 (page 73). The following year, he painted the Luiseño artist Fritz Scholder.

Edmund Gaultney, a gallerist who aided Warhol with portrait commissions in New York and also worked with several galleries in the Southwest, encountered Scholder and his wife at the time, Romona, in Scottsdale, Arizona. Scholder had been exhibiting in New York since the 1970s and made frequent visits there. The connection with Gaultney in Arizona led to Scholder meeting up with Warhol in New York. Romona Scholder described how the portraits came about: "We went out a couple of nights with Andy Warhol and Diana Vreeland, and it was so much fun being around them, being around a person you know you'll never talk to again in your life. That's when Andy took the photographs of Fritz."[1]

Generally, such commissioned portraits were produced from a Polaroid converted to halftone prints on acetate enlarged to the size of the canvas. Warhol would trace large areas onto the canvas and fill them in with paint before the photograph would be silkscreened onto the painted layer.[2] Scholder said about Warhol in 1979, "He has a great sense of humor, takes pop culture and blatantly uses it for his own thing. . . . And has a book coming out of

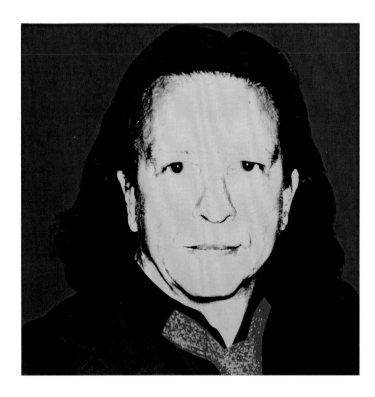

Andy Warhol
Portrait of Fritz Scholder,
1980
Acrylic and silkscreen on canvas
40 × 40 inches
Dallas Museum of Art, TWO × TWO for AIDS and Art Fund, 2018.46.2

his photographs of beautiful people—all of them in the worst poses."[3] Indeed, the photo used for the Scholder portraits might be described as one of the "worst poses." Compositionally, the Polaroids resemble passport photographs. In one portrait, Scholder's face emerges from darkness, hair and blazer scarcely distinguishable from the background. His necktie is red, and a blue outline surrounds each iris. The other portrait, based on the same Polaroid, maintains the appearance of photographic gray scale. The texture of the blazer, stitching of the shirt collar, details of hair, and bright background are preserved. Made in 1980, this pair of portraits came at one of the turning points in Scholder's career, as he contemplated a move to New York.

Scholder had come to painting early in life; as a high school student in the early 1950s, he studied under Oscar Howe, a noted Yankton Dakota artist. Scholder moved in 1957 to Sacramento, where he studied under Wayne Thiebaud, who had an early career background in commercial art in New York but had a smoother transition into the fine art world than did Warhol. Both Thiebaud and Scholder were slowly finding success in the crowded California painting scene when Scholder took up the offer of a faculty position at the newly formed Institute

of American Indian Arts (IAIA) in Santa Fe, New Mexico. Scholder, of mixed German and Luiseño Indian heritage, found himself enveloped within an intertribal social milieu. Because of his upbringing away from the Luiseño lands in southern California and having had non-Indian schooling, Scholder resisted being labeled an "Indian artist." He was also understandably wary of that label because of the stylistic limitations that accompanied it. In fact, he resisted painting "Indians," but found the need for more flexibility on that issue once he began teaching art to young Native Americans at IAIA and discovered that a new means of representation was necessary.[4]

Scholder's paintings revealed that cultural specificity and racial representation broke apart the supposed consumerism of pop art and the individual emotional subjectivity of abstract expressionism. A painting of a beer can or an ice cream cone in the hand of a Native American, by a Native American painter, carries a completely different set of meanings than, for example, Thiebaud's *Girl with Ice Cream Cone* (1963) or Warhol's *Death and Disaster* series (1962–63), which included images of violence, conflict, and death but removed their immediacy through repetition. The supposed vacuousness and banality of Warhol's portraits are revealed as disturbingly fraught with (pop) cultural and racial assumptions when considered alongside Scholder's works. And in fact, works by the two artists had been exhibited together as early as 1973, when one of Warhol's *Flowers* and Scholder's *Indian with Fan* were included in *Taos Collects the Modern since 1900* at the Taos Art Association (now Taos Center for the Arts) Stables Gallery.[5] And in 1980, the year Warhol's portraits of Scholder were completed, they were exhibited along with Warhol's *Flowers* and *Mao* portraits in Scottsdale.[6]

Scholder was sometimes called "the Indian Andy Warhol" by collectors and critics,[7] perhaps because he had such a public presence as an artist, with several documentary television programs about his work aired by PBS and coverage in the regional press. Pop art did not describe Scholder's painterly style or the content of his imagery, but it was a label often appended to his work. Warhol and Scholder both took nonpolitical stances in interviews, but their works resonated with the public because of the controversies their art invoked in relationship

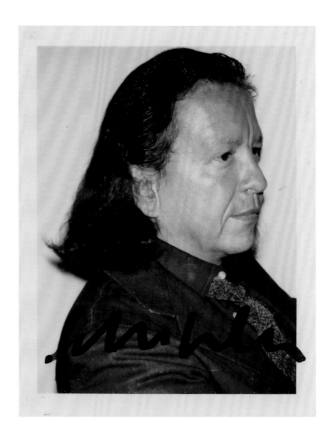

with other images in the public domain. Considering Scholder's work in conjunction with Warhol's reveals the uneasy depths of Warhol's supposed "pop."

———

Lara M. Evans

NOTES

1. Michael Abatemarco, "Self-Determination: Fritz Scholder's 'Figures of Paradox,'" *Pasatiempo* (Santa Fe), July 7, 2017, http://www.santafenewmexican.com/pasatiempo/art/self-determination-fritz-scholder-s-figures-of-paradox/article_f0af0051-217b-5452-93b3-80993c222841.html.

2. Riva Castleman, *The Prints of Andy Warhol* (Paris: Flammarion/Fondation Cartier; New York: Museum of Modern Art, 1990), 32–33.

3. Quoted in "The Warhol Connection," *Arizona Republic*, October 30, 1979, C2.

4. Paul Chaat Smith, "Monster Love," in *Fritz Scholder: Indian/Not Indian*, ed. Lowry Stokes Sims (New York: Prestel, 2008), 28.

5. "Taos Collects the Moderns," *Taos News*, January 24, 1973, 7.

6. Hardy Price, "People and Places," *Arizona Republic*, June 24, 1980, B7.

7. Sims, *Fritz Scholder: Indian/Not Indian*, 13.

Andy Warhol
Fritz Scholder, 1979
Polaroid
4¼ × 3⅜ inches
The Andy Warhol Museum, Pittsburgh; Founding Collection, Contribution The Andy Warhol Foundation for the Visual Arts, Inc., TC285.75

———

ANDY WARHOL
Portrait of Fritz Scholder, 1980
Acrylic and silkscreen on canvas
40 × 40 inches
Dallas Museum of Art, TWO × TWO for AIDS and Art Fund, 2018.46.1

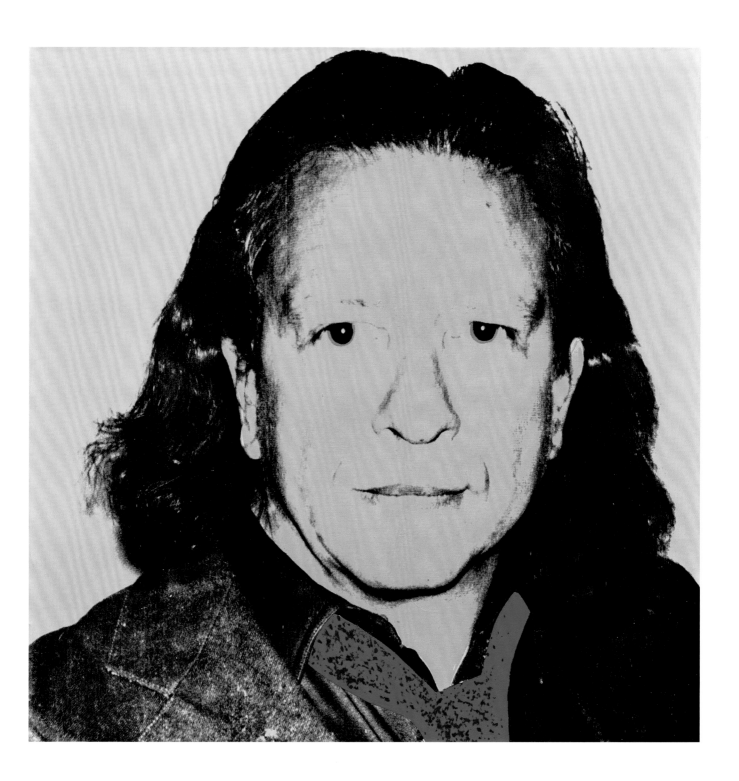

Georgia O'Keeffe

In 1979 Warhol set out to photograph the famous American modernist painter Georgia O'Keeffe. At this time, the 92-year-old O'Keeffe was not actively painting. Living in isolation at her ambient adobe home in Abiquiú, New Mexico, far from the bustle of distractions of urbanity, O'Keeffe defined the image of, and was documented as, the solitary woman dressed in black walking through sagebrush and ominous mesas studded with cedar trees.

The organic and humble icon as seen through Warhol's eyes—seemingly the antithesis of his world of fame and celebrity—had once been a prominent figure in New York City as well. Before O'Keeffe was living in solitude in a remote village above a winding river, she was part of a high-profile New York artist community. The time of her marriage to the photographer and gallerist Alfred Stieglitz saw O'Keeffe connected to a collective of American modernists, including Marsden Hartley, John Marin, and Paul Strand. By the time of Warhol's encounter with her, that life was a memory of what once was, in a world that had changed exponentially.

It is perplexing to see the results of Warhol's finished silkscreens done in diamond dust and some with gold pigment—the effect almost conflicts with the persona of this great American painter. Warhol honors O'Keeffe with these portraits, perhaps in the same way that artists used gold leaf to honor

the sacred figures in Byzantine icon paintings of their time. His focus brings us to some glamorous idea of how we see O'Keeffe, one that is just as recognizable as Warhol's repetitive depictions of celebrities but in her case connected to flowers, bones, and black stones . . .

An artist chooses a path to escape celebrity but is found and then christened with adoration. Warhol seems to have captured O'Keeffe in the light that the art world has created for her, shimmering in reflective splendor and grace.

———

Tony Abeyta

Andy Warhol
Georgia O'Keeffe, 1979
Polaroid Polacolor Type 108
4¼ × 3⅜ inches
The Andy Warhol Museum, Pittsburgh; Contribution The Andy Warhol Foundation for the Visual Arts, Inc., 2000.2.121

Christopher Makos
(American, born 1948)
Andy Warhol and Georgia O'Keeffe, 1983
Gelatin silver print
7½ × 11 inches
makostudio.com

———

ANDY WARHOL
Georgia O'Keeffe, circa 1979

Screenprint with diamond dust on Arches Cover black paper
44¼ × 30 inches
The Andy Warhol Museum, Pittsburgh; Founding Collection, Contribution The Andy Warhol Foundation for the Visual Arts, Inc., 1998.1.2591

Howdy Doody

Nothing affected popular culture in the 20th century like television and films, and no genre was more dominant than television westerns of the 1950s and 1960s. Many acclaimed movie stars got their starts in TV westerns, including Clint Eastwood (*Rawhide*), Steve McQueen (*Wanted Dead or Alive*), James Garner (*Maverick*), and Burt Reynolds (*Gunsmoke*). In 1958 the top 10 Nielsen-rated television shows included 7 westerns, and 47 westerns were broadcast each week in prime time in 1959. Westerns even had their own Emmy category. The craze for television westerns spurred the manufacturing of toys, costumes, board games, and lunchboxes connected to specific shows (see page 18, fig. 3).

Early TV westerns were modeled after western B movies of the 1940s starring Gene Autry, Roy Rogers, and others that were shown in theaters on Saturday afternoons. Some programs came directly from radio to television, such as *The Lone Ranger* in 1949. *The Cisco Kid* was one of the earliest TV westerns in color and one of the first to feature Hispanic actors. President Dwight D. Eisenhower's well-known interest in western novels also played a role in the genre's popularity. Highly respected feature films such as *Red River* (1948), *High Noon* (1952), and *Shane* (1953), highlighting frontline dramatic actors such as Montgomery Clift, Gary Cooper, and Alan Ladd, respectively, also fueled a craze for western furnishings. Warhol owned publicity materials from *The Virginian* (1929), starring Gary Cooper, and from *The Man Who Shot Liberty Valance* (1962), featuring John Wayne and Jimmy Stewart, among many examples.

Warhol recalled trips to the movie theaters on Saturdays as among his most blissful times as a child. B westerns, often running back to back to back for a nickel, composed a large part of his movie-watching fare. Usually set in Texas, Arizona, Oklahoma, or Montana, these stories of derring-do encouraged the escapism and fantasy Warhol would later recollect:

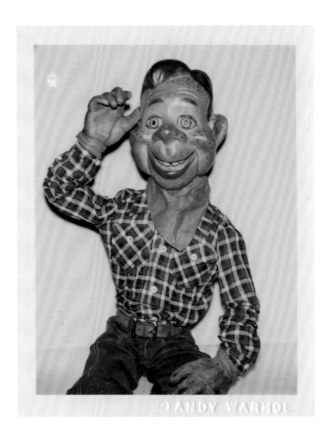

When I was little, I never left Pennsylvania. . . . I used to have fantasies about things that I thought were happening in the Midwest, or down South, or in Texas, that I felt I was missing out on. But you can only live life in one place at a time. And your own life while it's happening to you never has any atmosphere until it's a memory. So the fantasy corners of America seem so atmospheric because you've pieced them together from scenes in movies and music and lines from books. And you live in your dream America that you've custom made from art and schmaltz and emotions.[1]

It stands to reason that Howdy Doody, the puppet and television western "star," today dubbed kitsch, may be the "schmaltz" that Warhol deemed important to conceiving his "dream America."

Begun on radio as a character-voice created by Bob Smith (Robert E. Schmidt) for his show *Triple B Ranch* in Buffalo, New York, Howdy Doody the

Andy Warhol
Howdy Doody, 1980
Polaroid Polacolor 2
4¼ × 3⅜ inches
The Andy Warhol Museum, Pittsburgh; Contribution The Andy Warhol Foundation for the Visual Arts, Inc., 2001.2.1525

———

ANDY WARHOL
Myths: Howdy Doody,
1981
Screenprint with diamond dust on Lenox museum board
38¹⁄₁₆ × 38 inches
Artist's proof 10/30
The Andy Warhol Museum, Pittsburgh; Founding Collection, Contribution The Andy Warhol Foundation for the Visual Arts, Inc., 1998.1.2452.6
Courtesy of Ronald Feldman Gallery, New York

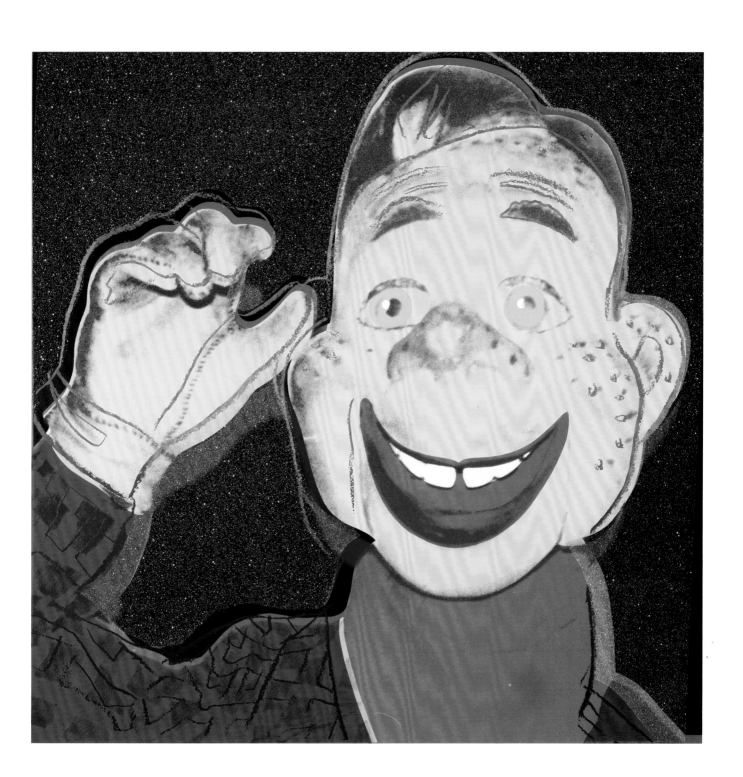

puppet debuted as a television character on NBC's *Puppet Playhouse* in 1947. *The Howdy Doody Show*, with Buffalo Bob Smith as the main character, ran five days per week on television from December 1947 to 1956, when it was moved to Saturday mornings and ran until September 1960. Puppeteer Frank Paris created the original Howdy, but after a dispute with Smith, Velma Wayne Dawson created the Howdy Doody puppet seen on television from 1948 until 1960.

The popularity of *The Howdy Doody Show* created demand for department stores such as Macy's to provide Howdy Doody merchandise. In 1949 Dell introduced the *Howdy Doody* comic book and the first Howdy Doody record was released. The producers offered Howdy Doody wind-up toys, a humming lariat, a beanie, clothing, and other licensed products, and the inevitable knock-offs appeared as well.[2]

Warhol had in his collection a Polaroid and a photographic print of a Howdy Doody puppet dated 1980. Howdy and his handler came to a photo shoot with Warhol, as did other celebrities. Warhol included *Howdy Doody* in his *Myths* portfolio of 1981, along with *The Star*, *The Witch*, *Uncle Sam*, *Superman*, *Mammy*, *Dracula*, *Santa Claus*, *The Shadow*, and *Mickey Mouse*, all highly recognizable figures from American culture and vital to Warhol's childhood remembrances. Warhol used costumed models to create the portraits of Santa Claus, Uncle Sam, and Mammy, but he cast Greta Garbo as *The Star* and himself as *The Shadow*, thus putting his own visage into the portfolio on the same level with other cultural icons.

He enhanced several of these screenprints with diamond dust, including the one of Howdy Doody. This added luminescence conceivably emphasized a particularly intimate connection with a puppet that inhabited Warhol's dream western America.

———

Michael R. Grauer

NOTES

1. Andy Warhol, *America* (New York: Harper & Row, 1985), 8; as cited in Seth Hopkins, "Andy Warhol's *Cowboys and Indians* Suite" (MA thesis, University of Oklahoma, 2005), 6.

2. The National Cowboy & Western Heritage Museum in Oklahoma City has in its collection a "Cowboy Marionette," clearly a Howdy Doody knock-off.

Bighorn Ram

Bald Eagle

Building on his success in marketing Warhol's portfolios *Ten Portraits of Jews of the Twentieth Century* in 1980 and the *Myths* series in 1981, the New York gallerist Ronald Feldman was back at it again in 1983 with the *Endangered Species* series. In addition to such offbeat subjects as the *Pine Barrens Tree Frog* and the *San Francisco Silverspot* butterfly, he included two major icons of the American West: the *Bighorn Ram* and the *Bald Eagle*.

For each of the earlier projects completed with Warhol, Feldman had set the number of edition prints at 200 for each of the 10 images selected. For *Endangered Species* only 150 edition prints were created, perhaps indicating less confidence about sales. Ten prints of each subject were numbered with Roman numerals and donated to various wildlife organizations for fundraising purposes. The original portfolio was displayed at the American Museum of Natural History in New York in 1983; Warhol later expanded the imagery with 15 illustrations for the 1986 book *Vanishing Animals* by Kurt Benirschke.

In the colophon of the published portfolio, the original photograph of *Bighorn Ram* is attributed to S. J. Krasemann, and the source image for *Bald Eagle* is credited to George Galicz.[1] Little is known about either photographer, but each image lent itself nicely to Warhol's manipulation.

Placing the images of endangered species within a square picture plane may have been meant to evoke a television screen for viewers at the time, when screens were in that format. As such, *Endangered Species* may have triggered people's memories of watching the popular television series *Wild Kingdom*, though now the role of the host Marlin Perkins was taken on by Warhol as he selected which animals to focus on for the portfolio.

Concern over animals in danger of becoming extinct was a fairly new concept when Warhol created the series in 1983. The Endangered Species Act was passed by Congress in 1973, and by the 1980s it had not yet achieved the successful recoveries we know of today.

The bald eagle is a natural choice for the series. During the early days of independence, in 1782, the United States chose the eagle as its national symbol. Reportedly, the bald eagle was selected because of its long life, great strength, and majestic appearance, and because it was then believed to exist only on our continent. The population of the species declined drastically in the 20th century due to pesticide usage and habitat loss. Through important conservation efforts, however, the bald eagle was removed from the endangered species list in 2007 in a remarkable comeback. The species continues to be protected under several laws, and it remains illegal to take any part of the bald eagle, its nest, or its eggs without a special permit.

Three species of bighorn sheep are found in the mountainous regions of western North America. The males, or rams, are admired for their large horns that curl around their ears. Warhol's selection of the bighorn sheep continues a centuries-long lineage of great artists who have pictured the majestic creatures in works ranging from petroglyphs found throughout the West to iconic western bronzes and oil paintings.

Faith Brower and Seth Hopkins

NOTES

1. George Galicz is listed in the Internet Movie Database for training and providing the birds for the 1976 film *Shadow of the Hawk*, starring Jan-Michael Vincent.

(following spread)

ANDY WARHOL

Endangered Species: Bighorn Ram, 1983

Screenprint on Lenox museum board
38 × 38 inches
Artist's proof 21/30
The Andy Warhol Museum, Pittsburgh; Founding Collection, Contribution The Andy Warhol Foundation for the Visual Arts, Inc., 1998.1.2466.10
Courtesy of Ronald Feldman Gallery, New York

ANDY WARHOL

Endangered Species: Bald Eagle, 1983

Screenprint on Lenox museum board
38 × 38 inches
Artist's proof 21/30
The Andy Warhol Museum, Pittsburgh; Founding Collection, Contribution The Andy Warhol Foundation for the Visual Arts, Inc., 1998.1.2466.4
Courtesy of Ronald Feldman Gallery, New York

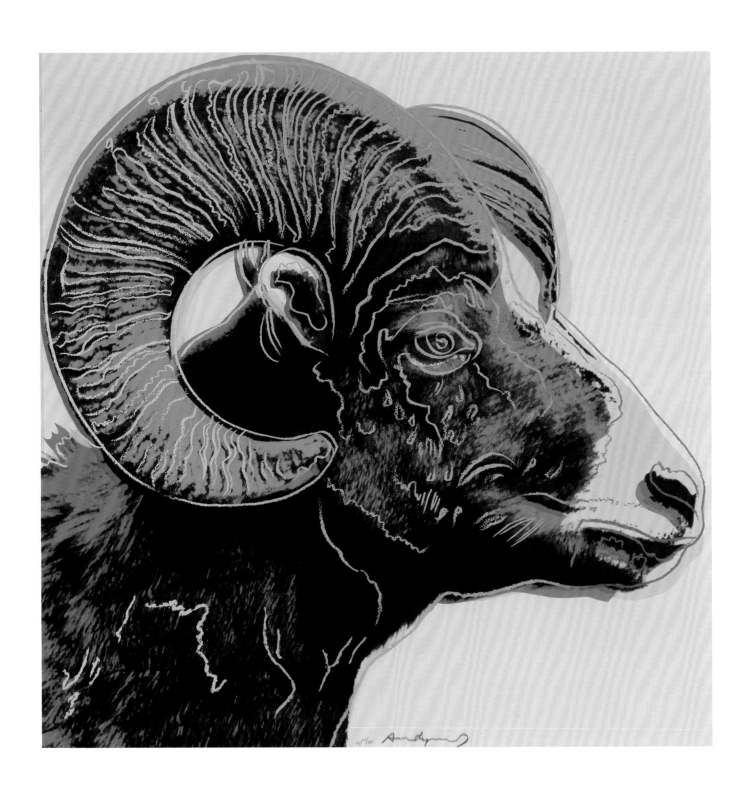

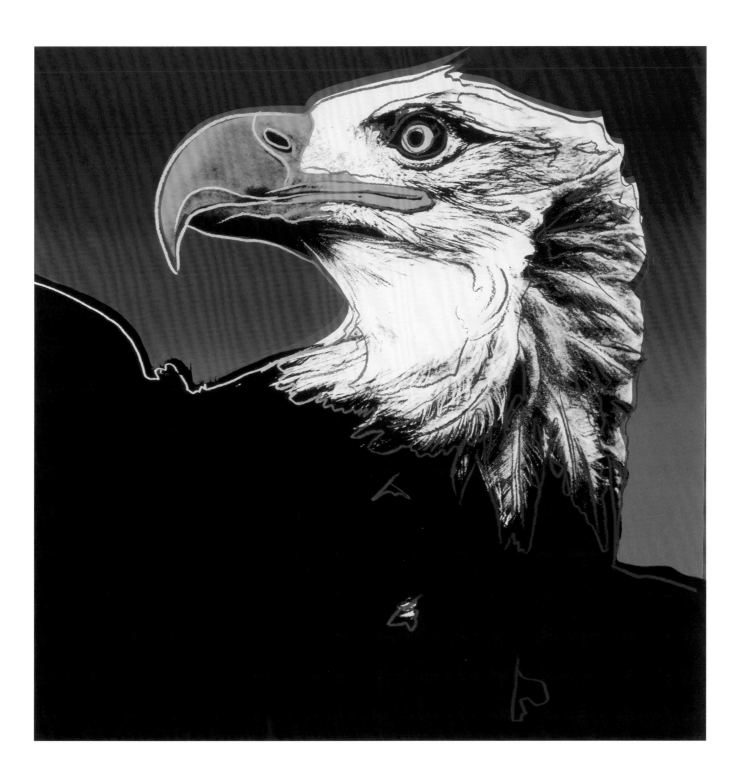

Have Gun Will Shoot

When Warhol produced a series of paintings and drawings of guns and knives in the early 1980s, he had already created a sizable body of work related to mortality. His loosely connected group of *Death and Disaster* works of the 1960s graphically depicts horrible deaths from car crashes, suicide jumps, and the electric chair. A majority of the images were appropriated directly from the front pages of major newspapers. The artist's 1968 series of screenprints dealing with the assassination of President John F. Kennedy, called *Flash—November 22, 1963,* combined images of the places and individuals involved with teletype copy from that day. Both of these series predate the most infamous day of Warhol's first 40 years.

On June 3, 1968, Valerie Solanas, a radical feminist and the sole member of the women's group SCUM, the Society for Cutting Up Men, entered Warhol's studio and shot and critically wounded the artist. Surgeons spent five hours repairing damage to his lungs, spleen, gallbladder, liver, and intestines; his chances for survival were said to be 50-50, and at some point during the surgery Warhol stopped breathing. Although he did survive, Warhol suffered physical complications from these operations, as well as psychological concerns for his own safety, for the rest of his life. He would later lament, "When you hurt another person you never know how much it pains. . . . Since I was shot everything is such a dream to me. I don't know whether or not I'm really alive—whether I died. . . . I wasn't afraid before. . . . And having died once, I shouldn't feel fear. But I'm afraid. I don't understand why."[1]

In the wake of his success as an artist, a rock-and-roll promoter, and a filmmaker, Warhol became a fixture among the social elite in New York. He was invited to all the best parties and made the rounds to all the "in" places. His flamboyance, however, did not endear him to everyone. Beginning in late 1965, Solanas repeatedly asked Warhol to produce a play she had written called *Up Your Ass*. Instead, Warhol gave her a role in his 1967 film *I, a Man,* which depicts a man having sexual encounters with eight women. Solanas's *SCUM Manifesto,* written over several years, envisioned a world without men, calling on "civic-minded, responsible, thrill-seeking females" to "overthrow the government, eliminate the money system, institute complete automation and eliminate the male sex."[2] Asked why she shot Warhol, Solanas simply replied, "He had too much control of my life."[3]

The weapon depicted in *Have Gun Will Shoot* is similar to the .22 snub-nosed pistol that Solanas carried as a backup to the .32 she used to shoot Warhol. While Warhol's earlier *Gun* series includes many images that could be considered in the tradition of still life, this drawing also includes text, much like the art Ed Ruscha was creating around the same time. The words depicted have been interpreted as reflecting on the ubiquity of violence in popular culture and the media, as well as the role of guns in US culture. The message included so prominently on this work of art seems somewhat out of place within the artist's oeuvre and his personal history, since he had looked down the barrel of a loaded gun. The project may have been cathartic for Warhol, an exercise in embracing that which scared him in order to deal with the emotional scars, which were perhaps deeper than the physical ones he showed off in photographs during his recovery.

Seth Hopkins

NOTES

1. Victor Bockris, *The Life and Death of Andy Warhol* (New York: Bantam Books, 1989), 238.

2. Steve Watson, *Factory Made: Warhol and the Sixties* (New York: Pantheon Books, 2003), 312.

3. Bob Colacello, *Holy Terror: Andy Warhol Close Up* (New York: Harper Perennial, 1991), 32.

ANDY WARHOL
Have Gun Will Shoot,
1985–86
Acrylic on HMP paper
30¾ × 40¼ inches
The Andy Warhol Museum, Pittsburgh; Founding Collection, Contribution The Andy Warhol Foundation for the Visual Arts, Inc., 1998.1.2205

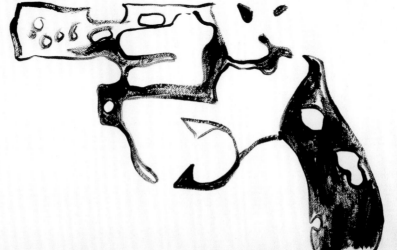

HAVE GUN

WILL SHOOT

Clint Eastwood

Having used his famed silkscreen methods to immortalize various pop culture icons, politicians, actors, artists, athletes, and other celebrities beginning in the early 1960s, in 1984 Warhol painted a series of small-format portraits of Hollywood's frontline actors, including Diane Keaton, Bill Murray, Meryl Streep, and Clint Eastwood.

Eastwood began his film career in uncredited roles in the mid-1950s, before landing a supporting role in the TV western *Rawhide*, which ran from 1959 through 1965. With his leading role in Sergio Leone's "spaghetti western" trilogy—*A Fistful of Dollars* (1964), *For a Few Dollars More* (1965), and *The Good, the Bad and the Ugly* (1966)—Eastwood had his big-screen breakthrough when these films were distributed in the United States in 1967. Through the 1970s he starred with A-list actors such as Richard Burton, Shirley MacLaine, and Lee Marvin in westerns and war movies, and carved out his own niche with his "Dirty Harry" films. By 1967 and the establishment of his own production company, Eastwood began starring in his own films such as *The Outlaw Josey Wales* (1976) and *The Gauntlet* (1977). Warhol owned a publicity still from the latter film, showing the actor torn, dirty, and bloodied, but still determined to right the wrongs.

Through the 1980s Eastwood's film career leveled off, with a variety of roles from a US Marine to a gunslinger to Dirty Harry. The fourth Dirty Harry film, *Sudden Impact* (1983), spawned his trademark catchphrase, "Make my day." By the late 1980s his career seemed headed for its twilight. But his star and directorial turn in *Unforgiven* (1992) garnered a nomination for Best Actor and Oscar wins for Best Picture and Best Director. Though ongoing success at that level proved elusive, Eastwood has continued to surprise with his directorial and acting talents.

Warhol had begun creating celebrity portraits in 1962 using publicity photographs that he then silkscreened using black ink on brightly colored or silver backgrounds, a process he repeated in his actor portraits of 1984. Using his Polaroid Big Shot camera, Warhol directed his sitters through multiple poses, sometimes going through five to ten packs of film. Then he and the sitter would choose the final image, which would be cropped, enlarged, and transferred onto acetate to allow Warhol to silkscreen it onto his hand-painted canvases. Emulating studio still-photography practices, Warhol framed his portraits reverently, thus indicating Hollywood's considerable sway on his life and art.

Eastwood's sitting with Warhol resulted in an almost whimsical depiction of the Hollywood tough guy. The actor's piercing gaze contains none of his famous squint; rather, along with the wry half-smile, it hints at his sense of humor and his vulnerability, which he had intimated in his films *Every Which Way But Loose* (1978), *Any Which Way You Can* (1980), and especially *Bronco Billy* (1980), Eastwood's commentary on the artificiality of theatrical westerns. In Warhol's portrait, Eastwood's famous shock of hair (a character in its own right from his *Rawhide* days through *Gran Torino* in 2008) is lighted from both sides. Moreover, his distinctive nose seems to protrude beyond the picture plane into direct and highly personal communication with the viewer.

Eastwood, not John Wayne, was the first choice to be included in the *Cowboys and Indians* portfolio; the project's backer Kent Klineman felt the younger actor was "more contemporary and potentially more popular than the deceased film veteran."[1] The notoriously private Eastwood refused to give his permission for the use of his image for *Cowboys and Indians*, so the partnership began negotiating with the Wayne estate. Nevertheless, the analysis of Warhol's obsession with reinterpreting the visages of celebrities—while still leaving them

ANDY WARHOL
Clint Eastwood, circa 1984
Acrylic and silkscreen ink on canvas
20 × 16 inches
The Andy Warhol Museum,
Pittsburgh; Founding Collection,
Contribution The Andy Warhol
Foundation for the Visual Arts, Inc.,
1998.1.542

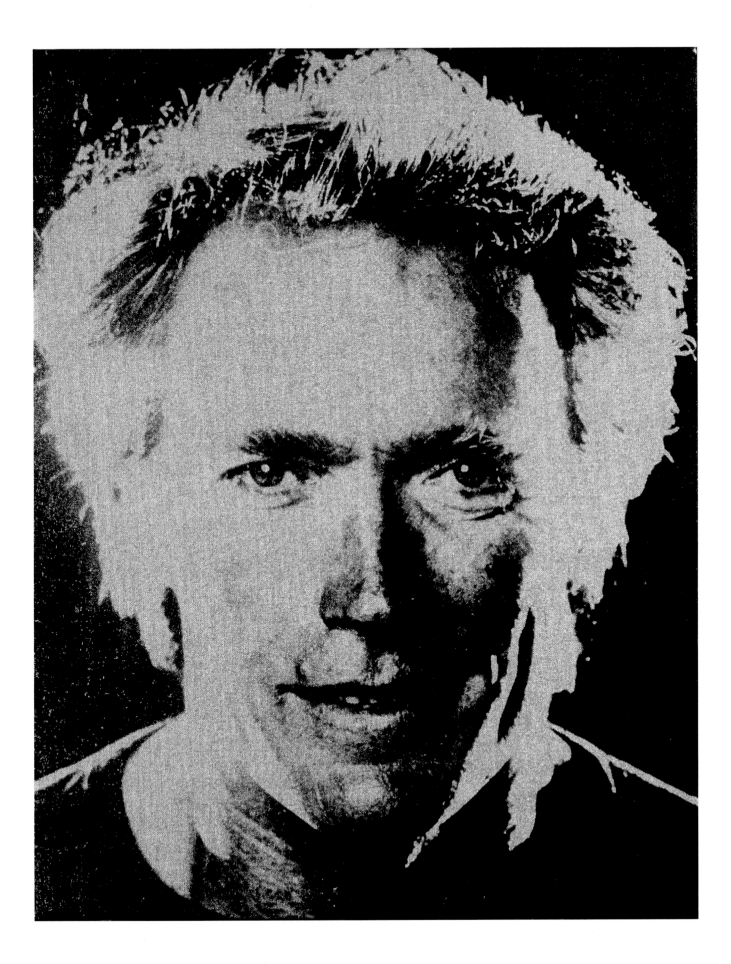

clearly recognizable—takes something of a turn with his own diary entry regarding the wrangling over Wayne's image: "It's a still from a Warner's movie and I don't know why it is even *called* a John Wayne because otherwise you couldn't tell *who* it is."[2] Perhaps *Cowboys and Indians* is less about biography and history and those who "played" them than it is about the roles and types used to construct myths.

As Warhol said, "They always say that time changes things, but you actually have to change them yourself."[3] We have literally watched Eastwood age and change before our eyes on-screen, as he seemed to care little for venturing into the various surgical procedures many Hollywood stars resort to in order to stay "relevant." By allowing us to see his once muscled and sinewy arms become stringy and his hair become a skein across his head, Eastwood became more and more approachable. The actor remained a person, something Warhol captured in his portrait. Perhaps by not including him in *Cowboys and Indians*, Warhol saved Eastwood from the vagaries of becoming a cliché.

———

Michael R. Grauer

NOTES

1. Seth Hopkins, "Andy Warhol's *Cowboys and Indians* Suite" (MA thesis, University of Oklahoma, 2005), 41.

2. Diary entry from May 17, 1986, quoted in Hopkins, "Andy Warhol's *Cowboys and Indians* Suite," 41.

3. Andy Warhol, *The Philosophy of Andy Warhol (From A to B and Back Again)* (New York: Harcourt Brace Jovanovich, 1975), 111.

Indian Head Nickel

After working with western subjects throughout his career, Warhol completed *Cowboys and Indians*, an entire series dedicated to the region, in 1986, just a few months before his untimely death. The series is an anomaly in Warhol's oeuvre. In it he merged iconic portraits of historical figures with depictions of cultural objects, and the portfolio's copublishers, Kent Klineman and Edmund Gaultney, had significant input regarding its subjects and aesthetics. Warhol screenprinted 14 subjects (although he imagined, discussed, and worked through several additional ones that were not more fully realized), ultimately yielding 10 for inclusion in the final portfolio that was released as a set in the fall of 1986. The final portfolio included a colophon indicating an order for the prints that is mirrored here, starting with *Indian Head Nickel*, which appropriated the 1913 five-cent piece designed by the sculptor James Earle Fraser.

Seeking to improve the artistic qualities he felt were lacking in American coinage, in 1904 President Theodore Roosevelt attempted to enlist the help of his friend the American sculptor Augustus Saint-Gaudens. Saint-Gaudens then designed a special medal celebrating the president's inauguration to his second term in March 1905. Before his death in 1907, Saint-Gaudens designed the new cent piece, the eagle ($10) gold coin, and the double eagle ($20). Sculptor Bela Lyon Pratt designed in 1908 the half eagle ($5) and the quarter eagle ($2.50) using a profile of an American Indian allegedly based on a photograph of the Brule Lakota chief Hollow Horn Bear. In 1911 President William Howard Taft's administration turned to Saint-Gaudens's protégé James Earle Fraser to submit designs to replace the Liberty Head nickel, issued in 1883 and designed by the US Mint's chief engraver, Charles Barber. Fraser's designs showing an American Indian in profile on the front, with an American bison on the back, were approved in 1912. Fraser wrote: "I felt I

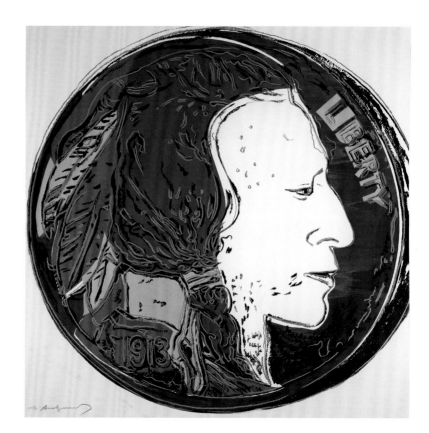

wanted to do something totally American—a coin that could not be mistaken for any other country's coin. It occurred to me that the buffalo, as part of our western background, was 100% American, and that our North American Indian fitted into the picture perfectly."[1]

Born in Minnesota, Fraser grew up in Dakota Territory near the Great Sioux Reservation.[2] He became empathetic to the plight of Native Americans, culminating in his best-known work, *The End of the Trail*, depicting an exhausted rider and horse. It was first modeled in 1894 and later sculpted in plaster at a monumental scale for the 1915 Panama-Pacific International Exposition in

Andy Warhol
Cowboys and Indians:
Indian Head Nickel, 1986
Screenprint on Lenox
museum board
36 × 36 inches
Trial proof 2/36
The Andy Warhol Museum,
Pittsburgh; Founding
Collection, Contribution The
Andy Warhol Foundation
for the Visual Arts, Inc.,
1998.1.2494.13

James Earle Fraser
(American, 1876–1953)
Indian Head nickel/Buffalo
nickel obverse, 1913
Plaster model
⅝ × 4⅞ inches
James Earle Fraser and
Laura Gardin Fraser Studio
Papers, Dickinson Research
Center, National Cowboy &
Western Heritage Museum,
1968.001.02.08.02

Based on a drawing by James
Earle Fraser
1913 Indian Head nickel
Minted copper and nickel
1 × 1 × ¼ inches
Booth Western Art Museum

San Francisco, likely informing his Indian Head nickel design.

Fraser based the design of his nickel on sketches from at least three models,[3] intending to create a composite of what he felt were their best characteristics—in other words, to create what he called a "type." The Old West "type" became something of a buzzword for Fraser's western art contemporaries such as Frederic Remington, Charles M. Russell, and W. Herbert Dunton. For example, Remington's 1901 portfolio *A Bunch of Buckskins* contains chromolithographs of eight pastels by him, with titles such as *Arizona Cowboy*; *A Trapper*; *A Breed*; *Army Packer*; and *A Sioux Chief*. (In effect, Remington's *A Bunch of Buckskins* may be the natural progenitor of Warhol's *Cowboys and Indians*.) By 1938, when his nickel design was being replaced, Fraser identified three models for the Indian Head portrait: Iron Tail (Oglala Lakota), Big Tree (Kiowa), and Two Moons (Cheyenne). Meanwhile, Two Guns White Calf (Blackfoot) and John Big Tree (Seneca) had been claiming to be the model, the latter until his death in 1967.[4]

The first coins to be distributed were given to American Indian leaders present at the February 22, 1913, ground-breaking ceremonies for the National American Indian Memorial at Fort Wadsworth, Staten Island, New York. Due to metal shortages caused by World War I, the memorial, designed by the sculptor Daniel Chester French and the architect Thomas Hastings, was never built. Ironically, there were plans for Fraser's *The End of the Trail* to be cast in bronze and placed on a prominence in San Francisco, but war-related shortages prevented this casting as well.

Warhol's reasons for selecting this image for inclusion in *Cowboys and Indians* remain elusive. As the Pratt designs for the half and quarter eagle gold coins are incused rather than in relief, Warhol may have considered Fraser's relief design more easily transferable to silkscreen. Fraser's Indian Head design was also clearly the basis for the controversial logo of the National Football League's Washington Redskins.

———

Michael R. Grauer

NOTES

1. Roger W. Burdette, *Renaissance of American Coinage, 1909–1915* (Great Falls, VA: Seneca Mill Press, 2007), 224.

2. As noted by Alan L. Neville and Alyssa Kaye Anderson, "Ultimately, the Dawes Act [of 1887] ended what remained of the Great Sioux Reservation, dividing it forever into separate reservations. These newly established reservations were: Pine Ridge, Rosebud, Standing Rock, Cheyenne River, Lower Brule, and Crow Creek." Neville and Anderson, "The Diminishment of the Great Sioux Reservation: Treaties, Tricks, and Time," *Great Plains Quarterly* 33 (Fall 2013): 241.

3. Many of the sketches—in both pencil and clay—maquettes, and plaster-positive castings for the coins are in the National Cowboy & Western Heritage Museum collection.

4. David Q. Bowers, *A Guide Book of Buffalo and Jefferson Nickels* (Atlanta: Whitman Publishing, 2007), 39.

———

ANDY WARHOL

*Cowboys and Indians:
Indian Head Nickel*, 1986

Screenprint on Lenox
museum board
Edition 55/250
36 × 36 inches
Booth Western Art Museum

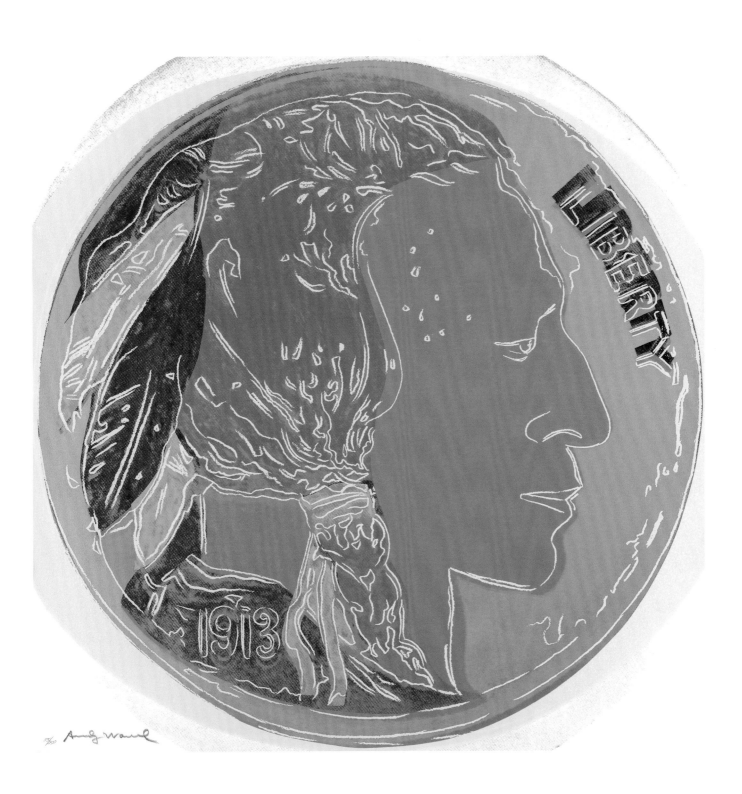

General Custer

Mathew Brady's famous 1865 photograph of General George Armstrong Custer taken during the Civil War provides the basis for Warhol's *General Custer*.[1] One of the most famous western figures of all, Custer had received significant acclaim as a Union cavalryman during the Civil War. His death at the Little Big Horn, however, brought him immortality. The source photograph captures Custer's aloof and confident persona, and Warhol did nothing to dull these qualities in his print. Although the officer's uniform in at least two of the trial proofs is close to its authentic blue color, in the edition print the general is clad in a white coat with gold buttons and insignia. His hat and bandana are bright red. Despite Warhol's claims that his images contained no social commentary, one cannot view this image without considering Custer's historical reputation, which varies from fool to martyred hero depending on the commentator. Warhol would seem to side with the hero worshippers by enrobing Custer in saintly white.

In an attempt to identify the significance of the Custer image and the use of white, along with red and blue, it might be helpful to look at a work created by the Native American artist Fritz Scholder, who was at least an acquaintance of Warhol's. Borrowing the image of the 1899 painting *Custer's Last Stand* by Edgar Samuel Paxson as the basis for his 1976 lithograph *American Landscape*, Scholder employed the same appropriation technique Warhol favored. Using color metaphorically, Scholder depicted Custer at the center of the composition in pure white, surrounded by a blood-red sea and backed by a bright blue sky. He has also rearranged elements from the original painting to highlight several individual figures. It is not accidental that Scholder created his image of Custer in America's bicentennial year of 1976, the same year that Warhol's series *The American Indian (Russell Means)* appeared (page 69).

Warhol may well be indebted to Scholder when it comes to Custer imagery. Both artists used the same Brady photograph of the famous soldier as the basis for portraits. Scholder's use of the image in another work from 1976, *Portrait 1876–1976*, however, predates *Cowboys and Indians* by a decade. Unlike Warhol's rendition, this Scholder work portrays Custer in generally realistic colors. Besides the bizarre, Francis Bacon–inspired alterations of facial features for which he was famous, Scholder added another layer of poignancy to this image with a gestural swatch of red pigment that stretches from the general's throat to the edge of the canvas. "With his bold color and broad brushwork," wrote the collector William Foxley, who owned the painting at one time, "contemporary expressionist Fritz Scholder has used the occasion of the centennial of Custer's Last Stand to dispatch the infamous cavalry general grotesquely once again."[2]

It is a further irony that Warhol used a photograph by Brady in this series in that the latter is credited not only with popularizing photography

Mathew Brady (American, 1823–1896)
General Custer, 1865
Pigment print
11½ × 8 inches
Booth Western Art Museum

ANDY WARHOL
Cowboys and Indians: General Custer, 1986
Screenprint on Lenox museum board
Edition 55/250
36 × 36 inches
Booth Western Art Museum

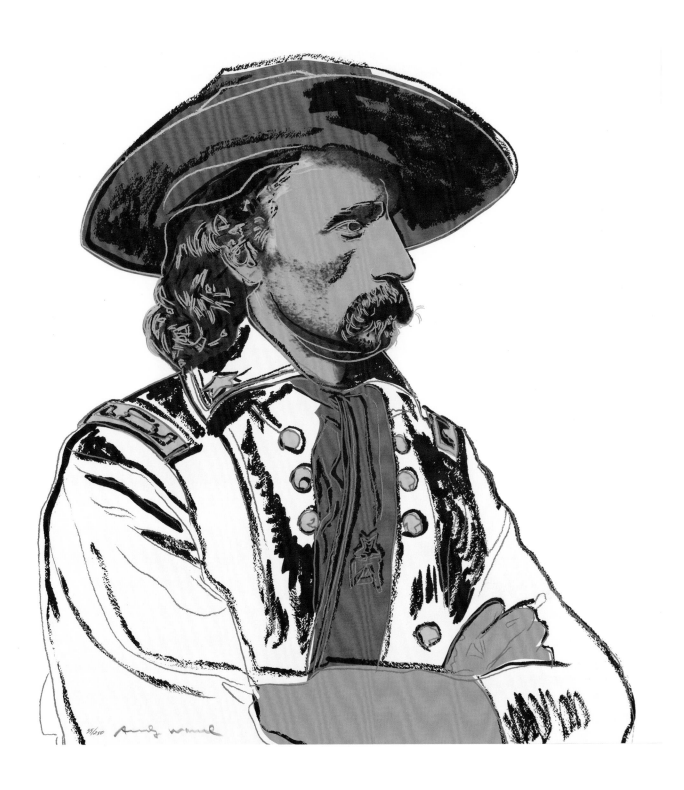

Andy Warhol

among the American people but also with creating a distinctive style of portraiture of famous people. "In the crafting of the mythos of the public portrait," the cultural historian Alan Trachtenberg writes, "which included a public image of the image maker, no American played a greater role than Mathew Brady."[3] Like Warhol, Brady spent much of his time soliciting celebrities from all walks of life to sit for portraits at one of his studios, basking in the reflected glow of the stars he attracted into his sphere of influence. Moreover, the two entrepreneurs ran their businesses similarly. Although neither Brady nor Warhol did all of the physical work required to create the finished products of their studios, the master's touch and name were inescapable.

The depth of Warhol's devotion to the Custer mystique may be reflected in the artist's diary entry for October 3, 1984: "I don't love my name so much. I always wanted to *change* it," Warhol noted. "When I was little I was going to take 'Morningstar.' Andy Morningstar. I thought it was so beautiful. And I came so close to actually using it for my career."[4] Warhol may have encountered the name in connection with Custer, whom many dubbed "Son of the Morning Star." Kent Klineman, the copublisher of Warhol's *Cowboys and Indians* suite, recalled the artist being a "huge Custer fan" and that he lobbied to include the general in the series even though Klineman felt Custer was "an idiot and an overused cliché."[5]

———

Seth Hopkins

NOTES

1. Frayda Feldman and Jörg Schellmann, *Andy Warhol Prints: A Catalogue Raisonné, 1962–1987*, 3rd ed., revised and expanded by Frayda Feldman and Claudia Defendi (New York: Distributed Art Publishers in association with Ron Feldman Fine Arts, Edition Schellmann, and The Andy Warhol Foundation for the Visual Arts, 1997), 273.

2. William C. Foxley, *Frontier Spirit: Catalog of the Collection of the Museum of Western Art* (Denver: Museum of Western Art, 1983), 184.

3. Alan Trachtenberg, *Reading American Photographs: Images as History, Mathew Brady to Walker Evans* (New York: Hill and Wang, 1989), 33.

4. Pat Hackett, ed., *The Andy Warhol Diaries* (New York: Warner Books, 1989), 605.

5. Kent Klineman, telephone interview by author, February 11, 2005.

Northwest Coast Mask

SONNY ASSU AND THE TIME-TRAVELING CANOE

When I set out to write this piece on Catalog Number 14/9626, the mask that inspired Andy Warhol's *Northwest Coast Mask* from the *Cowboys and Indians* series, I thought I had an angle. The original Kwakwaka'wakw mask was shown to me via email, with an incomplete record from the Smithsonian's collection. Incomplete records from that era are not uncommon. Anthropologists and collectors back then were hungrily scavenging the Pacific Northwest Coast for such items. The insidious potlatch ban (1884–1951) was an amendment to the still active Canadian statute called the Indian Act. This amendment made it illegal for my ancestors to practice their culture and way of life. And when I say my ancestors, I'm talking about my grandparents: this is current history with people alive today who can speak to it firsthand. Under the ban, the simple act of gathering to share wealth, knowledge, and culture was forbidden under federal law for 67 years. This "sparked joy" (to borrow an already dated phrase out of 2019's pop-culture lexicon) for anthropologists and collectors, who feverishly gathered up all they could of the people they figured were going to be relegated to lives known only in history books.

I first saw the Smithsonian mask as a small image on the screen of my iPhone. It was catalogued as a man's head with sea lions. "Pffpth. No way is this a man's head with sea lions," I thought as I studied the photo. "This has to be a Sisi'utł! The supernatural two-headed sea serpent who represents duality and balance. Light and dark. Who can transform into a canoe, taking the user anywhere they wanted." Clearly, I was excited, which caused that little light bulb to go off. Indigenous futurisms, pop culture, sci-fi, and time travel all came to mind. "What if the Sisi'utł—as

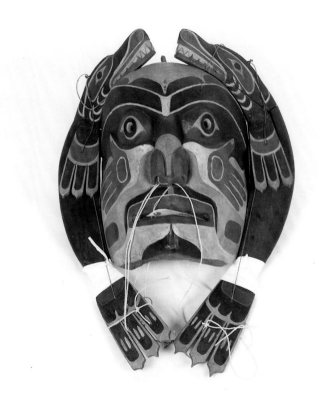

a magical seafaring canoe—transported me to where I want to go? All I need to do is think about *when*, not where, I want to go. Sisi'utł can take me anywhere, so who's to say it can't take me across time?" Simple, right? "I can craft a story around the idea of 'Hey, Sisi'utł, take me to WHEN this mask was made' and BOOM, I'm back in the past, eating k̓awas[1] and chilling with my ancestors. I could find out who made this mask and for whom. What its name is and how it was danced! Duuude," I said to myself, "I could totally find all this out and INFORM the hell out of the Smithsonian."

Kwakwaka'wakw (Kwakiutl)
Mechanical mask with sea lions flanking a human face, 1880–1920
Carved and painted wood, commercially tanned leather, vegetal fiber, iron nails
25 × 18 inches
National Museum of the American Indian, Smithsonian Institution

So I set off toward my computer in the studio to write this epic 1,200-word tale of time travel and eating dried salmon with Warhol and my kinfolk. I grabbed some air, bit my bottom lip, and flopped into my chair. I spun around with my hands landing on the keyboard. After a while, I saved what I had as I became bound by a feeling. I fired up the provided catalog link in my browser to study "man's head with sea lions" one last time. Then I closed my writing app and track-padded over to the file labeled "epic_AW_NWC_timeTravel.txt" on my desktop. With a flu-wheezed sigh, I command-deleted the file and waited for the satisfying sound of crumpling electronic trash.

"It's totes a man's head with sea lions."

Defeated, I decided to run some errands. While at the pet store, I ran into Jake Smith, a fellow community member. Jake is the nephew of Jerry Smith, my mother's ex-husband. In 1986 we were living in East Vancouver, on the top floor of an old duplex. It was a cool house, which would have been more than 100 years old by now if it hadn't been torn down for ugly '90s condos. My room was the loft. Which was pretty badass to a nine-year-old. Previous to that, it was Jerry's work space. Jerry was a carver, and a great one at that. The old jeweler's desk where he would carve bone and other precious materials remained in my room. I was told not to touch it, so sometimes I would sit in the old wooden chair and spin. And more often than not, touch things I wasn't supposed to.

Since Jerry lost his dedicated work space in the house, we'd spend evenings and weekends at Frank Charlie's house. Jerry would carve there with his friends, including his brother Russell. When I wasn't too busy watching cartoons or playing with my Transformers, I would hang out in the carving room. Watching him adze out a rough mask like it was nothing. Adding the details with knives so sharp they made these fragrant little cedar ringlets; occasionally I would try to catch them before they hit the ground. I watched Jerry and his friends carve masks, rattles, and bowls out of cedar. Some, like Catalog Number 14/9626, were mechanical in nature.

"I was talking to my uncle the other day," Jake said. "He was asking about you. Are you still painting?" I haven't seen Jerry in over two decades. The last time I spoke to him on the phone was in

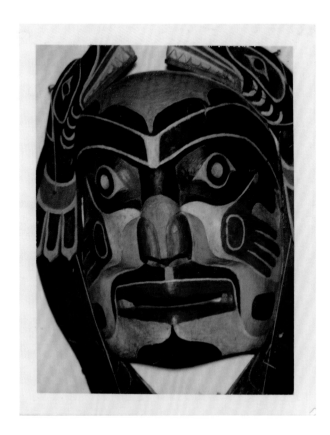

2011. I was just wrapping up my studio in Vancouver at the time, about to set off to Montreal to be with the woman who is now my wife. My mom had called me up and told me that Jerry was looking to speak to me about his upcoming potlatch and gave me his number. I left Jerry a voice message because he never did pick up the phone. He called back a few minutes later. His voice still familiar, but older. "I'm having a potlatch next year," he said. "I want you to come, if you can. I want to give you a name." I told him I was in the process of moving to Montreal, to be with Sara. She was pregnant with the amazing little girl who came to be known as Lily Béa. "I can give her a name too." I was honored.

In the end, I wasn't able to go. Cost and weather put a damper on everything. Sonny of 2019 would travel back in time on the Sisi'utł time-canoe and smack some sense into Sonny of 2011. Wait! Why not just transport me and my family to the day of the potlatch? If the original intent of this story was time travel and Indigenous futurisms, why not dream big!

Andy Warhol
Mask, 1985
Polaroid Polacolor ER
4¼ × 3⅜ inches
The Andy Warhol Museum, Pittsburgh; Contribution The Andy Warhol Foundation for the Visual Arts, Inc., 2001.2.1783

ANDY WARHOL
Cowboys and Indians: Northwest Coast Mask,
1986
Screenprint on Lenox museum board
Edition 55/250
36 × 36 inches
Booth Western Art Museum

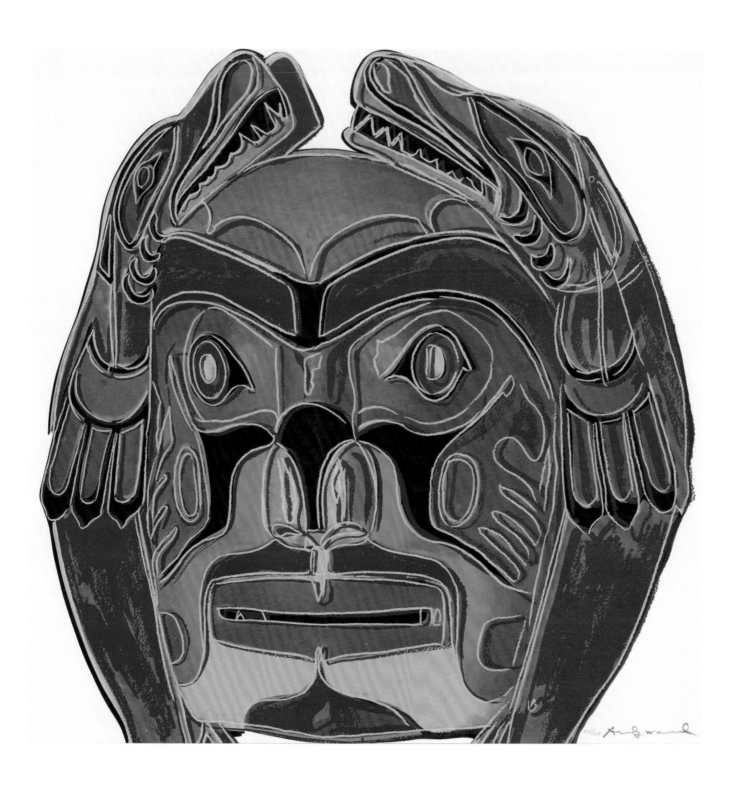

"I'll hit you up on Messenger and get Jerry's number from you," I said to Jake. "I've been meaning to call him for a while now. The last time I spoke to him was in 2011 when he was getting ready for his potlatch. I'd like to catch up and get that name he gave me." "Oh, I have it written down," Jake said with a smile. "I'll send it to you." I grinned from ear to ear.

Eight years is how long I've been waiting to find out my gifted ancestral name and the history behind it. Eight years is roughly the age I would have been when Warhol started his *Cowboys and Indians* series. An ironic and timely coincidence for the direction of this story. Eight years is a drop in the bucket compared to Catalog Number 14/9626's unknown name and origin. One day, cousin, who is totally a man's head with sea lions, you will be known. It's the least I can promise you.

———

Sonny Assu (Ǧʷaʔǧʷadəx̌ə)

NOTES

1. Dried salmon.

Kachina Dolls

TIHU HOPITUY AMUMI PAS HIMU (KATSINA DOLLS IMPORTANT TO HOPI CULTURE)

For Hopi, it is always interesting to see elements of Hopi culture and religion interpreted and explored in diverse artistic expressions. It is even more interesting to view Warhol's interpretation of a *tihu* (katsina doll, Hopi's preferred spelling). It may seem out of context for Warhol to create art representative of an Indigenous people of America, but many of his works explored relationships with diverse elements of American society.

ITAM HOPINAVOTIT EP PIW NAAT HONGVA (HOPI, A LIVING CULTURE)

Hopi is a living ancient Indigenous culture in the southwestern United States that continues to thrive and prosper. Within the context of our religion and ceremonies that continue to be practiced, we actively maintain our collective ancestral history and retain the knowledge of our migrations to and throughout this land through multiple clan histories. Ancestral knowledge is relayed from one generation to the next. Throughout our long history as Hopisinom (Hopi people), we have withstood European conquest, the unjust taking of ancestral lands, and the attempted suppression of our lifestyle, culture, and religion. The burdens and effects of such history continue into the present; even so, Hopisinom have adapted to exist as a living culture within the 21st century and still endeavor to fulfill our responsibilities as stewards of the land according to our ancestral covenant with Máasaw. Today, Hopi religious beliefs live alongside the positive elements of the modern world that Hopi have chosen to adopt in an effort to make our community stronger. Hopisinom have remained stalwart, but not static, and ever mindful of our responsibilities and our religious and ceremonial obligations.

TIHU (KATSINA DOLLS)

Hopi *tihu* are important figures that are representative of spiritual beings known as *katsinam* (plural term for katsina). Each katsina is the spiritual manifestation of an element within the Hopi world. Their songs and sounds become familiar to Hopisinom as they grow and mature within the Hopi religion starting from birth. All Hopi babies will receive a *tihu* as a gift from the *katsinam* during their first year of life, accompanied by prayers for a long, healthy life. Thereafter, the annual ceremonial gifting of a *tihu* to young Hopi girls continues until she completes initiation into the katsina society.

Hopi society is built upon a close-knit community where members are actively involved in the daily cultural life within their respective villages. Each village maintains its own account of how the various clans within the village were established. In the mid-1800s, when anthropologists and researchers began arriving in waves to Hopi villages, the clan groups would instinctively put up barriers to safeguard clan knowledge and ceremonial information. As a result of this practice, past researchers would extract sensitive information from Hopi families under a pretense of friendship. Once this was accomplished, the individual would leave Hopi and never be seen or heard from again.

The arrival of anthropologists, archaeologists, researchers, and tourists within the Hopi villages eventually led to the publication of photographs, ethnographies, and anthropological reports detailing various aspects of Hopi life. All these subsequently generated an appetite in the national and international communities for Hopi cultural materials later termed as "art." The imagery of religious ceremonies unique to Hopi encouraged the curiosity of many travelers utilizing the newly established railroad and later interstate highway. This left the Hopisinom powerless to control both

the information shared with the outside world and how it would ultimately result in the appropriation, commercialization, and exploitation of Hopi culture.

The Hopi language does not have a word for art. The purpose of art is unclear and ever changing, and any artist's work could reference where that person comes from, historically and culturally. Warhol's interpretive production of a *Hopitihu* raises questions about its true purpose and the inspiration behind it, especially in light of how the rights of Hopisinom with regard to their cultural property have been violated time and again.

As a marginalized people within the United States, we historically have had very little power to determine which aspects of Hopi religion should be shared with the world and how. This has led to the appropriation, commodification, theft, and exploitation of both sacred and secular elements of Hopi culture such as the *Hopitihu,* which are now carved by our neighboring tribe or internationally manufactured and adorned with excessive fur, positioned in strange stances, and painted with bright colors, effectively erasing and/or distorting the figure's meaningful and sacred origin.

Because of the continued misrepresentation, exploitation, and abuse of Hopi cultural property, it has become necessary to establish and strictly follow a set of guidelines that will protect the cultural property rights of Hopisinom today and for future generations. To this end, it is the current practice of the Hopi Tribe to require that any institution consult with the Hopi Cultural Preservation Office on plans to display, manufacture, or honor the Hopi people so that we may work together collaboratively to showcase the beauty of the *tihu* or any other aspect of Hopi lifestyle, culture, or religion.

Hopisinom continue to abide by their commitment to Máasaw. There is a certain mind-set one needs to receive and care for a *tihu*. The Hopisinom view a *tihu* as a living entity. Our religious teachings provide guidance to live the ideal Hopi way of life and for our children's future.

———

Gloria Lomahaftewa and Daryn A. Melvin

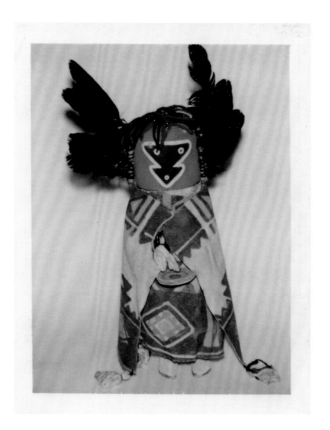

Andy Warhol
Kachina Doll, 1985
Polaroid Polacolor ER
4¼ × 3⅜ inches
The Andy Warhol Museum,
Pittsburgh; Contribution The
Andy Warhol Foundation
for the Visual Arts, Inc.,
2001.2.1782

———

ANDY WARHOL
*Cowboys and Indians:
Kachina Dolls,* 1986

Screenprint on Lenox
museum board
Edition 55/250
36 × 36 inches
Booth Western Art Museum

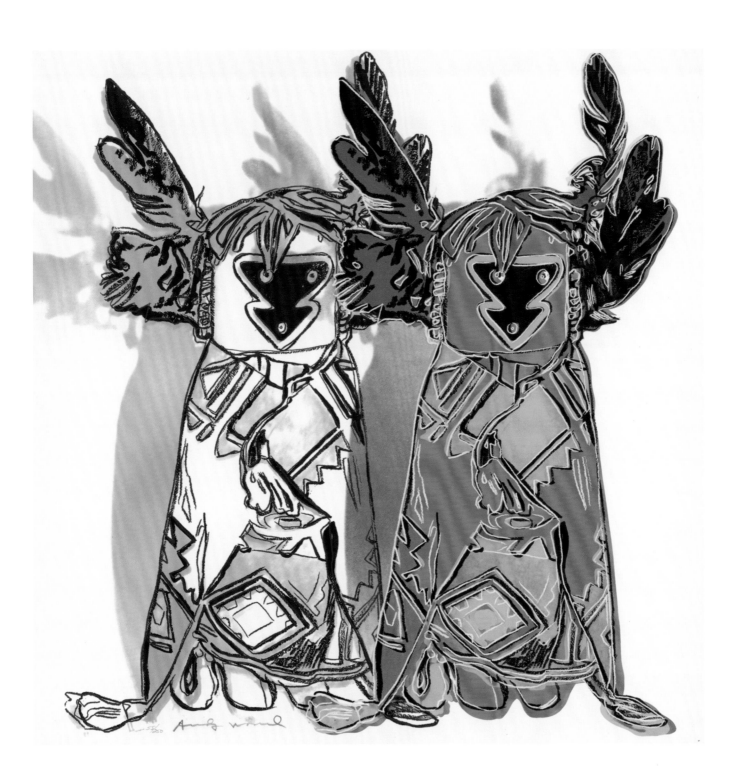

John Wayne

Of the prints that make up Warhol's *Cowboys and Indians* suite, his image of the actor John Wayne stands out in a number of ways. For one, Wayne is the most modern of Warhol's subjects in that series, an icon of the 20th rather than the 19th century. While other subjects in the suite such as Teddy Roosevelt, Geronimo, and Annie Oakley lived into the 1900s, we associate them, or at least their western exploits, with the 1800s, and more precisely with the period we think of as the "Old West." More than any other moment in American history, this era occupies a special place in the American imagination, captivating audiences and inspiring artists and filmmakers for more than 150 years. This suggests another division within Warhol's western pantheon that also leaves Wayne the odd man out: a division between history and myth. Geronimo, Roosevelt, and other subjects in the series, including George Armstrong Custer, actually lived in the Old West. The Duke? He just pretended to be there.

It's ironic, then, that no one person is more closely associated with the Old West in the popular imagination than John Wayne. To millions of moviegoers in the 20th century, Wayne personified the mythical cowboy hero: the man with a code, who did the right thing, whatever the cost. Still today, four decades after his death, the actor's image symbolizes western movie valor.

The basis for Warhol's screenprint of Wayne is a photograph of the actor used in the promotion of *The Man Who Shot Liberty Valance*, directed by John Ford and released in 1962. The movie is framed as the recollection of a celebrated politician named Ransom Stoddard, played by James Stewart. Stoddard has returned to Shinbone, a frontier town in an unnamed western state where, 25 years earlier, he arrived from the East as a young, idealistic lawyer. Asked by the local newspapermen why he's returned to the town, Stoddard shares

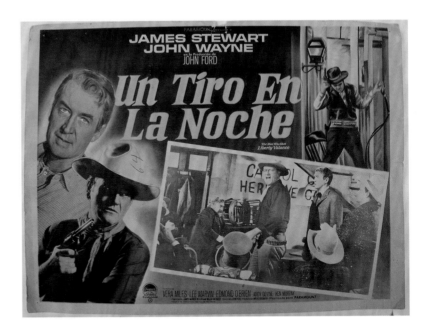

the story of how he teamed with the recalcitrant, experienced gunman Tom Doniphon, played by Wayne, to rid Shinbone of the notorious outlaw Liberty Valance, paving the way for peace, prosperity, and statehood for the territory.

By the mid-1980s, when Warhol was producing *Cowboys and Indians*, *The Man Who Shot Liberty Valance* was already regarded as both a classic of the western genre and the last great film made by Ford. In terms of Wayne's career, the movie falls within the remarkable span between the late 1940s and late 1960s when the actor's star was at its peak. During this period, bookended by his performance as the tyrannical rancher Thomas Dunson in *Red River* (Howard Hawks; 1948) and his Oscar-winning turn as the cantankerous one-eyed lawman Rooster Cogburn in *True Grit* (Henry Hathaway; 1969), Wayne established the persona that defined his career: "the authority figure, the guide for younger men, the melancholy person weighed down with responsibility."[1]

It is not surprising, then, that Warhol would select for reproduction an image of Wayne from this phase of his career. Yet then as now, *The Man Who Shot Liberty Valance* did not enjoy the reputation of some of Wayne's other westerns. *Red River*, *Rio Bravo* (Howard Hawks; 1959), and especially *The Searchers* (John Ford; 1956) all tend to rank higher in appraisals by both critics and fans. Wayne himself

Paramount Pictures (Mexico)
The Man Who Shot Liberty Valance poster, 1962
Ink on paper
13 × 17 inches
Booth Western Art Museum

ANDY WARHOL
Cowboys and Indians: John Wayne, 1986
Screenprint on Lenox museum board
Unique edition print
Edition 217/250
36 × 36 inches
The Andy Warhol Museum, Pittsburgh; Founding Collection, Contribution The Andy Warhol Foundation for the Visual Arts, Inc., 1998.1.2493.1

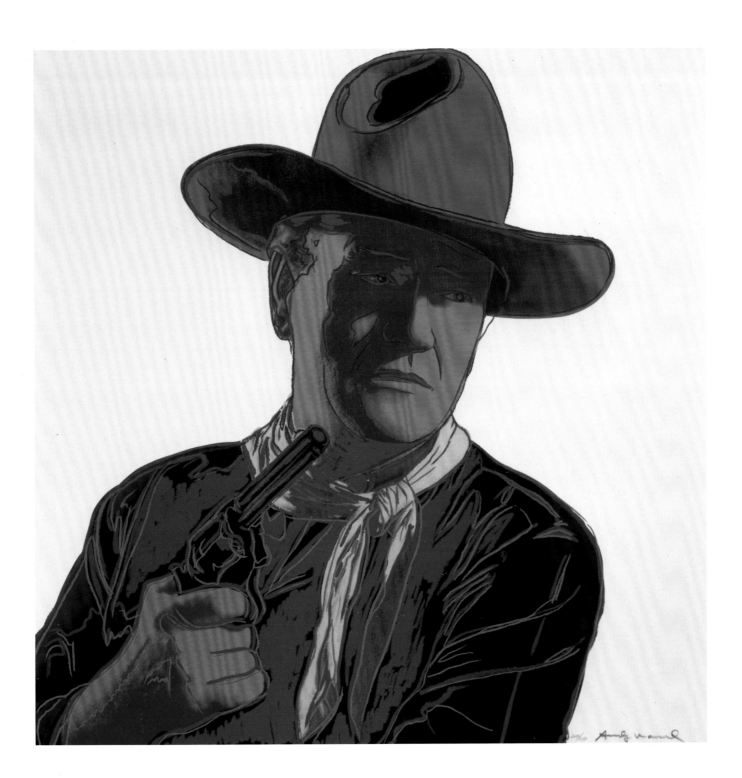

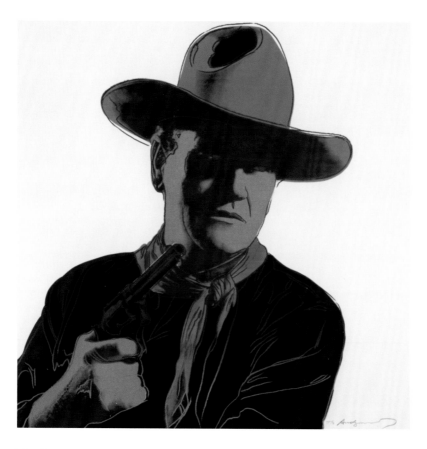

never counted the film among his favorites.[2] So why would Warhol choose this particular image out of the actor's many memorable western roles?

In the course of telling his tale, Stoddard reveals that a famous event from his past, the act upon which he built his entire political career, is a lie. He did not shoot Liberty Valance. Doniphon did. To his surprise, the newspapermen elect not to print the true story. "This is the West, sir," says the newspaper's editor, Maxwell Scott. "When the legend becomes fact, print the legend." This may be the most famous line of dialogue ever spoken in a western movie. It is surely the most suggestive. This is the line critics have in mind when they claim that the western became increasingly self-reflective and sad in the 1960s, reaching a point where neither filmmakers nor their audiences accepted the myths as they had 20 years before. Here we have a character in a western movie explicitly stating that "the West," as most people understand it, is more myth than history.

This is also arguably true of John Wayne, the western genre's greatest star. Wayne always

insisted that he was really Marion Morrison, his given name, and not John Wayne, the stage name first given to him for *The Big Trail* (Raoul Walsh; 1930). At the same time, perceived congruencies between Wayne's on- and off-screen personas gave rise to the durable idea that he was simply playing himself. Some of his famous quotations—"I don't act; I react," for example—and his insistence that sincerity and honesty were keys to his success reinforce this view. This conflation between Wayne and his roles endures, now driven by a marketing imperative that sees licensed merchandise inscribed with lines of movie dialogue—lines that are attributed not to the characters Wayne played, but to Wayne himself. "Print the legend" seems as apt a description as any for what's going on here.[3]

Is this what Warhol is doing? Is he printing the legend? It's tempting to see it this way; to argue that Warhol's neon pop art aesthetics obscure the man beneath the paint, just as the celebrity persona of "John Wayne" eclipsed the actor's true self. Tempting, but too simple.

Andy Warhol
Cowboys and Indians: John Wayne, 1986
Screenprint on Lenox museum board
Trial proof 2/36
36 × 36 inches
The Andy Warhol Museum, Pittsburgh; Founding Collection, Contribution The Andy Warhol Foundation for the Visual Arts, Inc., 1998.1.2494.5

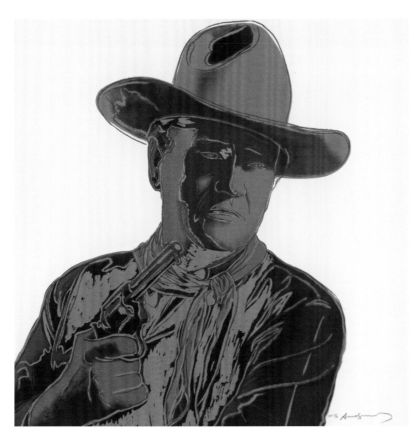

It's natural to assume that a memorable line of dialogue, especially when it appears near the end of the story, when we expect to hear a moral, is the key needed to unlock a movie's deeper meaning. Oftentimes, though, the simplicity of a great line is at odds with the complexity of everything we've seen and heard to this point in the film. "When the legend becomes fact, print the legend" is a great line, but it's not as if, watching the movie, we are privy to only one side of the ledger, or must choose to see either legend *or* fact, myth *or* history. The film gives us *both*.

Likewise, Warhol's print does not erase the presence of John Wayne. Instead, it enhances it in a way that, paradoxically, makes us all the more aware of the actor's photorealistic presence. Just as John Wayne could not exist without "Duke" Morrison, however fluid the boundary between the two may have been, Warhol's print could not exist without the photograph of Wayne.

What *The Man Who Shot Liberty Valance* tells us, and what Warhol's choice of image to reproduce

indicates the artist understood, is that the mythical West is *not* history, but it nevertheless served a larger purpose. In both film and artwork, we are offered not the legend, but the truth.

——

Andrew Patrick Nelson

NOTES

1. Gary Wills, *John Wayne's America* (New York: Touchstone, 1997), 127.

2. See Scott Eyman, *John Wayne: The Life and Legend* (New York: Simon & Shuster, 2014), 545.

3. The careful promotion and protection of Wayne's image by his heirs was already in full effect by the mid-1980s. Wayne Enterprises sued Warhol and his publisher for unauthorized use of the actor's likeness. The suit was settled when Warhol gave a complete set of the *Cowboys and Indians* suite to Wayne's heirs, who later sold the prints, including the one of their father, at auction in 2011. See David Cook, "Kin Sue Over Wayne's Image in Warhol Print," *Los Angeles Times*, December 5, 1986; Hector Cantú, "Memories of a Legend: Ethan Wayne Remembers His Dad, John Wayne," *Southeastern Antiquing and Collecting Magazine* (May 2012), http://www.go-star.com /antiquing/john-wayne -collection.htm.

Andy Warhol
*Cowboys and Indians:
John Wayne*, 1986
Screenprint on Lenox
museum board
Trial proof 11/36
36 × 36 inches
Booth Western Art Museum

Teddy Roosevelt

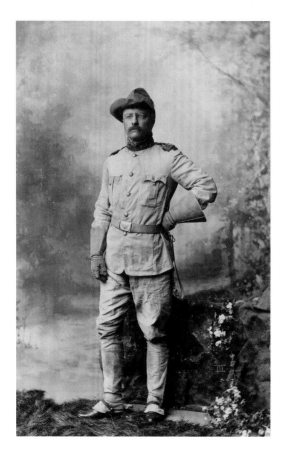

Recent scholarship on Theodore Roosevelt points toward his experiences in the American West as critical to what he became in the American consciousness.[1] As a US president, progressive politician, champion of the preservation of wilderness and wildlife, and purveyor of the importance of being a "man with the bark on," Teddy Roosevelt is today both vilified and monumentalized.

In 1884, crushed by the loss of his mother and new bride on the same day, Roosevelt sought escape, solace, and ultimately restoration in the American West. Roosevelt literally remade himself, from a child stricken with asthma to a young man with great fitness, and he continued to pursue vigor in all things for the rest of his life, usually in nature. His books celebrating these restorative powers, *Ranch Life and the Hunting Trail* (1888) and the multivolume *Winning of the West* (1889–96), were bestsellers at the time, though are highly controversial today. Moreover, both books contributed mightily to the mythology surrounding cowboys that is being reevaluated today.

Roosevelt's pursuit of challenge placed him squarely in harm's way in Cuba during the Spanish-American War, at the head of a suddenly horseless cavalry. His "Rough Riders," made up largely of cowboys from Arizona, New Mexico, and Texas, arrived in Cuba and charged up San Juan Hill on foot, as most of their mounts had been left in the United States due to lack of space on American ships. It is the image of Teddy Roosevelt as a Rough Rider that was selected for inclusion in Warhol's *Cowboys and Indians.*

Warhol's image was drawn from an 1898 George Gardner Rockwood full-length photograph of Roosevelt in his Rough Rider uniform. Using only the head and shoulders from that photograph, Warhol depicted Roosevelt's original khaki uniform in gray, blue, or yellow and his face in a similar range of

colors in trial proofs. In the final version, Roosevelt's uniform is in two different shades of blue, with the collar devices, buttons, and epaulets in a peach color outlined in red, and the face is rendered in black, gray, and blue. Moreover, Warhol changed the position of Roosevelt's eyes from looking to the left of the viewer in the original photograph to gazing at the viewer directly.

According to the portfolio's backer, Kent Klineman, the coloring of Roosevelt's face partly in black was a reference to what Klineman considered a condescending rendering of an African in a sculpture of Roosevelt in front of the American Museum of Natural History in New York.[2] This James Earle Fraser sculpture of 1939 forms the centerpiece for the Theodore Roosevelt Memorial Building, which constitutes the museum's Central Park West entrance. On the building's facade, bas reliefs of animals from around the world flank the Roosevelt statue, while above the columns along a parapet wall stand four life-size sculptures of notable American explorers and naturalists: Daniel

George Gardner Rockwood
(American, 1832–1911)
Col. Roosevelt, circa 1898
Photograph
Library of Congress Prints
and Photographs Division,
Washington, DC

ANDY WARHOL
*Cowboys and Indians:
Teddy Roosevelt*, 1986
Screenprint on Lenox
museum board
Edition 55/250
36 × 36 inches
Booth Western Art Museum

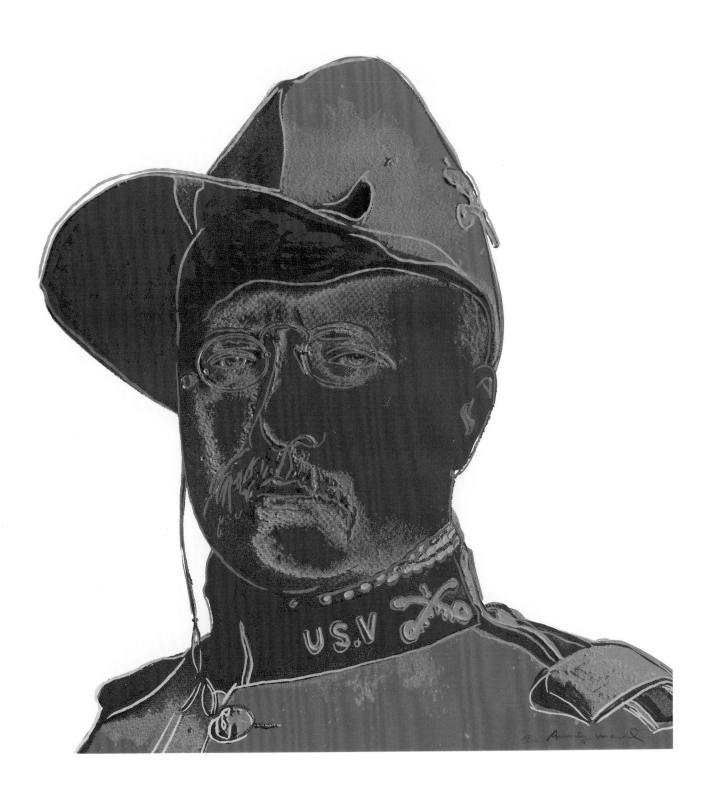

Boone, John James Audubon, William Clark, and Meriwether Lewis, also by Fraser.[3]

Fraser, the sculptor of the Indian Head/Buffalo Nickel (see pages 92, 130), took the Roosevelt likeness from a 1909–10 bust he had done when the US Senate asked Roosevelt to sit for a sculpture for its vice-presidential bust collection. (The Senate rejected this bust and a second one, a 1910 marble, is in the Senate chambers.) Although Roosevelt requested to be depicted without his glasses and with his head thrown back, Fraser convinced him to wear his glasses and captured him with his head tilted forward in his Rough Rider rig. This is the source for the Roosevelt Memorial central figure.

Flanked by a muscular American Indian man in full-feather bonnet and bearing a rifle (representing America) and an equally muscular African (representing Africa) also bearing a rifle, Roosevelt's robust figure (albeit mounted) assumes the triumphal position of conqueror, clothed in cowboy attire (but no hat), complete with revolver and cartridge belt. Though he rides a western stock saddle, the bridle on his horse is clearly military-issue. Fraser references equestrian monuments from the Italian Renaissance[4] but was also acutely aware of the success of his mentor Augustus Saint-Gaudens's 1903 Sherman Monument at Grand Army Plaza in New York City. Furthermore, at the time of the Roosevelt Memorial, Fraser's wife, the sculptor Laura Gardin Fraser, was working on her double equestrian Lee and Jackson Monument (completed in 1948) for the City of Baltimore.[5]

Roosevelt was for the most part egalitarian—and prescient—in his views on the advancement of people of color in America. For example, Roosevelt wrote in rebuttal to Charles H. Pearson's *National Life and Character: A Forecast* (1893) that after generations of repression the descendants of former enslaved people would find themselves "as intellectual as the Athenian" and having gained in economic power would be "strengthened by the fact that they [were] treated as reasonable beings with rights of their own."[6] Yet Roosevelt would prove inconsistent in his views of African Americans.

Also pertinent to discussions of the Roosevelt Memorial's central figures (and, ultimately, of Warhol's *Teddy Roosevelt*) is the presence of African American soldiers during the Spanish-American War. Soldiers from the 9th and 10th Cavalry and

24th and 25th Infantry (Buffalo Soldiers) served with distinction during that conflict alongside members of the 1st Volunteer Cavalry (the Rough Riders) led by Lieutenant Colonel Theodore Roosevelt. After the Battle of San Juan Hill, Lieutenant John J. Pershing wrote, "They [black soldiers] fought their way into the hearts of the American people."[7] Roosevelt commented, "No one can tell whether it was the Rough Riders or the men of the 9th who came forward with the greater courage to offer their lives in the service of their country."[8] In 1899, however, Roosevelt about-faced in his views of black soldiers in Cuba (probably for political reasons), and would also refuse to pardon the accused (likely falsely) African American soldiers at Fort Brown, Texas, following the so-called Brownsville Raid in 1906.

In view of these inconsistencies in Roosevelt's racial assessments, and without knowing Warhol's thoughts on these topics, Klineman's claim about the inspiration for the black coloring in the face of *Teddy Roosevelt* may have merit. On the other hand, the "black and blue" coloring may, rather, speak to Roosevelt's image having been pummeled by the mid-1980s and even today.[9] Consequently, Warhol's *Teddy Roosevelt* is among the most layered and loaded images in the edition.

———

Michael R. Grauer

NOTES

1. Michael F. Blake's *The Cowboy President: The American West and the Making of Theodore Roosevelt* (2018) is the most recent in a series of studies of Roosevelt and his time in the Dakotas. Edmund Morris's *The Rise of Theodore Roosevelt* (1979), David McCullough's *Mornings on Horseback* (1981), Timothy Egan's *The Big Burn: Teddy Roosevelt and the Fire That Saved America* (2009), and Douglas Brinkley's *The Wilderness Warrior: Theodore Roosevelt and the Crusade for America* (2009) all point to the West as *the* place of renewal of spirit not only for Roosevelt, but for all.

2. Seth Hopkins, "Andy Warhol's *Cowboys and Indians* Suite" (MA thesis, University of Oklahoma, 2005), 57.

3. Donald Martin Reynolds, *Masters of American Sculpture: The Figurative Tradition from the American Renaissance to the Millennium* (New York: Abbeville Press, 1993), 91–93.

4. See especially Donatello's *Gattamelata* (1453) in Padua and Andrea del Verrocchio's *Equestrian Statue of Bartolomeo Colleoni* (1483–88) in Venice for the pose of Roosevelt.

5. This sculpture was removed by order of the City of Baltimore in 2017.

6. Edmund Morris, *The Rise of Theodore Roosevelt* (New York: Coward, McCann & Geoghegan, 1979; New York: Modern Library Paperback Edition, 2001), 482–84.

7. Gail Buckley, *American Patriots: The Story of Blacks in the Military from the Revolution to Desert Storm* (New York: Random House, 2001), 146.

8. Buckley, *American Patriots*, 152.

9. The Roosevelt statue in front of the American Museum of Natural History has been dubbed "racist" and splashed with red liquid/"blood" as recently as 2017. See Colin Moynihan, "Protesters Deface Roosevelt Statue Outside Natural History Museum," *New York Times*, October 26, 2017.

Mother and Child

When Warhol's estate went to auction, the sale included the artist's collection of nearly 300 historical photographs of Native Americans taken by various white photographers. There was a particularly large cache of Edward S. Curtis photogravures, suggesting that Warhol was interested in his work, but exactly how he engaged with these images is not clear.[1] Their presence confirms that, whether or not he fully realized it, he was surrounding himself with the stereotypical ways in which Native Americans are portrayed in popular culture and art by non-Natives, some of which he would perpetuate in his own work.

Among the ten published works in Warhol's *Cowboys and Indians* series and the four trial proofs, there are five prints that have Native people as the subject: *Geronimo* (page 119); *Sitting Bull* (page 125); *War Bonnet Indian*, based on an imagined representation of a Native person (page 129); *Indian Head Nickel*, with its fictitious rendering (page 93); and *Mother and Child*. With sales of the portfolio in mind, Warhol and the publishers of this series selected material they thought would appeal to the American public, thereby suggesting that they believed these romanticized representations would have greater sales potential than more contemporary or less stereotypical images of Native people. It is troubling that they selected works that maintain stereotypes and that only two identifiable Native persons were deemed famous or recognizable enough by Warhol and his publishers to be included in the series. Portraits of unknown people are uncharacteristic of Warhol's work; his legacy is based in part on his keen selection of popular subjects. The choice to replicate stereotypes commonly upheld in popular culture is concerning, especially considering Warhol's vast reach.

This image is the only Native woman, as well as the only child, depicted in the series. It was

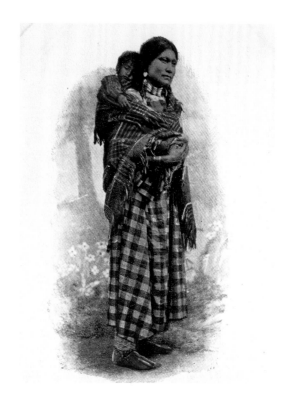

appropriated from a photographic postcard with a derogatory title published by E. C. Kropp Company of Milwaukee.[2] It is worth noting that Warhol selected this vernacular image rather than one of a historically prominent Native woman. Instead of featuring and honoring any of the Native women who have risen to popular consciousness for their knowledge and contributions, Warhol and his publishers opted for a generic image.[3]

Set against a bright white background, the mother faces right while carrying a sleeping child on her back; her facial expression is calm and peaceful, perhaps even tired. Warhol cropped the postcard image to eliminate the woman's black-and-white plaid skirt, which lent her a slightly modern look. By removing a sense of modernity, Warhol situates the

Published by E. C. Kropp Co., Milwaukee
Postcard (detail), circa 1900
Ink on paper
5½ × 3¼ inches
Booth Western Art Museum

ANDY WARHOL
Cowboys and Indians: Mother and Child, 1986

Screenprint on Lenox museum board
Edition 55/250
36 × 36 inches
Booth Western Art Museum

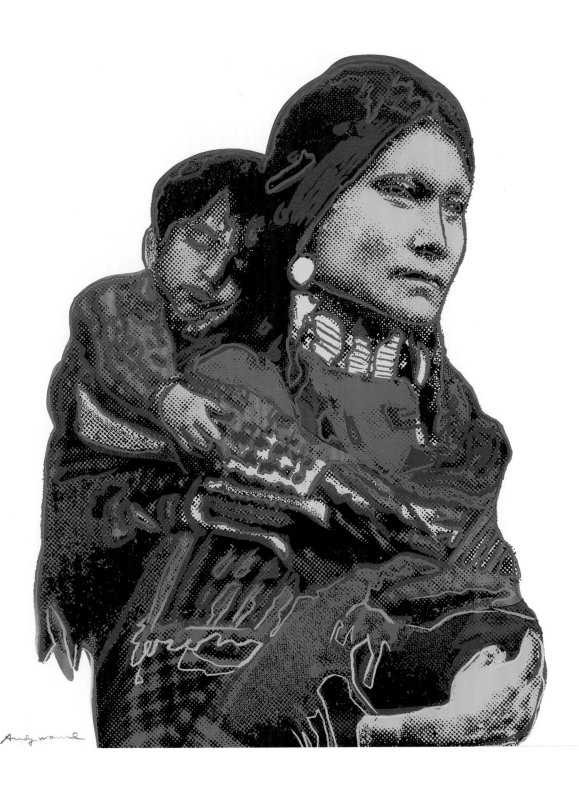

woman in the past, which regrettably is how many non-Native people misrepresent and view Native Americans.

Warhol applied vibrant colors to the print that contrast with the sober mood projected by the subject. The rich red blanket and turquoise shirt that the woman wears are perhaps colorful references to southwestern cultures and arts popular among Warhol and the American public at large. Both mother and child have an imagined pink skin tone that is characteristic of the facial tint that the artist applied in many of the portraits of Marilyn Monroe and Liz Taylor, though here Warhol does not add any bright lip color or eye shadow. The subdued presentation diverges from the sexualized manner in which he portrayed many female celebrities and aligns *Mother and Child* more closely with the artist's portrait of his own mother, *Julia Warhola* (1974).

Warhol had a very close relationship with his immigrant mother, who lovingly cared for him, her youngest son, especially when he was severely sick as a child. Later in life they lived together for nearly two decades after she moved to New York in 1952. Their closeness was somewhat private, and at the time of her death in 1972, he concealed her passing from many of his associates. Warhol completed several posthumous portraits of his mother in 1974. In them, she wears thin glasses and has a subtle smile; her gray hair is tied back. The portrayal is not that of a glamorous or youthful woman, like so many of Warhol's female subjects, but rather an everyday woman.

Similarly, Warhol's depiction of the Native woman reflects her role as a child bearer. Images of mothers are intimate, private, and, as many would argue, psychological. Because this particular woman's identity and story are unknown, we have no idea of her individual social contributions or ingenuity. We can aspire, however, to uncover more information about her through future research, so that her name and achievements can be recognized and celebrated.

———

Faith Brower

NOTES

1. For an in-depth discussion of Curtis's photography of Native Americans, see heather ahtone's essay in the present volume.

2. Postcard object page, Museum of Fine Arts, Boston, website, https://www.mfa .org/collections/object /bright-eyes-squaw-and -papoose-5755533.

3. In 2000 the United States Mint released a gold one dollar coin with Glenna Goodacre's portrait of Sacagawea carrying her infant son Jean Baptiste on her back, similar to the image Warhol appropriated for the *Cowboys and Indians* series, further reinforcing the ways in which American culture continues to project images of American Indian women and children.

Plains Indian Shield

———

Pryor, Montana, is a place far removed, both geographically and culturally, from Andy Warhol's childhood home in Pittsburgh and his infamous existence as a pop artist in the urbanity of New York City. Pryor sits at the foot of a mountain range and creek in southeastern Montana named for a member of the Lewis and Clark expedition, but was known for millennia by the Apsáalooke (Crow) and other Native peoples as their ancestral homeland. The collection records for the shield with its decorated cover (dated 1875) held in the National Museum of the American Indian, the very same that appears in Warhol's 1986 *Cowboy and Indians* series, simply lists: "USA; Montana; Big Horn County; Pryor, Crow Reservation."[1]

This all too sparse description of a museum object is tragically common, as is the fact that the shield, with its sacred and personal imagery, was separated from its original owner along with its intended use and meaning. We know that it arrived at the Smithsonian from collector J. B. Linde in 1909, but not much more. Despite the chasm of separation from its creator and cultural context, the shield resonates today within our artistic and cultural sensibilities as an icon for very different reasons: it manifests on one hand the tragedy of appropriation on Warhol's part, and on the other an awareness of the eternal persistence of what is more than just a "museum object" or "artistic image."

By including the shield image in his *Cowboys and Indians* series, Warhol depersonalized its iconography within his artistic representation of the power and prevalence of American popular culture. The shield appears in a colorful lineup of stereotypically western subjects. Nineteenth-century celebrities representing an exaggerated and mythical past, notably Annie Oakley, George Armstrong Custer, and John Wayne, are presented alongside a Native mother and child who were not

mythical but have a nameless existence. Warhol also included two images of objects with sacred meaning: a Northwest Coast ceremonial mask and a pair of southwestern katsina (known by the common misnomer "kachina") spirit figures.

When Warhol saw the shield and captured its features in a color Polaroid, he may not have known that Apsáalooke and other men of Native cultures produced art on shields when they had dreams and visions. He may not have appreciated that the painted bison, fighting during the rut with elongated penises and protruding tongues, gave their power and protection to the shield's owner. Warhol used silkscreen ink and photographic transfer methods for his own images, but did he ponder the significance of the pigments on hand-tanned bison hide or the tough rawhide shield hidden beneath the decorated cover? Did he celebrate the glory of a single golden eagle feather as a symbol of earned leadership and accomplishment in Native beliefs? Was the fact that the bison is an animal integral to the spiritual and economic well-being of Native cultures lost in the pursuit of aesthetics?

Warhol took the essence of the shield and changed its colors to suit his artistic vision. Simple tones of red, black, and green representing the realms of the earth and spirit worlds morphed into a bright 1980s palette with hand-drawn white outlines that add a striking three-dimensionality, spontaneity, and unmistakable Warhol style. While the practice of making multiple versions of a shield to give to one's relatives for ceremonial use was not uncommon, copying a Native design for the sake of aesthetic indulgence is akin to taking another's spiritual property.

The image was stolen and manipulated, and yet this shield and its visionary impressions persist as an incredible expression of a 19th-century Apsáalooke man and ultimately as a symbol of cultural identity. Ironically, Warhol's attempt

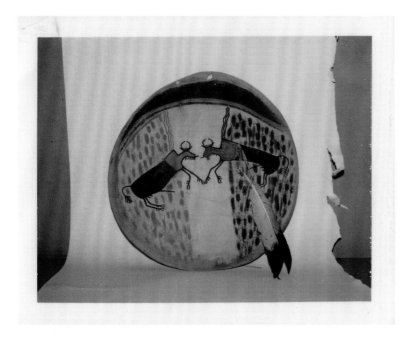

Andy Warhol
Plains Indian Shield, 1985
Polaroid Polacolor ER
3⅜ × 4¼ inches
The Andy Warhol Museum,
Pittsburgh; Contribution The
Andy Warhol Foundation
for the Visual Arts, Inc.,
2001.2.1784

to reduce the shield to an abbreviated cultural
commodity has kept it in our consciousness.
Although the shield resides far from home in the
Smithsonian's National Museum of the American
Indian, the relatives of its creator still live in and
around Pryor and around the nation. The shield
outlives definitions that we are so fond of analyzing
in art historical and museum arenas. It survived
a round with pop art, and although Warhol's
image is vivid, the shield's true self is alive in
spirit and message as a physical manifestation of
Native cultures.

Rebecca West

NOTES

1. Shield and Cover, cat.
nos. 024426.00, 024426.001,
J. B. Linde Collection, National
Museum of the American
Indian collections database,
Washington, DC, 2018.

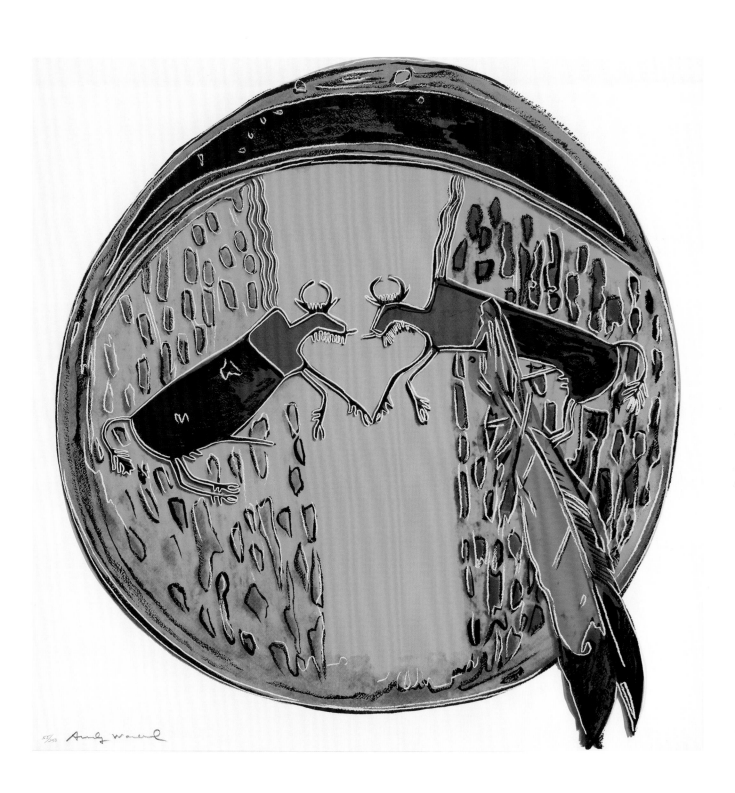

Geronimo

The historian Robert M. Utley writes: "During the two-year period ending at Skeleton Canyon [Arizona], Geronimo's name appeared almost daily in the national press. That he became the best known of all Indian leaders sprang largely from this two-year period. . . . Ironically, despite the atrocities committed during raids on civilians, his fame grew not from war but from his uncanny avoidance of war."[1] Geronimo's fame as a creation of the press was echoed by contemporaries who saw the US Army as playing a part: "I am inclined to the belief that the military have created Geronimo's chieftainship and kept him as such before the public," wrote a clerk at the Chiricahua agency at Canada Alamosa, New Mexico, in the early 1870s.[2]

Although it is unlikely that Warhol knew the extent of Geronimo's fame at the turn of the 20th century, he certainly capitalized on that fame by using Geronimo's highly recognizable visage in *Cowboys and Indians*. Warhol's carefully orchestrated and composed images, despite his insistence that the only thing behind his paintings was "the wall," find particular resonance in the *Cowboys and Indians* subjects.

The composing of Geronimo's 1884 cabinet card by the photographer A. Frank Randall parallels and reverberates with Warhol's *Geronimo* on multiple levels and deserves an unpacking of its layers and its context. Moreover, the selection of the "last resistance fighter" of the reservation period further dialogues with the then-new American Indian "resistance fighter" in Warhol's portrait of Russell Means (page 69).

Born in 1823 into the Bedonkohe band of the Chiricahua Apaches in the upper Gila River Valley in what is now southwestern New Mexico,[3] Goyathlay (also spelled Goyaałé or Goyathle), whose name translates as "one who yawns," is better known by his Spanish name, Geronimo. During his heyday, the Chiricahuas numbered about 3,000. As a youth,

Geronimo came under the influence of the leader Mangas Coloradas (Red Sleeves). Although never a chief, Geronimo was a known leader believed to have spiritual and healing powers. In March 1851 Mexican soldiers killed his mother, his wife, and their three children. He lamented, "I had lost all. I was never again contented in our quiet home."[4]

By 1860 Geronimo lived in the sphere of Cochise, a leader of the Chokonen band of Chiricahuas who made peace with Americans. After the death of Cochise in 1874, Geronimo resumed fighting in 1877. He was arrested in April that year and sent to the San Carlos Reservation in southeastern Arizona, where nearly 5,000 Apaches of multiple bands were crammed.[5] He escaped San Carlos in August 1878, but returned by January 1880, although he never surrendered. Geronimo left San Carlos for Mexico in September 1881, agreeing to return in March 1884.

In May 1885 Geronimo and Cochise's son Naiche bolted from San Carlos with 142 others and headed to the Sierra Madre in Mexico. Nearly a year later, in March 1886, Geronimo and the remnants of their followers attempted to surrender to General George Crook at Cañon de los Embudos, Sonora, Mexico. Mistrusting Crook, they escaped again to the Sierra Madre. Geronimo surrendered for good on September 3, 1886, at Skeleton Canyon, Arizona, to General Nelson A. Miles. Nearly 5,000 US Army regulars and a series of false promises led to their "capture." Sent first to Fort Bowie, Arizona, in September 1886, the 27 Chiricahuas then boarded

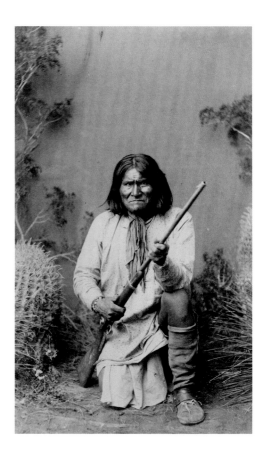

A. Frank Randall (American, 1854–1916)
Geronimo (Goyathlay, 1829–1909), a Chiricahua Apache; full-length, kneeling with rifle, circa 1886
Photograph
Library of Congress Prints and Photographs Division, Washington, DC

ANDY WARHOL
Cowboys and Indians: Geronimo, 1986
Screenprint on Lenox museum board
Edition 94/250
36 × 36 inches
Booth Western Art Museum

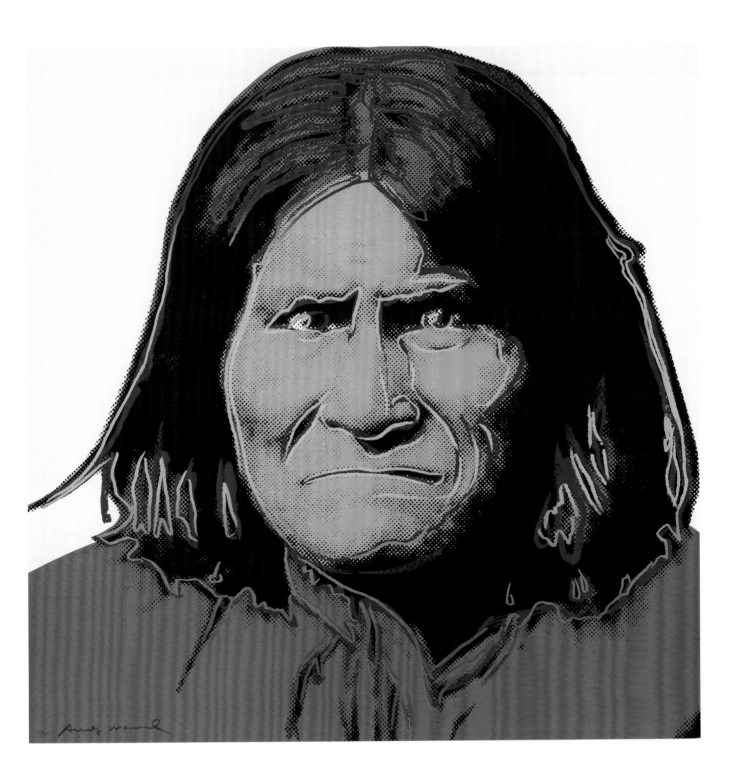

a special train to Fort Marion in Florida. They stopped and were housed for six weeks at Fort Sam Houston, San Antonio, Texas. Along the railroad route, Geronimo cut buttons off his coat and sold them and his hat to souvenir hunters. He also learned to print his name and sold his autograph. Geronimo and his warriors were sent to Fort Pickens in Florida, while the women and children went to Fort Marion. For more than 20 years Geronimo's people were kept in captivity at Fort Pickens; at Mount Vernon Barracks, Alabama; and finally at Fort Sill, Oklahoma.

In 1898 Geronimo was part of a Chiricahua delegation from Fort Sill to the Trans-Mississippi and International Exposition in Omaha, Nebraska, where he was a star attraction and launched his celebrity status. He was also present at the Pan-American Exposition at Buffalo, New York, in 1901, and the Louisiana Purchase Exposition in Saint Louis in 1904. Typically, Geronimo appeared in traditional Apache clothing, posing for photographs and selling crafts such as canes.

Geronimo also appeared with Pawnee Bill's Wild West show and the Miller Brothers 101 Ranch Wild West show. Geronimo, Quanah Parker of the Comanche, Buckskin Charley of the Ute, Hollow Horn Bear of the Brule Lakota, American Horse of the Oglala Lakota, and Little Plume of the Blackfeet rode horseback in President Theodore Roosevelt's 1905 inauguration parade. A prisoner of war for 23 years, and never allowed to return to his homeland, Geronimo died in Oklahoma.

When Randall came to the San Carlos Reservation in 1884 to photograph Geronimo and other Native leaders, he placed them "against a contrived background of desert plants."[6] Randall posed the Apache leader as a warrior. Geronimo awkwardly holds a rifle—probably a cut-down US Model 1855 service rifle and a studio prop much like the barrel cactus. He grips the rifle by the barrel with his left hand and just forward of the action in his right, in a manner that would be unnatural to anyone familiar with firearms. This unfireable position of the rifle may speak to Geronimo's agreement to ostensibly walk the "white man's road." He wears a calico shirt, a breechcloth, a bandana around his neck, and at least one bracelet. Oddly, while Geronimo sports Apache boots, he also appears to be wearing spurs. His "costume" speaks

to having acquiesced to his new life as a symbol. Yet Geronimo's facial expression is anything but submissive. Consequently, more recent scholars have interpreted this photograph very differently.

John M. Coward in his 2016 *Indians Illustrated: The Image of Native Americans in the Pictorial Press* reports that an anthropologist felt that Geronimo understood the power of the photograph and affected his own pose of defiance, "one of the few illustrated Indian portraits to show an Indian leader as an overtly hostile warrior." Coward also deduces that Randall attempted to capitalize on the American public's interest in the "vanishing race," noting that as "the Indian threat in the West was fading, photographs of Indians—especially angry or hostile Indians—became interesting to many Americans as vivid symbols . . . [and] Randall was prepared to cash in on Geronimo's continuing appeal."[7] Ironically, Geronimo himself, and later Warhol, would cash in on this "continuing appeal."

Consequently, it is on Geronimo's face only that Warhol focused, sans all the costume accoutrements seen in the remaining *Cowboys and Indians* portraits. In this respect, *Geronimo* has more in common with Warhol's depictions of Clint Eastwood (page 89), Marilyn Monroe, Mickey Mouse, and Elizabeth Taylor as recognizable symbols of America than with the other sitters in *Cowboys and Indians*.

———

Michael R. Grauer

NOTES

1. Robert M. Utley, *Geronimo* (New Haven: Yale University Press, 2012), 220.

2. Cited in Doug Hocking, *Tom Jeffords: Friend of Cochise* (Guilford and Helena: Twodot Books, 2017), 114.

3. Biographical information, including Geronimo's disputed year of birth, is taken from Utley, *Geronimo*.

4. Utley, *Geronimo*, 27–28.

5. Paul A. Hutton, *The Apache Wars: The Hunt for Geronimo, The Apache Kids, and the Captive Boy Who Started the Longest War in American History* (New York: Crown Publishers, 2016), 224–25.

6. Angie Debo, *Geronimo: The Man, His Time, His Place* (Norman: University of Oklahoma Press, 1976; new edition, 1982), 210.

7. John M. Coward, *Indians Illustrated: The Image of Native Americans in the Pictorial Press* (Champaign: University of Illinois Press, 2016), 40–41.

Annie Oakley

Warhol's image of Annie Oakley, the famous female sharpshooter with Buffalo Bill's Wild West show, is based on a photograph by an unknown photographer, included as the frontispiece in the 1927 biography *Annie Oakley* by Courtney Riley Cooper.[1] Born Phoebe Moses in Ohio in 1860, Oakley defeated the top male shooters of her day and traveled the world with Buffalo Bill, amazing audiences with her shooting prowess.[2]

Oakley is shown in full profile, her hat well back on her head. The marksmanship medals on her jacket—representing shooting contests she had won around the world—provided an abstract design around which Warhol experimented during the trial-proofing process. In the regular edition prints, her skin is starkly pale, with only a hint of red lipstick decorating her face. Her clothing and medals appear in various shades of pink and purple. Warhol experimented with reversing the image in the trial proofs, which show a fairly narrow range of skin color and overall palette. In the edition print, Oakley faces to the viewer's left.

Warhol's decision to include a strong female figure in this portfolio suggests a departure from the traditional male-dominated view of western American history and foreshadowed the development of the academic movement known as the New Western History only a few years later. Oakley's inclusion, however, may also have been the result of her reputation being kept alive by popular culture treatments of her legacy. The poet and critic Bill Berkson believes her story would be all but lost to history without Irving Berlin's Broadway musical *Annie Get Your Gun* or the 1950s television series of the same name, based loosely on her life.[3]

Oakley's image provides an interesting comparison with Warhol's most famous depictions of women: Marilyn Monroe, Elizabeth Taylor, and Jacqueline Kennedy. Although all four achieved worldwide fame, the power resident in the images of the latter group is due to the tragic events that befell them. Monroe died young, at the height of her celebrity; Taylor had a number of serious illnesses, not to mention multiple husbands; and Kennedy endured the shocking assassination of her husband, President John F. Kennedy, with grace and poise. Oakley, on the other hand, personifies the Cinderella story, rising from poverty to fame and fortune. When Oakley beat the champion marksman Frank Butler in a shooting contest, she also won his heart, and the two married several years later.[4] Rather than presenting "pride before the fall" or "grace under pressure" as seen in the images of Monroe, Taylor, and Kennedy, the *Annie Oakley* print captures the image of a young woman balancing the confidence of succeeding in a perceived man's domain with delicate femininity.

Throughout his career Warhol carried a camera wherever he went and was constantly shooting pictures. His photo shoots with portrait subjects were an important part of his working method. In *Cowboys and Indians*, however, it would be other people's photographs that would provide the source material for the majority of the subjects. Not long after Warhol's death, one critic saw the irony of a relatively new artistic medium in the 1800s chronicling the end of an era, something the artist himself might also have recognized: "Most of the portrait images in the series have come down to us by way of 19th century photography, a technology that at the time was well suited to capture the last gasps of the American Wild West."[5] In the hands of Warhol and his helpers, these gasps gain new life and become accessible to new generations.

Seth Hopkins

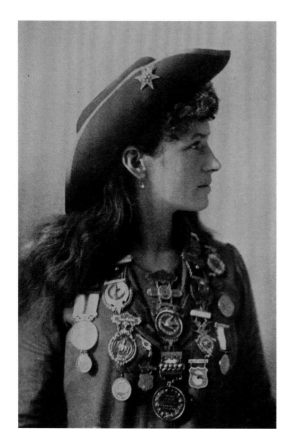

NOTES

1. Frayda Feldman and Jörg Schellmann, *Andy Warhol Prints: A Catalogue Raisonné, 1962–1987*, 3rd ed., revised and expanded by Frayda Feldman and Claudia Defendi (New York: Distributed Art Publishers in association with Ron Feldman Fine Arts, Edition Schellmann, and The Andy Warhol Foundation for the Visual Arts, 1997), 273.

2. Glenda Riley, *The Life and Legacy of Annie Oakley* (Norman: University of Oklahoma Press, 1994), 3.

3. Bill Berkson, *The Sweet Singer of Modernism and Other Art Writings, 1985–2003* (Jamestown, RI: Qua Books, 2003), 248.

4. Riley, *Life and Legacy of Annie Oakley*, 18.

5. Nicole Plett, "Andy Warhol's *Cowboys and Indians*," *Southwest Profile*, November–December 1989, 32.

Unidentified photographer
Annie Oakley, 1927
Pigment print
6½ × 4¼ inches
Booth Western Art Museum

Andy Warhol
Annie Oakley, 1986
Graphite on HMP paper
32 × 24 inches
Booth Western Art Museum

ANDY WARHOL
Cowboys and Indians: Annie Oakley, 1986

Screenprint on Lenox museum board
Edition 55/250
36 × 36 inches
Booth Western Art Museum

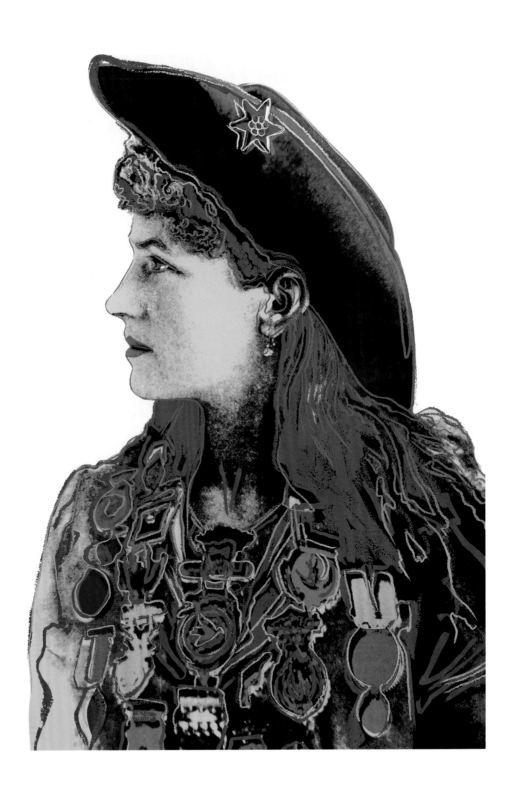

Sitting Bull

In an autobiographical pictograph made in 1882, Sitting Bull is riding a red horse while wearing an elaborate war bonnet with a dozen feathers and five ermine tails.[1] He carries a green shield depicting a thunderbird and with four feathers dangling from its perimeter; he has just thrown a spear aimed at an Apsáalooke man. This self-portrait depicts Sitting Bull's war deeds prior to his illustrious defeat of the United States Army under the leadership of Lieutenant Colonel George Armstrong Custer at the Battle of the Little Bighorn in 1876. It is a stunning drawing in graphite and colored pencil that shares intimate details of Sitting Bull's life that are often lost in staged portraits, like the one that Warhol appropriated for his own rendition of the Hunkpapa Lakota leader.

It is rather surprising that the publishers did not select Warhol's portrait of Sitting Bull for inclusion in the final *Cowboys and Indians* portfolio. Tatanka-Iyotanka, better known as Sitting Bull, is one of the most recognizable Native American men of all time. Perhaps his legendary accomplishments are not even as well known as his image. Although his anglicized name is not a true translation of Tatanka-Iyotanka, which more properly translates to "Buffalo Bull Who Sits Down,"[2] Sitting Bull has been a household name for more than a century. So why did Warhol's publishers exclude *Sitting Bull* from the final portfolio? It remains unclear and is especially problematic since an image of his adversary, *General Custer*, was included (page 95), demonstrating how the legends of these famed warriors symbolically compete for recognition more than 100 years after the historic battle.

Warhol's image of Sitting Bull, a symbol of Native strength and resilience, brings vibrant colors to a man who is often seen only in black-and-white photographs. For the print, Warhol appropriated one of the most familiar images of Sitting Bull, taken in 1881 by Orlando S. Goff, a western frontier

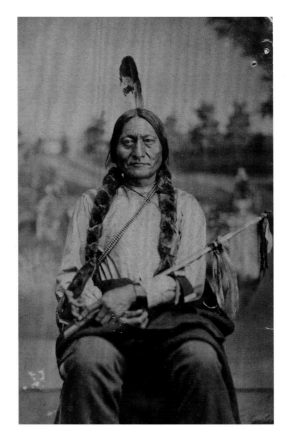

Orlando S. Goff (American, 1843–1916)
Sitting Bull, 1881
Photographic print on cabinet card
6¼ × 4¼ inches
Tacoma Art Museum, Museum purchase with funds from Liliane and Christian Haub, 2019.7

photographer. Goff had a studio in Bismarck, in the Dakota Territory, about 200 miles from the Canadian border. It is not clear whether the portrait was staged there or farther south at Fort Yates.[3]

Goff's photograph was not the first portrait of Sitting Bull. The artist and journalist Jerome Stillson created an early portrait, which appeared in *Harper's Weekly* on December 8, 1877, just a year and a half after the Battle of the Little Bighorn and 13 years before the passing of the remarkable leader. Stillson's portrait is a pencil sketch of a man with dark hair that falls loosely past his shoulders. He wears a fur hat and a collared jacket with a button at the neck. His dark arching eyebrows, prominent nose, and sincere gaze are combined with otherwise soft features and a slight upturn of the mouth that makes it appear as though he is almost smiling. This youthful image is in contrast to the older man that Goff recorded just four years later.

When Goff photographed Sitting Bull in 1881, it was a profound time in the leader's life. He had just recently surrendered to the US Army and was on

ANDY WARHOL
Cowboys and Indians: Sitting Bull, 1986

Screenprint on Lenox museum board
36 × 36 inches
Extra, out of the edition
Designated for research and educational purposes only
Jordan Schnitzer Museum of Art WSU, Pullman, Washington, 2013.9.27.9

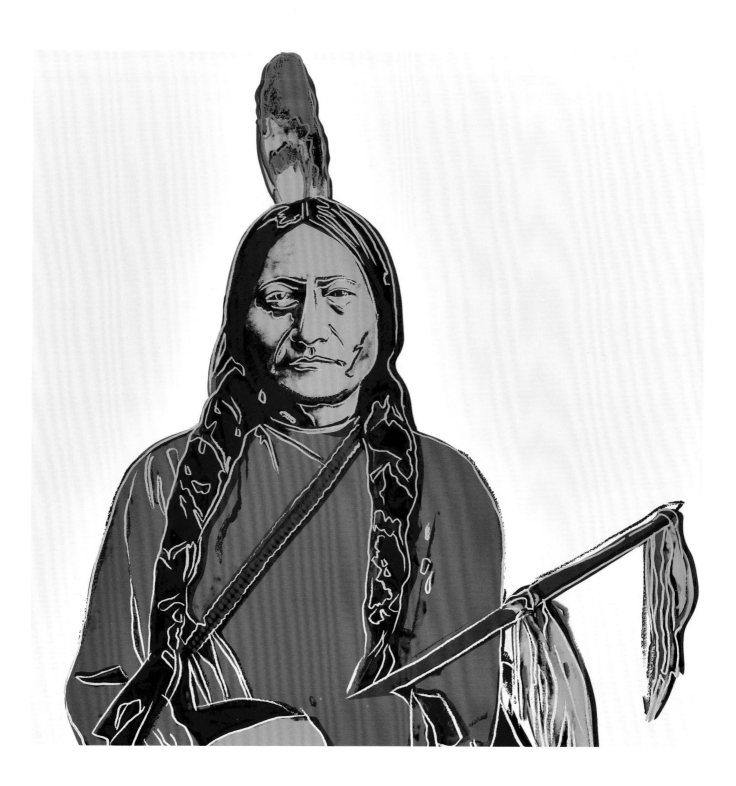

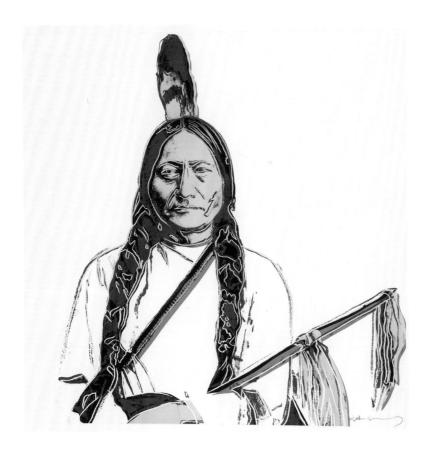

his way from exile in Canada to a military prison at Fort Randall near the present-day border of South Dakota and Nebraska. Sitting Bull was held for two years at Fort Randall before being relocated to the Standing Rock Reservation in the Dakota Territory, where he eventually lost his life, in December 1890, in an incident widely recognized as the trigger for the massacre at Wounded Knee on the Lakota Pine Ridge Reservation two weeks later. While incarcerated at Fort Randall, Sitting Bull created at least 22 autobiographical drawings of his war efforts.[4] Although his future was uncertain, his past remained present in his mind.

The portraits of Sitting Bull by Goff and Warhol are in stark contrast to the autobiographical pictographs. In Goff's photograph, Sitting Bull is pictured against a fake landscape with blurred trees in the background. In what Warhol deemed his final print for the *Cowboys and Indians* series, he eliminated the background so the figure sits boldly against a white backdrop that matches the rest of the portfolio prints. In the trial proofs, as well

as in preparatory drawings, however, Warhol had tested placing Sitting Bull within a pseudonatural environment, more closely mirroring the original historical photograph.

Warhol also experimented with skin tones. In the unpublished print, Sitting Bull is blue in the face, although in the trial proofs various shades of red and orange were used for his skin tone. His face is boldly framed by his black, fur-wrapped hair with yellow, blue, and white highlights. A single feather prominently stands upright behind his neatly parted hair. His shirt is bright red in the final print, although it appears white in a few of the proofs and faded orange in another.

The colors in the unpublished print are similar to those in the *General Custer* edition print, where Custer wears a red hat and white shirt. In fact, the two images visually complement each other. Whether or not Warhol was well versed in the histories of these two figures, his selection of source imagery and his color choices show that he may have been thinking through their

Andy Warhol
Cowboys and Indians: Sitting Bull, 1986
Screenprint on Lenox museum board
36 × 36 inches
Trial proof 2/36
The Andy Warhol Museum, Pittsburgh; Founding Collection, Contribution The Andy Warhol Foundation for the Visual Arts, Inc., 1998.1.2494.4

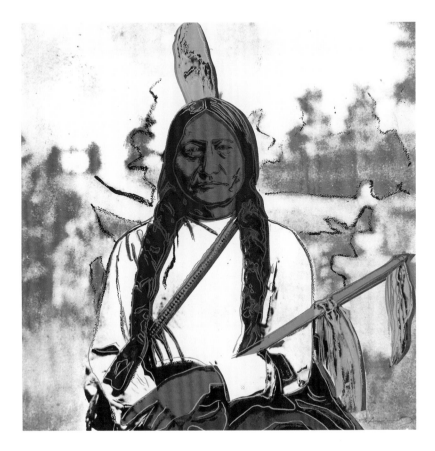

interaction and how each has been canonized in public consciousness.[5] In this light, *Sitting Bull* and other works in the *Cowboys and Indians* series address how we collectively memorialize historical figures, much like Warhol's portraits of then contemporaneous pop icons.

Although Sitting Bull appears confrontational and stares directly at the viewer, his demeanor is stoic and poised. This image diverges greatly from his own self-portraits, in which he depicts the conquests of a strong warrior and the powers he harnessed through various medicines.[6] By facilitating his own representation, Sitting Bull shares with us the moments he would like recorded in history and in doing so projects a much more honest and intimate image than Goff or Warhol could achieve.

———

Faith Brower

NOTES

1. The drawing is in the collection of the Smithsonian's National Anthropological Archives, https://sova.si.edu/details/NAA.MS1929B#ref8.

2. Ernie LaPointe, *Sitting Bull: His Life and Legacy* (Layton, UT: Gibbs Smith, 2009), 16.

3. For more on the Goff photograph, see Louis N. Hafermehl, "Chasing an Enigma: Frontier Photographer Orlando S. Goff," *North Dakota History: Journal of the Northern Plains* 81, no. 2 (Summer 2016): 19.

4. The 22 known drawings that Sitting Bull created in 1882 while imprisoned at Fort Randall are now in the collection of the Smithsonian's National Anthropological Archives, searchable online at https://naturalhistory.si.edu/research/anthropology.

5. Alvin M. Josephy Jr. discloses in an article that, based on his meeting with Warhol, he believes the artist was unfamiliar with Sitting Bull's history. Josephy, "Andy Warhol Meets Sitting Bull," *American West*, January–February 1986, 42–44.

6. Candace Greene, "Pictographs by Sitting Bull's Hand: A Smithsonian Ethnographer's Perspective," December 17, 2009, The On Being Project, https://vimeo.com/8280794.

Andy Warhol
Cowboys and Indians: Sitting Bull, 1986
Screenprint on Lenox museum board
Trial proof 13/36
36 × 36 inches
Booth Western Art Museum

War Bonnet Indian

In the final selection of 10 images that make up the *Cowboys and Indians* series, from among the 14 for which trial proofs were created, the artist and/or the publisher, Kent Klineman, did not include the two most exciting images of the lot: *Action Picture*, based on an early 20th-century painting of a cavalry charge by Charles Schreyvogel (page 132), and *War Bonnet Indian*, showing a stereotypical stoic Indian chief mounted on his horse, carrying a lance and riding through a village (note the tipis in the background). The image is reminiscent of scenes in scores of classic western films. Klineman felt these images did not fit in well with the others in the suite,[1] and there is an argument to be made to support his point. Presented against stark white backgrounds, all of the final edition prints are portraits or still lifes and all appear relatively flat, lacking modeling and depth. Only *Kachina Dolls* (page 103) shows significant depth, indicated by the dark shadows.

By contrast, *War Bonnet Indian* and *Action Picture* are dynamic images—all movement and including indications of three-dimensional space. The tipis behind the Indian rider help to create a setting for whatever story might be unfolding. Similarly, *Action Picture* also has a depth of field stretching well back into the image, in this case transferred from the original painting. These images might even be paired as representing the two sides in a conflict or similar narrative.

Until very recently, *War Bonnet Indian* was the most mysterious image in the entire project. The colophon accompanying the assembled portfolio when purchased as a set listed the source for this screenprint as a publicity image from an unknown western movie. It seems unlikely that Warhol was the one who found and suggested the image, considering that Klineman and his staff did most of the research for this project, and equally unlikely that the source photograph did not have some kind

of identification on it indicating who the actor is, the movie it is from, or a date at least. For whatever reason the individuals involved in producing the suite and the accompanying text/image credits did not include any clues regarding the source. Several researchers, including myself, spent many hours trying to identify the image by reviewing movie posters, lobby cards, publicity photo archives, and actual films, with no success. However, in the course of producing this volume, the book's designer, Thomas Eykemans, using reverse-image-finding technology, was able to determine that the inspiration for this work was a publicity photograph for the 1955 film *White Feather*.

———

Seth Hopkins

NOTES

1. Kent Klineman, telephone interview by author, February 11, 2005.

Still from *White Feather*, 1955, directed by Robert D. Webb
Twentieth Century Fox

———

ANDY WARHOL

Cowboys and Indians: War Bonnet Indian, 1986

Screenprint on Lenox museum board
Trial proof 13/36
36 × 36 inches
Booth Western Art Museum

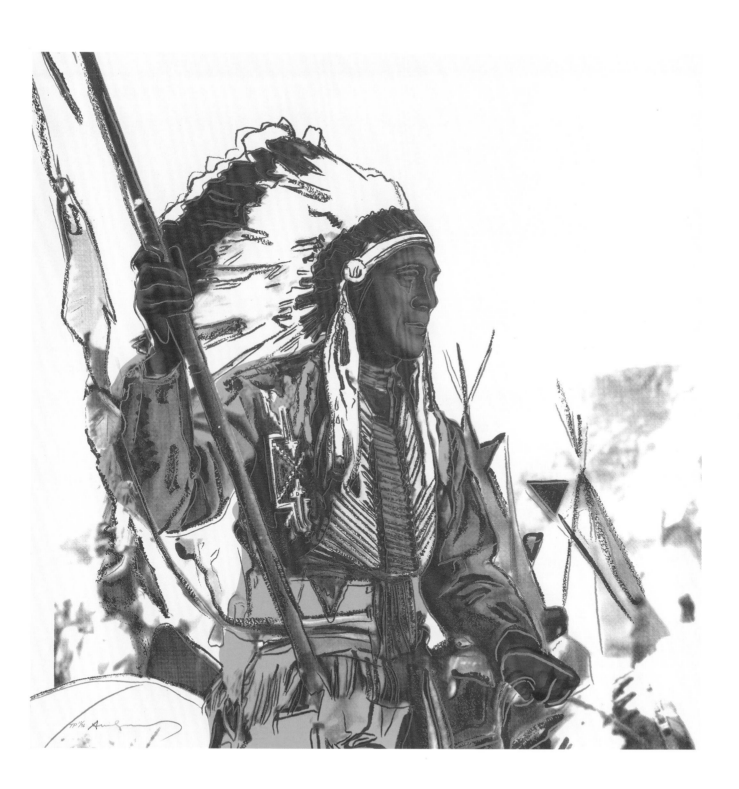

Buffalo Nickel

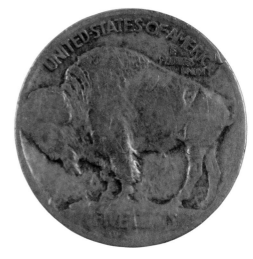

My name comes from the Nez Perce people. I was named after my paternal great-grandparents, Frank Henry and Mary Buffalo.

The buffalo is revered in almost all of the nations in North America. The Onondaga Nation has some 30 head that I grew up around and at times helped corral.

At the turn of the last century, the North American bison was pushed to the brink of extinction. Tickets were sold to passengers on trains where they could aim rifles out the windows when the train stopped as buffalo grazed on either side. They were slaughtered where they stood and nothing was harvested. This was a tactic used to starve out the "savages" during the "Indian Wars." When an Indigenous person felled a bison, no part was left to waste; horns to hooves equaled sustenance.

The 1913 Buffalo/Indian Head nickel, designed by James Earle Fraser, was part of the US Mint's attempt to beautify the five-cent piece. Its design was meant to be inclusive of many different tribes as the Indian Head side was a composite of features of various nations. But in actuality, it was an early example of stereotypes and appropriation. It is strikingly similar to the Washington Redskins logo. In an attempt to honor us. Sound familiar?

It has been written that Warhol's *Cowboys and Indians* suite was an ahistorical comment on the reality of Native Americans versus the Hollywood serialization of them. I disagree. I think that no matter his intentions, Warhol only really succeeded in reinforcing the stereotypes, thus furthering appropriation.

It seems that whenever any advertisement company, fashion designer, or pop musician is strapped for a concept they immediately go to the rich cultural images of the Indigenous people of North America. In *Buffalo Nickel* all the hallmarks of 1980s excess are there, with the offset line work that became the visual vocabulary of the decade,

James Earle Fraser
(American, 1876–1953)
Indian Head nickel/Buffalo nickel reverse sketch, 1913
Pencil on onionskin
8 × 8⅝ inches
James Earle Fraser and Laura Gardin Fraser Studio Papers, Dickinson Research Center, National Cowboy & Western Heritage Museum, 1968.001.04.022.01

James Earle Fraser
Indian Head nickel/Buffalo nickel reverse, 1913
Plaster model
⅝ × 4⅞ inches
James Earle Fraser and Laura Gardin Fraser Studio Papers, Dickinson Research Center, National Cowboy & Western Heritage Museum, 1968.001.02.08.03

Based on a drawing by
James Earle Fraser
1913 Buffalo nickel
Minted copper and nickel
1 × 1 × ¼ inches
Booth Western Art Museum

though absent the vibrant color of Warhol's many iconic works.

Think about the fact that at one point not so long ago, Indigenous people were considered to be subhuman, an inconvenience to be cleared like brush. There were open bounties on red skins—$75 to $200 per scalp. These often ended up being displayed in historical societies. Can you imagine walking into a museum and seeing your brother's, mother's, aunt's, uncle's, grandfather's, grandmother's skull or scalp on the wall for public entertainment?

If Warhol truly wanted to create dialogue about or comment on the misrepresentation of Native America, he should have had scalps on one side of his nickel and buffalo skulls on the other.

Frank Buffalo Hyde

ANDY WARHOL
*Cowboys and Indians:
Buffalo Nickel*, 1986
Screenprint on Lenox museum board
Trial proof 13/36
36 × 36 inches
Booth Western Art Museum

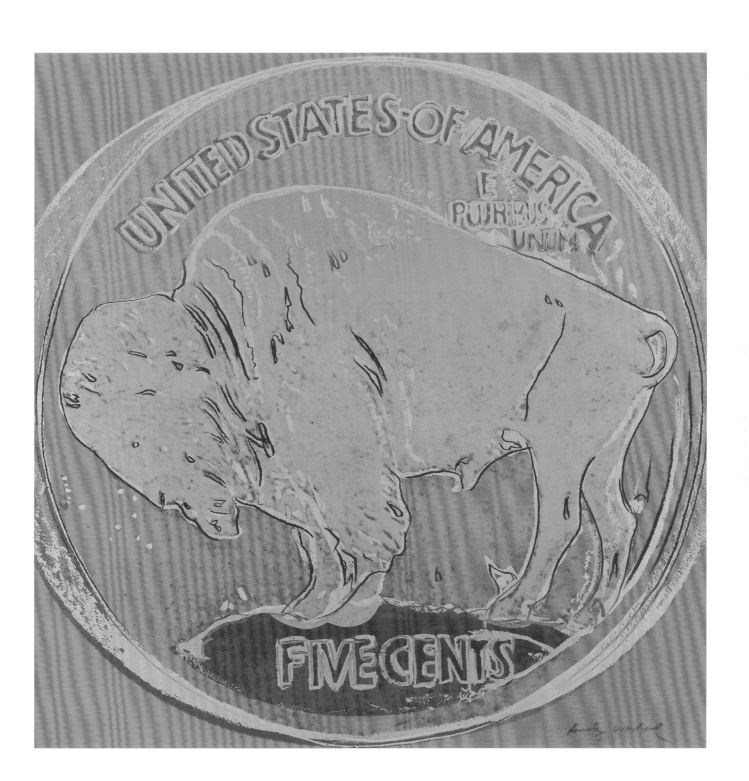

Action Picture

Warhol's use of Charles Schreyvogel's early 20th-century painting *Breaking Through the Line* for his *Action Picture* references multiple disciplines in art history. Paintings and prints in which figures and subjects engage directly with the viewer's space have appeared since the Italian Renaissance when artists began using linear perspective to create the illusion of objects and/or subjects extending beyond the picture plane into the viewer's space. This type of engagement, in which the artist forces the viewer to first acknowledge the engagement and then respond to it, was (and still is) often an attempt to challenge the status quo. Likewise, in theater and public spectacle, audience participation was encouraged from medieval times forward, and the players and action occasionally broke the "fourth wall." This naturally segued into early films, including *The Great Train Robbery* (1903) in which an outlaw "fires" a revolver point-blank at the audience.

Early western cinema relied heavily on painted depictions of the West. The director John Ford leaned especially hard on the work of Frederic Remington, often replicating specific Remington paintings in composing scenes in his films. Conversely, Warhol deliberately sought more unsentimental depictions of western imagery for his own work, which led somewhat naturally to the paintings of Schreyvogel. Remington's greatest rival as the chronicler of the Old West—at least in his own mind—was not Charles M. Russell, but rather Schreyvogel.

Remington's notorious one-sided feud with Schreyvogel over who the New York critics felt was the most credible western painter devolved to the point where even Theodore Roosevelt lamented that his friend Remington was making an ass of himself.[1] After Schreyvogel's 1903 *Custer's Demand* was exhibited at Knoedler Gallery in New York, Remington criticized Schreyvogel's accuracy in the painting through letters he sent to the *New York Herald*. Remington labeled the painting "half baked

stuff," a product of the artist's "hallucinations."[2] Schreyvogel refused to enter the fray. When Libbie Custer (Custer's widow) sent a letter defending Schreyvogel's picture, however, Remington attacked again. He offered $100 if Colonel John S. Crosby, who had been present at the event depicted, would defend the painting against his criticisms. Crosby did more, replying with biting sarcasm: "It is very evident that had Mr. Remington painted this picture he would have drawn from his vast knowledge of how things should have been at that particular date, rather than how they actually were. . . . Mr. Schreyvogel, on the other hand, seems to have painted the picture after the facts . . . not after a nice sense of the proprieties derived from misleading dates."[3] Remington was humiliated.[4]

This same wont of critical respect infused much of Warhol's art-making practices and socially provocative behaviors in the face of the push on the part of the champions of abstract expressionism. Warhol's rivalry, and that of other pop art icons, especially Roy Lichtenstein, Jasper Johns, and Robert Rauschenberg, with critics supportive of abstract expressionism was all-consuming, as they were all vying for the same clients, collectors, and critics, as well as strategic relationships and adoration. The influential art critic Clement Greenberg decried the "kitsch" and "low culture" of pop art,[5] compared

Charles Schreyvogel
(American, 1861–1912)
Breaking Through the Line,
early 20th century
Oil on canvas
46¼ × 58¾ × 2³⁄₁₆ inches
Gilcrease Museum, Tulsa,
Oklahoma, GM 0127.1235

ANDY WARHOL
*Cowboys and Indians:
Action Picture*, 1986
Screenprint on Lenox
museum board
Trial proof 13/36
36 × 36 inches
Booth Western Art Museum

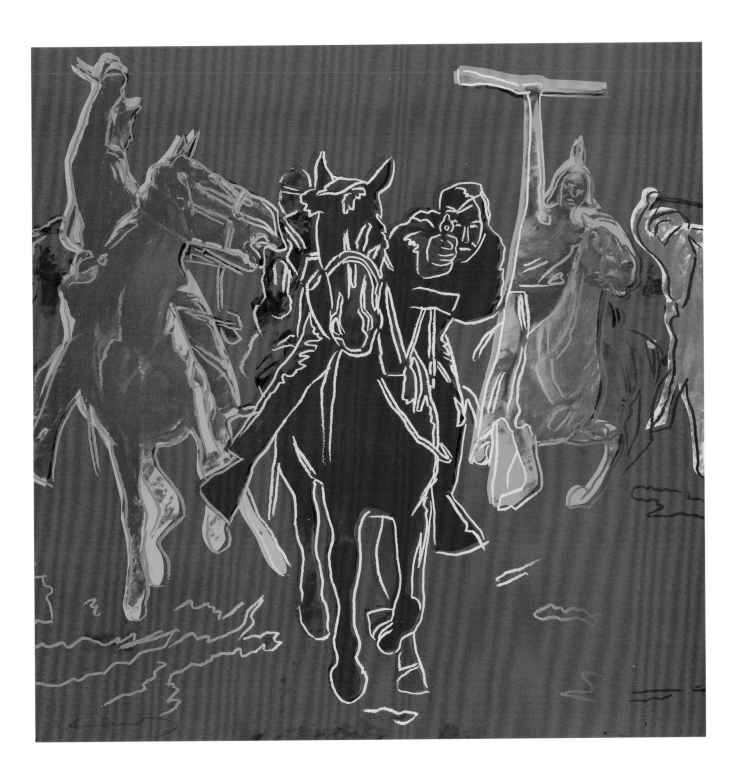

to the "serious, introspective, artistically tortured" artists of the New York School.[6] The abstract expressionist painters themselves projected an image of being "hard drinking, physically violent, and homophobic," which "led to a national image of the lot of them as rogue cowboy-types," especially Jackson Pollock.[7]

The lack of connection between the viewer/audience and abstract expressionist paintings was not lost on Warhol. Therefore, the attempt to make Schreyvogel's work part of *Cowboys and Indians* was tactical. For Schreyvogel's use of audience confrontation and participation in many of his paintings is not found in the work of Russell or Remington. In fact, this particular technique is relatively unique in the western genre. And this uniqueness, coupled with Warhol's fascination with the strange, wonderful, and uncommon, as well as with the American West, perhaps made Schreyvogel's paintings more attractive to Warhol than those of Remington and Russell. Moreover, Schreyvogel's provocative scenes aligned with Warhol's own penchant for provocation. *Action Picture* was not included in the final *Cowboys and Indians* edition. According to the portfolio's backer, Kent Klineman, Warhol "was generally a portrait painter" and *Action Picture* did not fit.[8] This particular image deserves additional research on its exclusion from *Cowboys and Indians*.

———

Michael R. Grauer

NOTES

1. Roosevelt reportedly said, "What a fool my friend Remington made of himself, in his newspaper attack, he made a perfect jack of himself, to try to bring such small things out, and he was wrong anyway." Letter from Charles Schreyvogel to his wife, November 25, 1903, Dickinson Research Center, National Cowboy & Western Heritage Museum, Oklahoma City, Oklahoma.

2. *New York Herald*, April 28, 1903.

3. *New York Herald*, May 2, 1903.

4. Schreyvogel never replied; two years later, in an interview, he stated simply that Remington "is the greatest of us all" and offered no further comment. Gustave Boehm, "Painter of Western Realism," *Junior Munsey* 8

(1900): 432–38, as cited in James D. Horan, *The Life and Art of Charles Schreyvogel* (New York: Crown Publishers, 1969), 36.

5. Clement Greenberg, "Avant-Garde and Kitsch (1939)," in *Art and Culture: Critical Essays* (Boston: Beacon Press, 1961), 9, as cited in Alycia Faith Reed, "Fifteen Minutes and Then Some: An Examination of Andy Warhol's Extraordinary Commercial Success" (MA thesis, University of Iowa, 2012), 22, https://ir.uiowa.edu/cgi/viewcontent.cgi?article=3120&context=etd.

6. Reed, "Fifteen Minutes and Then Some," 21.

7. Reed, 21, 23.

8. Seth Hopkins, "Andy Warhol's *Cowboys and Indians* Suite" (MA thesis, University of Oklahoma, 2005), 59.

Contributors

Tony Abeyta is an artist working in mixed-media paintings. He is based in Santa Fe, New Mexico, and Berkeley, California. He is a member of the Navajo Nation.

heather ahtone is Senior Curator at the American Indian Cultural Center and Museum in Oklahoma City. She is a member of the Chickasaw Nation and has strong family ties to the Choctaw, Kiowa, and Navajo communities.

Sonny Assu (Ǧʷaʔǧʷadəx̌ə) is an interdisciplinary artist. He is Ligwiłda'xw (of the Kwakwaka'wakw nations) and resides in unceded Ligwiłda'xw territory (Campbell River, BC).

Faith Brower is the Haub Curator of Western American Art at Tacoma Art Museum.

Gregg Deal is a performance artist, painter, and activist. He is Pyramid Lake Paiute and resides in Colorado Springs, Colorado.

Lara M. Evans is an art historian and Associate Academic Dean at the Institute of American Indian Arts in Santa Fe, New Mexico. She is a member of the Cherokee Nation.

Michael R. Grauer is McCasland Chair of Cowboy Culture/Curator of Cowboy Collections and Western Art at the National Cowboy & Western Heritage Museum in Oklahoma City.

Seth Hopkins is the Executive Director at the Booth Western Art Museum in Cartersville, Georgia.

Frank Buffalo Hyde is an artist. He is from the Onondaga Nation (Beaver Clan) and is Nez Perce.

Tom Kalin is Professor of Film in the School of the Arts at Columbia University. He is an award-winning filmmaker and a member of the AIDS activist collective Gran Fury.

Gloria Lomahaftewa serves as the Hopivewat Project Manager for the Hopi Cultural Preservation Office in Kykotsmovi, Arizona. She is of Hopi and Choctaw heritage.

Daryn A. Melvin is Staff Assistant to the Office of the Vice Chairman of the Hopi Tribe in Kykotsmovi, Arizona. He is a member of the Hopi and Navajo Tribes and a member of Sitsomovi village on the Hopi Reservation.

Andrew Patrick Nelson is Associate Professor of Film History and Critical Studies at the School of Film & Photography, Montana State University in Bozeman.

Chelsea Weathers is an editor and arts writer based in Santa Fe, New Mexico. She is a contributing art critic at *Artforum*.

Rebecca West is Curator of the Plains Indian Museum at the Buffalo Bill Center of the West in Cody, Wyoming.

Copyright and Photography Credits

The *Warhol and the West* catalogue was published by the Booth Western Art Museum, the National Cowboy & Western Heritage Museum, and Tacoma Art Museum in association with the University of California Press. The traveling exhibition of the same name was co-organized by the Booth Western Art Museum, the National Cowboy & Western Heritage Museum, and Tacoma Art Museum.

At the Booth Western Art Museum the exhibition and catalogue are generously supported by an anonymous donor, Neva and Don Rountree, Anne B. Eldridge, Luther King Capital Management, and Karen and Joel Piassick. At the National Cowboy & Western Heritage Museum the exhibition and catalogue are generously supported by Devon Energy, The E. L. and Thelma Gaylord Foundation, The True Foundation, Arvest Bank, Cox Communications, MassMutual Oklahoma, Oklahoma Gas & Electric, and Oklahoma City Convention and Visitors Bureau. At Tacoma Art Museum the exhibition and catalogue are generously supported by the Haub Family Endowment, Virginia Bloedel Wright, and, in part, ArtsFund.

National tour:

BOOTH WESTERN ART MUSEUM
Cartersville, Georgia
August 24–December 31, 2019

NATIONAL COWBOY & WESTERN HERITAGE MUSEUM
Oklahoma City, Oklahoma
January 31–May 10, 2020

TACOMA ART MUSEUM
Tacoma, Washington
July 1–September 20, 2020

TACOMA ART MUSEUM
1701 Pacific Avenue
Tacoma, WA 98402
tacomaartmuseum.org

UNIVERSITY OF CALIFORNIA PRESS
Oakland, California
ucpress.edu

Produced by Lucia|Marquand, Seattle
luciamarquand.com

Designer: Thomas Eykemans
Editor: Michelle Piranio
Project Manager: Zoe Donnell
Image Acquisitions and Permissions: Gina Broze
Typesetter: Tina Henderson
Proofreader: Karen Davison
Indexer: Enid Zafran
Printer: C&C Offset Printing Co., Ltd., China

LIBRARY OF CONGRESS CATALOGING-IN-PUBLICATION DATA

Names: Ahtone, Heather. | Brower, Faith. | Hopkins, Seth. | Booth Western Art Museum, organizer, host institution. | National Cowboy and Western Heritage Museum, organizer, host institution. | Tacoma Art Museum, organizer, host institution.
Title: Warhol and the West / essays by Heather Ahtone, Faith Brower, Seth Hopkins ; contributions by Tony Abeyta, Sonny Assu, Faith Brower, Gregg Deal, Lara M. Evans, Michael R. Grauer, Seth Hopkins, Frank Buffalo Hyde, Tom Kalin, Gloria Lomahaftewa, Daryn A. Melvin, Andrew Patrick Nelson, Chelsea Weathers, Rebecca West.
Description: Tacoma, Washington : Tacoma Art Museum ; Oakland : in association with University of California Press, [2019] | Includes bibliographical references and index.
Identifiers: LCCN 2019013743 | ISBN 9780520303942 (hardback)
Subjects: LCSH: Warhol, Andy, 1928–1987—Exhibitions. | Warhol, Andy, 1928–1987. Cowboys and Indians—Exhibitions. | West (U.S.)—In art—Exhibitions. | BISAC: ART / Collections, Catalogs, Exhibitions / General. | ART / Individual Artists / General. | ART / American / General. | ART / History / Contemporary (1945–). | ART / Popular Culture. | ART / Native American. | HISTORY / United States / State & Local / West (AK, CA, CO, HI, ID, MT, NV, UT, WY).
Classification: LCC N6537.W28 A4 2019 | DDC 700.92—dc23
LC record available at https://lccn.loc.gov/2019013743

IMAGE CAPTIONS
Dimensions for all works in this publication are provided as height by width by depth, unless otherwise noted.

Front cover: Andy Warhol, *Cowboys and Indians* portfolio, 1986, left to right starting with top row: *Indian Head Nickel* (p. 93); *General Custer* (p. 95); *Northwest Coast Mask* (p. 99), *Kachina Dolls* (p. 103), *John Wayne* (p. 105), *Teddy Roosevelt* (p. 109), *Mother and Child* (p. 113), *Plains Indian Shield* (p. 117), *Geronimo* (p. 119), *Annie Oakley* (p. 123)
Endsheets: Andy Warhol's 1963 exhibition *Elvis Paintings*, installation view, Ferus Gallery, Los Angeles
Page 2: Andy Warhol, *The American Indian (Russell Means)* (detail; p. 69)
Page 4: Andy Warhol, *Cowboys and Indians: Annie Oakley* (detail; p. 123)
Back flyleaf: Andy Warhol in Aspen [Andy Warhol covered in snow after a snowmobile crash documented in *The Andy Warhol Diaries* on New Year's Day, January 1, 1983, in Aspen, Colorado]
Back cover: Andy Warhol, *Cowboys and Indians: Buffalo Nickel* (p. 131)